Uncommon
Cultures

r before

Uncommon Cultures
Popular Culture and Post-Modernism

Jim Collins

ROUTLEDGE

New York

London

Note: A condensed version of Chapter Five appeared in *Screen* 28, no. 2 (Spring 1987).

Published in 1989 by

Routledge
An imprint of Routledge, Chapman and Hall, Inc.
29 West 35th Street
New York, NY 10001

Published in Great Britain by

Routledge
11 New Fetter Lane
London EC4P 4EE

Library of Congress Cataloging-in-Publication Data

Collins, Jim, 1953–
 Uncommon cultures : popular culture and post-modernism / Jim Collins.
 p. cm.
 Bibliography: p.
 Includes index.
 ISBN 0–415–90016–6; ISBN 0–415–90137–5 (pbk.)
 1. Postmoderism. 2. Popular culture. I. Title.
NX456.5.P66C65 1989 89–30886
700′.9′04–dc 19 CIP

British Library Cataloging-in-Publication Data also available.

Once upon a time there were the mass media and they were wicked, of course and there was a guilty party. Then there were the virtuous voices that accused the criminals. And Art (ah, what luck!) offered alternatives for those who were not prisoners of the mass media. Well, it's all over. We have to start again from the beginning, asking one another what's going on.

Umberto Eco
Travels in Hyperreality
1986

Contents

For Ava

Acknowledgments

I owe an enormous debt of gratitude to Rick Altman, Dudley Andrew, David Bordwell, Joe Buttigieg, Jane Feuer, Tom Lewis, Tania Modleski and David Morris, who all read parts of this book in manuscript and offered invaluable advice and criticism. I have also learned a great deal from my students and colleagues at the University of Notre Dame, especially Pam Falkenberg, Bill Krier, Jim Peterson and John Welle. The patience, wit and perspicacity of my editor, Bill Germano were all very much appreciated and made significant contributions to the finished product. The scrupulous copy-editing of Diane Gibbons at Routledge also played an essential role in making my prose fit for human consumption.

I would especially like to thank Patrice Petro for endless conversations, arguments, pep talks and thorough readings that helped me refine my thinking time and time again.

Without the unwavering support of my parents and father-in-law, this work would never have been completed. May I believe in my children the way they believe in me. I must also thank my daughters A.V. and Nell for putting up with their father during a difficult stage in his development.

Finally, I owe everything to my wife, Ava, who has been the virtual co-creator of this book. She remains my severest critic and the light of my life.

Preface

I believe that any book with a title as enigmatic as mine should begin with a brief explanation that will give readers some idea of its contents. This of course tends to kill the suspense, but since the two subjects of this study—popular culture and Post-Modernism—have each generated numerous debates, the partisans of various sides might appreciate a brief description of what this book sets out to do. Stated as simply as possible, this study emphasizes the interconnectedness of popular culture and Post-Modernism; developing a coherent theory of the latter depends on our understanding the complexity and historical development of the former. It is of course no secret that Post-Modern texts in a number of different media have appropriated conventions and images normally associated with popular culture. I am concerned less with the actual appropriations as with the factors that have given rise to this process. Post-Modernism is most productively understood not just as a transitional reaction against Modernism, but as the culmination of the ongoing proliferation of popular narrative that began nearly two centuries ago. We need to see popular culture and Post-Modernism as a continuum because both reflect and produce the same cultural perspective—that "culture" no longer can be conceived as a Grand Hotel, as a totalizable system that somehow orchestrates all cultural production and reception according to one master system. Both insist, implicitly or explicitly, that what we consider "our culture" has become *discourse-sensitive*, that how we conceptualize that culture depends upon discourses which construct it in conflicting, often contradictory ways, according to interests and values of those discourses as they struggle to legitimize themselves as privileged forms of representation. The goal of this book is to come to terms with the "uncommoness" of contemporary cultures, to investigate how these decentering and recentering processes occur and to explore their ramifications for notions of textuality, intertextuality, audience, ideology and the history of narrative.

As the opening epigraph from Umberto Eco suggests, we do indeed need to start again and question many of the presuppositions that have served as the foundation for cultural analysis for the past three decades. This process of re-examination has already been initiated within the past few years by feminists and British culturalists anxious to demonstrate that "mass culture" is far from monolithic, particularly in regard to audiences and the various ways they give meaning to the texts that surround them. This book, then, is an attempt to bring together that groundbreaking work with concepts of Post-Modernism—theorized largely by novelists, architects, and architectural semioticians—in order to arrive at a more comprehensive critical framework for understanding the complexity of both production and reception within contemporary cultures. While this book in some ways is built on this very stimulating work, the main thrust of my argument is that we need to be far more radical in our reformulations in order to account for that complexity.

While I hope, of course, that my argument will find a receptive audience, I realize full well that much of this book will provoke consternation in many readers, if not the occasional fit of apoplexy. For some critics, my suggestion that we need to question the utility of concepts like "mass culture" and "the dominant" would be rather like suggesting that we abandon "the devil" to a group of fundamentalist ministers. "Mass culture," "the dominant," and "the devil" serve as convenient concepts on which the blame for all evil may be easily fixed, providing a simple narrative explanation for why utopian states cannot be achieved, as well as allowing for self-righteous poses in the present. But while "the devil" might make for marvelous explanatory myths, most sophisticated theologians would stress that such myths only trivialize the complexity of moral questions and human psychology. In much the same way, "the dominant" ruling class that controls all facets of cultural life may well be a fascinating methodological fiction, but it only obstructs our understanding of the complexity of the conflictive power relations that constitute our cultures. A more sophisticated understanding of *domination* as a process must begin with the rejection of the monolithic category of "the dominant." This book, then, is intended to be heretical, but only in order to help bring about a profound re-examinatin of the sacred "givens" of cultural analysis which lead to the automatic rejection of both popular culture and Post-Modernism. It is intended to be antagonistic only to those who refuse to see the need for such a re-examination, to those critics on both the left and the right for whom cultural analysis has become a reified set of value judgments.

Adopting an eclectic approach was essential for overcoming the territorial isolation that has kept more comprehensive theories of Post-Modernism from emerging. In attempting to trace key points of contact as well as the significant differences in the way the "object" that is contemporary culture has been

constructed, I have concentrated on the all-pervasiveness of certain features of textuality. Because of this broad scope it will be easy sport to find significant omissions in my argument, and most readers will surely be surprised at one time or another that I have failed to menion a favorite text or critical work. I hope this is indeed the case, because this book is intended as a prolegomena rather than as a definitive study, a set of new and revised questions rather than more easily defended answers.

One

Cultural Fragmentation and
the Rise of Discursive Ideologies

Peter Sellars, Opera Director:
We're living in a culture that is incredibly multifaceted.
I grew up with John Cage and Merce Cunningham as old
masters. But while they were giving birth to something,
Norman Rockwell was also in his prime. With a push of a
button we can choose some 18th-century Chinese lute
music, the Mahler 6th, or Prince.[1]

Bruce Springsteen, Rock Musician:
We learned more than a three-minute record baby than
we ever learned in school ... So maybe we can cut
someplace of our own with these drums and these guitars,
'Cause we made a promise we swore we'd always
remember, No retreat, baby, no surrender.[2]

Tomas Borge Martinez, Sandinista:
Perhaps I could say that I was led to the revolutionary
life by reading an author named Karl May. Karl May, not
Karl Marx. May was a German who wrote novels about
the wild West in the United States (without ever visiting
America). I was about 12 years old when I read his books
and they affected me profoundly. In the May westerns,
the heroes were archetypes of nobility—courageous,
audacious, personally honest. I wanted to be like them.
But since in Nicaragua we didn't have the Great Plains of
the North American West, and since the injustices we
were facing were different from those in Western novels,
I decided to confront Nicaraguan injustices.[3]

Within the past decade a wide range of cultural critics representing radically
different ideological perspectives have pointed to the crisis within cultural life.

Culture is no longer a unitary, fixed category, but a decentered, fragmentary assemblage of conflicting voices and institutions. Whether described as the dissolving of the "mainstream" into a delta by an avant-garde composer like John Cage[4] or the loss of a "common legacy" by the Secretary of Education,[5] a widespread awareness exists that an "official," centralized culture is increasingly difficult to identify in contemporary societies. Although explanations for this development differ quite drastically from theorist to theorist (as do their responses to it), the common denominator remains a recognition that our supposedly "common" culture is continuing to fragment.

Despite this consensus, few attempts to develop new models for cultural analysis to account for this situation have appeared, largely because most theorists have treated earlier, more homogeneous cultures as a kind of "paradise lost" that must be reclaimed. Consequently, most of the theorizing on Post-Modernism or "education reform" remains predicated on 19th-century presuppositions about society and cultural production. Most ideological analyses of popular fiction, for example, either insist on an all-pervasive cultural anarchy or continue to maintain the existence of a "dominant culture," no matter how tortured its justification. Surface alterations have been employed to account for the recognized disintegration of such unitary structures, but the premises of such studies remain outmoded, rather like a remodeled, "modernized" Victorian house still resting on century-old foundations. In order to come to terms with the decentering and *recentering* processes at work in contemporary culture we need to develop new ways of theorizing "culture" that will recognize the impact of those processes on the construction of the texts and subjects that constitute it.

The quotations I have cited to begin this chapter appear to describe quite different cultural phenomena. The avant-garde theater director emphasizes the multiple-choice nature of contemporary cultural production, the rock star defends his music against the world, and the revolutionary explains the origins of his political commitment. While these perspectives may seem at best tangentially related, they all describe interconnected aspects of the same situation, where cultural production is no longer a carefully coordinated "system," but provides a range of simultaneous options that have destabilized traditional distinctions between High Art and mere "mass culture." This destabilization produces conflicts between competing forms of discourse as they try to "cut" a place for themselves, resulting in the need for a given genre, medium, or institution to promote itself as a privileged mode of representing experience. As texts define themselves over and against these other push-button choices, a legitimation crisis naturally occurs in which that text must justify not a social class, but its ability to perform a particular function, to fulfill a specific need within their culture. Once such a situation arises, individual readers, viewers, and listeners are inevitably drawn to specific types of discourse that may become the primary or base level of their

consciousness. At this point they begin to recognize themselves not in their culture "as a whole," but in the discourse of choice, whether it be Karl May Westerns, Harlequin romances, evangelical television, or the "Great Books" tradition.

The origins and/or causes of the profound changes in the "wholeness" of cultures have been attributed to any number of different factors. On a more specific level, a diverse group of literary and social historians have begun a thorough re-examination of the changing nature of "writing" and "reading" over the past three centuries. The seminal work of Robert Darnton[6] and Carlo Ginzburg[7], to mention only two examples, has brought about a far more subtle understanding of the diversity of cultural production and its possible uses. As brilliant and useful as this work is, the vast majority of such studies concentrate on shedding greater light on sharply delimited historical periods and therefore do not explain how we have arrived in this state of apparent "cultural crisis" in the latter half of the 20th century. If we are to develop satisfying explanations of the fundamental changes in how culture has been produced and consumed we need to piece togther the factors responsible for those changes and develop a historical continuum for appreciating those changes not as sudden breaks, but as culminations.

One of the most comprehensive attempts to construct such a continuum for understanding the changing nature of what constitutes culture is set forth by Terry Eagleton in *The Function of Criticism*.[8] He situates the origins of this cultural fragmentation in the 18th century, specifically in regard to the changing role of criticism. In defining the nature of "culture" in the Enlightenment he utilizes the term "public sphere" (borrowed from Jürgen Habermas) to describe that network of social relations and institutions that constitute "public opinion." The distinguishing feature of this sphere in England in the 18th century was its "consensual character," and the body of opinions concerning things cultural was relatively homogeneous due to the cohesiveness of the educated class that produced and circulated those opinions. The critic was still cultural rather than "literary," owing to the lack of intense specialization that would begin in the 19th century, but also because "culture" was a relatively stable, commonly held set of beliefs within polite Enlightened society. But this cohesive public sphere begins to fragment by the end of the century. Eagleton develops the political and economic factors responsible for its gradual disintegration in regard to the British class structure and the change from a literary patronage system to one in which the professional writers could be supported by their publics. He also signals another fundamental change regarding the varying levels of literacy in the 19th century.

> There were naturally many degrees of literacy in eighteen-century England, but there was an obvious distinction between those who could

"read" in a sense of the term inseparable from the ideological notions of gentility, and those who could not. The nineteenth-century man of letters must suffer the blurring and troubling of this reasonably precise boundary. What is now most problematical is not illiteracy . . . but those who, capable of reading in a physiological and psychological but not culturally valorized sense, threaten to deconstruct the fixed oppositions between "influential persons" and "multitude." What is most ideologically undermining is a literacy which is not literacy . . . a whole nation which reads, but not in the sense of reading, and which is therefore neither quite literate nor illiterate, neither firmly within one's categories nor securely without. (pp. 51–52)

While Eagleton's account of the changing nature of criticism is quite comprehensive, he underplays the significance of another factor in the fragmentation of the public sphere that had a direct impact on the differences in "reading" among the various factions within British society. Just as a cohesive, homogeneous reading public fragments into a *series* of reading publics, "artistic expression" fragments into a network of competing discourses. The consensual public sphere disintegrates when textual production as well as textual consumption ceases to be unified by notions of "culture" or polite letters. Variations in "reading" were attributable to variations in what was read by those publics, involving a very similar blurring of "literature" and "non-literature," specifically in regard to popular fiction. Tony Davies,[9] in a fascinating article on railway fiction (popular literature sold in train stations) examines not only the shifting relationship between serious Literature and popular fiction, but the diversification of the latter as reading publics become increasingly gender-specific in the 19th century. To read narrative, then, is not necessarily to read great Literature. What Eagleton says of criticism in the 19th century could just as appropriately be said of fiction. "Criticism [fiction] needed such legitimacy because of the collapse of the public sphere which had previously validated it; but without such a common set of beliefs and norms there was no authority which criticism [fiction] could legitimate itself *to*. Its discourse was accordingly forced to be self-generating and self-sustaining" (p. 81).

This self-legitimation process is nowhere more obvious than in the various forms of popular narrative that appeared as the Enlightenment public sphere was beginning to fragment in the late 18th-early 19th centuries. Without a unitary tradition to align themselves with while they competed for overlapping and ever-shifting audiences, the new forms of popular narrative again and again sought to justify themselves as privileged, "legimate" modes of representing the world as it was or should be. In the 20th century, the hierarchies of class and aesthetic discourses that had begun to break up over the course of the 19th-century had at last disintegrated. The factors

contributing to this disintegration are interdependent: once literacy becomes widespread regardless of economic station, books become available in inexpensive editions, and publishing houses are outside direct state control, class distinctions become increasingly less important in determining audience. Once the means of production, distribution, and consumption all defy class orientations, correlations between class and genre begin to dissolve. This process begins to snowball with the advent of film, and particularly television, when problems of literacy and accessibility have virtually disappeared. Vestiges of such correlations appear in the 20th century, but they have been, for the most part, of rather limited duration. The emergence of film and television exemplifies the temporary resurgence of social/artistic hierarchies. Both were initially considered inferior art forms, mere sideshow attractions for the great unwashed, as opposed to "Literature," or "Theater," yet both have acquired a different status through the development of a highly heterogeneous audience.

Class distinctions are increasingly less influential in determining who reads what due to basic changes in publishing and literacy, but perhaps even more fundamentally, their influence has continued to decrease in the 20th century with the gradual redefinition of those very class distinctions. Kenneth Roberts et al. argue quite convincingly in *The Fragmentary Class Structure* that traditional class distinctions such as blue collar/white collar or working class/middle class are no longer sacred givens in regard to how groups of individuals perceive themselves within a given social formation.[10] The authors assert "the working class is splintered by numerous cross-cutting internal divisions. Some are hierarchical, as between different levels of skill, while others are lateral, as between different but equally skilled trades" (p. 97). The lack of coherence within a specific "class" is also the result of "the absence of a clearly defined other side.... For the working class the them in the us/them equation is not easily identified. The working class is not a caste and its boundaries are blurred" (p. 98). While class cohesiveness may be disappearing, no great leveling process is at work in which all classes slowly fade into one; thus the book resists any scenarios that posit the "embourgeoisement" or "proletarianization" of society as a whole. Distinctions remain, but the borders have shifted: "The days when it was realistic to talk about the middle class are gone. The trends are toward fragmenting the middle class into a number of distinguishable strata, each with its own view of place in the social structure" (p. 143).

The cohesiveness of the unitary public sphere was dependent upon a notion of "culture" as a relatively closed set regarding its rules and players. As soon as the categories of literature and public begin to diversify and multiply, "culture" becomes a fundamentally conflicted terrain. Standard literary scholarship lavishes critical attention on the tensions that arise when specific movements collide and catalogues the various "battle of *Hernani*" situations, but either ignores or minimizes the perpetual ongoing conflicts that are the

rule rather than the exception in cultural production. Edward Said, for instance, insists that

> the western novelistic tradition from *Don Quixote* on is full of examples of texts insisting not only upon their circumstantial reality, but also upon their status as *already* fulfilling a function, a reference, or a meaning *in the world*. . . . All texts essentially displace, dislodge other texts, or more frequently they take the place of something else. As Nietzsche had the perspicacity to see, "texts are fundamentally facts of power, not of democratic exchange."[11]

Said's analysis of how texts by Gerard Manley Hopkins, Oscar Wilde, and Joseph Conrad exemplify such struggles is compelling. But the battles here appear to be fought by great artists, rather than being endemic to the majority of texts in varying degrees of intensity once discourses are no longer content to fulfill specific co-ordinated functions in some kind of master system. Rather than isolatable anxieties of influence, the struggles texts engage in to "clear a space" for themselves within specific semiotic environments are the direct result of an all-pervasive anxiety of *confluence* that affects all cultural production.

My argument is that texts have always demonstrated a knowledge of their "worldliness," and have asserted their status in relation to an imagined "world" or context; but from the end of the 18th century and on to the present, the need for such assertions has been intensifying as the "world" becomes increasingly complicated due to competition among different discourses for the same status, for fulfilling the same or similar functions for a given culture. Since the latter half of the 18th century, this competition has become commonplace as a result of the steady collapse of any kind of hierarchy of narrative discourses that link up neatly with any kind of social hierarchy of consumers. The homologous hierarchies constructed by Jan Mukařovský,[12] in which discourses knew their place and social classes knew their proper reading material, have collapsed. One such hierarchies cease to exist, no unseen hand regulates which discourse can assert the fulfillment of which function, nor which individual can read which discourse, nor how individuals might decode them.

Fictional texts become, at this point, doubly "ideological" in that they vehiculate a particular political position, but also promote themselves as forms of discourse, generating their own set of distinctive values, sustaining their own stylistic uniqueness, constructing very particular subjects. To account for the impact of self-promotion on a public sphere, or even a "mass consciousness" in the most general sense, we need to develop a coherent notion of discursive ideologies. Earlier analyses focus on how a text manifests an ideological system that is both non-aesthetic and pre-existent rather than examining how an aesthetic discourse like detective fiction generates its specific

ideology as reaction to other competing ideologies within a given culture. The investigation of aesthetic ideologies is a first step in a much larger project of developing a theory of decentered cultures predicated on the conflictive heterogeneity of cultural production. By focusing on seemingly minor problems concerning the tensions among different aesthetics discourses, I hope to reveal the insufficiency of most contemporary cultural analysis, and to demonstrate that the very presence of such tensions suggests a radically different notion of culture than previously theorized. Very few studies have yet examined how the competition among different aesthetic discourses for ever-shifting audiences has affected the construction of those discourses and the very cultures that gave rise to them.

Inside the Grand Hotel: The "Mass Culture" Critique and Its Fantasies

The fragmentation of a unitary public sphere into multiple reading publics and diverse forms of narrative is clearly linked to the emergence of a "mass culture," the convenient cover term used to describe cultural production in the industrial and post-industrial eras. Yet the vast majority of the theories of mass culture have explicitly failed to recognize this fragmentation, instead emphasizing the standardization of cultural production resulting from the increasing technological sophistication in both its production and distribution. Rather than conceiving of the transition from the Enlightenment to the Industrial Age as a shift from one public sphere to multiple spheres, critics of mass culture, from Matthew Arnold to Jean Baudrillard, have characterized this transition as a profound fall from grace, in which the twin evils of mechanization and commodification have eliminated any kind of cultural heterogeneity. The diversification and proliferation of popular culture that begins at the end of the 18th century seems an appropriate starting point for examining the changing nature of what constitutes culture, but one of the basic tenets of mass culture theory effectively precludes any such inquiry—namely that popular culture itself is so contaminated by mechanization and commodification that it cannot be seen as a genuine expression of anything other than the corporations that standardize it for their own ends. In other words, the emergence of multiple public spheres has remained largely untheorized because of the widespread rejection of mass culture by both the Left and Right factions within the academy (the faithful remnant of the once and future public sphere), who are so anxious to deny any validity to the very forms of popular culture that have played such a significant role in destabilizing both the substance and participants of what once constituted the unitary public sphere.

What I refer to here as the critics of mass culture are theorists who have profoundly different aesthetic and ideological orientations, but share certain presuppositions: 1) that cultures can be conceived as having "centers" from which all cultural activity may be measured; 2) that all cultural production functions according to a unitary master system; 3) that within such systems binary oppositions must be made between authentic art (the "best that has been thought and said" in both classic and avant-garde versions) and mass culture; 4) that the former is diverse because it is produced by artists, but the latter remains undifferentiated because it is produced by machines and corporations; 5) that the audience for the former is also diverse because they are enlightened, but the audience for the latter is merely a mass, identical as the texts it consumes; 6) that the role of the cultural critic is essentially an evaluative one in which the criteria for authentic art must be defined and defended against the onslaught of mass culture, thereby emphasizing culture as a master system, a cohesive "whole" with appropriate and inappropriate representations.

The various incarnations of the mass culture critique throughout history have been lucidly traced by Patrick Brantlinger[13] and Alan Swingewood,[14] so a comprehensive overview of its permutations is unnecessary here. The work of Martha Woodmansee[15] on the debates of the 1790s in Germany is especially relevant here, though, because those debates represent the first attempts by academic critics to deal with the problem of increased literacy and the concomitant rise of mass culture, specifically in the form of popular literature. Woodmansee argues that while Joseph Addison advocated widespread reading (as a kind of amateur connoiseurship for the general public) as having only the most salutory effects, the German critics and philosophers of the late 18th century saw only the potential dangers. The conservative faction in those debates argued for the systematic regulation of reading, often calling for the outlawing of reading societies and lending libraries that spread literacy and "evil" popular literature, both of which threatened the established social order. This position is summed up rather neatly by Johann Georg Heinzman's contention that "A good police force ought to watch over the spiritual and moral welfare of its constituency no less than their physical well-being. We incarcerate enthusiasts and simpletons who disturb the peace, so why should we not ban wanton authors?" (quoted in Woodmansee, p. 7).

The liberal faction on the other side of the debate rejected the systematic control over supply and access to popular literature, concentrating their efforts on influencing the *way* this newly literate public would read. Their objection to the emerging mass culture was just as intense, but for very different political reasons; the all-pervasiveness of popular literature, rather than jeopardizing the status quo, only strengthened it by promoting an intellectual passivity that eliminated the possibility of opposition. Johann

Adam Bergk's *The Art of Reading Books* (1799) advocates the reading of classical authors who encourage the "free play" of the reader's imagination and condemns outright various forms of popular literature since they only produce readers "who devour one insipid dish after another in an effort to escape an intolerable mental vacuum. They watch events appear and disappear as in a magic mirror, each one more absurd than the last one. All mental activity is stifled by the mass of impressions." Woodmansee makes the essential point that the ultimate goal of liberal critics was to bring back "older reading strategies in order to direct them toward a limited body of *secular* texts capable of playing the same role in their lives that sacred texts had once played." What emerges from the debates of the 1790s, then, is not just the wholesale rejection of popular literature as social threat, but the constitution of sacred and profane categories that sought to legitimate earlier notions of "reading" and "literature." Perhaps most important, what becomes increasingly explicit is a fear that "culture" as a set of practices, values, and institutions is no longer controllable by an intellectual class. The greatest sin of these new publics and discourses was their resistance to being managed.

The perpetuation of this attitude toward mass culture in the 20th century is most obvious in Theodor Adorno's and Max Horkheimer's "The Culture Industry: Enlightenment as Mass Deception,"[16] only here the profane quality has been redefined. Rather than representing potential chaos, mass culture now merits condemnation because it is so rigidly controlled by corporations. Adorno and Horkheimer formulate a series of positions all predicated on the uniformity of popular and mass culture, arguing that "Culture now impresses the same stamp on everything. Films, radio and magazines make up a system which is uniform as a whole and in every part.... All mass culture is identical." No pertinent differences among various forms of discourse can exist, since "marked differentiations ... depend not so much on subject matter as on classifying, organizing and labeling consumers" (p. 123). This homogeneity is ensured by a rigorous coordination of the components of this system by a centralized authority: "There is the agreement—or at least the determination—of all executive authorities not to produce or sanction anything that in any way differs from their own rules, their own ideas about consumers, or above all themselves" (p. 122). Echoing Bergk and the liberals of the 1790s, Adorno's mass culture fails to "negate" or "refract" the voice of the State because the "need which might resist central control has already been suppressed by the control of the individual consciousness" (p. 121).

Perhaps the most extreme ramification of this position is their absolute denial of style in such a culture, particularly in relation to Hollywood films, jazz music, etc. Adorno and Horkheimer insist that "the style of the culture industry, which no longer has to test itself against any refractory material, is also the negation of style" (p. 129). Anything formulaic is therefore deemed

styleless since all formulaic texts, regardless of medium or genre, are only representative examples of a homogeneous whole. This decision to recognize "style" only in "great artists" leads to the promotion of the avant-garde as the new sacred text, the only possible opposition to the all-devouring consciousness industry, resulting in a left connoisseurship. Even in Adorno's later reconsideration of mass culture, the binary oppositions remain.[17] He retracts his wholesale dismissal of film as a medium, for example, but finds it acceptable only within an explicitly avant-garde framework.

The most troubling presupposition of the Adorno-Horkheimer essay is the fundamental centrality and cohesiveness of all cultural activity supposedly produced by this cabal of executive authorities. This notion of culture czars in master control rooms orchestrating all forms of mass culture bears a striking resemblance to the vision of the State constructed by Fritz Lang films of the twenties, especially *Metropolis* (1926), in which the State is conceived as one enormous circular Grand Hotel where the evil capitalist bosses reside at the top and the workers reside in the basement, and *Dr. Mabuse, the Gambler* (1922), in which virtually everything is manipulated by the evil genuis Mabuse, again in a master control room with an army of "eyes," i.e. a legion of underlings who do his bidding. While Lang's and Adorno-Horkheimer's conception of the centralized State may be interesting as visions of a totalitarian future within a specifically German context, problems begin to arise when such center-based models (with accompanying cultural orchestration) are applied to all cultural activity regardless of temporal or geographic context. Where, for instance, would one locate such a "master control room" or institution responsible for monitoring *all* cultural production in contemporary American or British societies? The issue of cultural orchestration becomes even more problematic when we bracket for a moment the issue of actual instrumentality (i.e. who are the figures responsible and where are these offices in the Grand Hotel?) and ask a more difficult question, namely what constitutes the official standards and demarcations for both mass culture and high culture within contemporary society?

If mass culture were indeed identical, one could expect some uniformity in its representations of life within the center, especially since center-based society with an identical mass culture would necessarily produce extremely similar versions of how it wanted itself viewed. Television, the quintessential mass culture medium in regard to both its transmission power and similarity of program format, would necessarily produce homogeneous visions of that center. Yet on the same night of the week at exactly the same time, two programs on opposing national networks present decidedly dissimilar visions of the urban center. During the 1987–88 season, on *St. Elsewhere* (a "hospital" program), the perils of urban experience—street crime chief amongst them—are diseases that can be treated by humanist understanding. *The Equalizer*, on the other hand, presents the city as overridden with criminals

who feed on the innocent, a form of vermin that must be exterminated by the title character. Within forty-eight hours, in the same time slot, the third major network presents yet another vision of urban life on *Max Headroom*. Here the city appears to be controlled by television networks in corporate boardrooms, and crime, more often than not, is a prime media event—a point made rather drastically in one episode when a news "packager" employs a terrorist group to commit mayhem on command, allowing him to sell the television rights to urban disasters in the making. We see a network boardroom give his offer serious consideration—it's a "sweeps hour" after all—followed by a scene set in the new "commodity exchange" where rival networks bid for coverage on the hottest stories.

This combination of programs throws into question the Adorno-Horkheimer identical mass culture/State-as-Grand-Hotel scenario in two ways. The first is quite obvious: these three programs advocate codes of behaviour in urban centers that are diametrically opposed rather than identical. But they have an even more troubling common denominator—all three present themselves as explicitly oppositional alternatives to imagined dominant cultures. The doctors on *St. Elsewhere* are a renegade bunch of humanitarians making a last stand in a dying part of the city, ignored by traditional medical and civic power structures that care only about bottom-line economics. McCall, the "Equalizer," can succeed where the State police force fails because he operates as an outsider according to his own sense of justice, developed largely as a rejection of the Company's (the Secret Service's) absence of ethics. Edison Carter and his associates on *Max Headroom* are able to report the "real story" amidst media hype primarily by using computer and television technologies against themselves, i.e. using those technologies to uncover the crimes perpetuated by them. In each case the concepts "care," "justice," and "reportage" have one definition produced by the imagined dominant which these programs somehow manage to abduct and redefine. In each case, however, those concepts are promoted as the primary cultural value—care, justice, and reportage becoming not just one value among many, but the central concern of all social life. Which is the official "mass culture" vision of the city, and which is the aberrant—especially when all three insist so self-righteously on their aberrant status?

The rest of this book will explore the causes and ramifications of such contradictory representations of supposedly the same dominant culture, so instead of lining up more such examples here, I will address some potential reservations about my brief analysis of these programs. One could object that the absence of "master control rooms" does not mean that cultural production is not ideologically determined, that such control rooms are unnecessary when discursive formations thoroughly prescribe what can be said by whom and for whom at any given point in cultural history. Discourses may indeed be repositories of disembodied power relations that become embodied by specific

individuals in particular contexts subject to the force of that discourse. But what guarantees the univocality of all such discursive formations so that they produce at the most basic level complementary modes of organizing experience within ostensibly the same culture? The necessity that discourses establish paradigms, set limits, and construct subjects (detailed thoroughly by Michel Foucault,[18] Thomas Kuhn,[19] and others) is a direct result of the competition *among* discourses to clear and maintain a space for themselves within a field of conflicting voices. In this situation, a high premium must be placed on the processes of differentiation justifying a given discourse as a privileged mode of representing experience. Such activity ensures the integrity of individual discourses, but in so doing also precludes the possibility that all such conflicting voices can be made to harmonize at some supra-discursive level by an invisible cultural conductor. Individual forms of discourse produce distinctive perspectives on contemporary society and labor to construct equally distinctive subjects, but the lack of any coordinated system to assign functions to specific discourses for specific audiences makes what we recognize as "our culture" *discourse sensitive*, thereby rendering impossible the notion that cultural production is one grand orchestra playing the identical tune on separate instruments.

The next objection that could be raised, of course, is that while the discourses described by Foucault and others (e.g. historical, psychiatric, scientific) all may indulge in such struggles, the differences among various forms of popular narrative like science fiction, Gothic romance, and detective fiction are relatively minor. But to insist that differences among popular narrative discourses are merely "spurious product differentiation" also involves a host of interrelated problems. It explicitly denies the possibility that an individual form of popular narrative can establish distinctive discursive modalities governing what can be said by what kinds of speakers for what types of imagined audiences; or that such features can become solidified as sources of value that can be invoked as antecedent traditions; or that they might have their own histories revealing different social/aesthetic determinants; or that popular texts themselves recognize their differences and foreground them; or that their reading/viewing publics can identify such differences and make highly selective decisions based on such differences. The last element is perhaps the most important in this context since it crystallizes the problem concerning what constitutes spurious versus significant difference. To argue that only certain stylistic features constitute *real* difference (thereby rendering all else identical) reveals a profound elitism that fails to acknowledge the diverse functions a narrative may have for various audiences. The very refusal to recognize differences within popular culture involves a similar refusal to recognize the diversified nature of its audiences—except, of course, for the enlightened outsider audience that appreciates "real" alternatives to mass culture. That definitive decisions concerning the

oppositional value of a given text can be made in a once-and-for-all fashion suggests only an alternative paternalism, a new inverted master control room, filled with enlightened culture czars who pass judgment on all cultural production and determine its ultimate value for the entire culture. The culture-as-Grand-Hotel model remains firmly in place; only the residents of the top floor, so to speak, have been changed.

The most disturbing aspect of this paternalism is the Romantic posturing that usually accompanies it. As enlightened, alienated outsiders who alone can discriminate between style and non-style for a monolithic mass audience incapable of discrimination regarding cultural messages surrounding them, the mass culture critic from Arnold to Adorno to Baudrillard bears a striking resemblance to the self-styled Romantic artist of the early 19th century: the self-exiled critic-hero stands elevated above those below, elevated through the refinement of "his" sensibilities. The ideological ramifications of this leftover Romanticism in a contemporary context will be explored more fully in Chapter Five but the binarism that serves as its foundation needs discussion here.

The denunciation of identical mass culture and the virtual canonization of the avant-garde as "authentic art" in its negation of mass culture is predicated on two-term oppositions in which the ideological/aesthetic characteristics of each term are fixed and invariable. The Romanticism inherent in the actual mise-en-scène of such oppositions between State Culture and Negating Alternative is perhaps best illustrated by the final scene of Hector Berlioz's opera *Benvenuto Cellini* (1838). Here one finds the artist as outlaw, his personal style engaged in mortal combat with the dominant institutions that seek to control or destroy him (in this case the Vatican). Cellini must finish his masterpiece, the Perseus, commissioned by the Pope, or face execution. With the Pope himself on stage, Cellini strives to save himself through his creativity, his intensely personal style his only weapon against the corrupt power structure that simultaneously admires and despises him. When he runs out of metal for the casting and defeat appears certain, Cellini throws all his previous works into the crucible, thereby quite literally saving himself with his own genius by making that genius the "raw material" of his private art form. With the artwork successfully realized, the power structure acquiesces and the rival, "official" artists (mere lackeys to the Pope) fade offstage into the night. Perseus, fully realized not only as a statue but as a metaphor for Cellini's own battle with the Pope, signifies the artist's final victory as he successfully beheads the monster who sought to destroy him.

The mise-en-scène of *Benvenuto Cellini*'s finale visualizes quite neatly the binary oppositions repeatedly used to characterize the struggle between the alienated avant-garde and the State, with its army of mass culture agents to do its bidding. While this scenario may be a comforting myth to many, the strict binarisms begin to break down when one discovers 20th century mass culture

texts adopting this perspective. The Bruce Springsteen song, "No Surrender" (1984) provides an interesting case in point. The stance adopted by the singer approaches remarkably that of Berlioz's sculptor. The song establishes an explicit opposition between the singer and an official power structure (the School) that must be abandoned for an alternative mode of existence. "We busted out of class, had to get away from those fools, we learned more from a three minute record, baby, than we ever learned in school." Just as Berlioz's Cellini makes his artwork his only means of escape, the singer stresses that we can "cut someplace of our own with these drums and these guitars." The literalizing of art-for-art's-sake ideology at work in the last scene of the opera works in much the same way in the song, since in each case the materiality of the artistic medium serves not only as the means of resistance, but also as the foundation for this space to be cut or cleared. Self-definition becomes contingent upon a self-enclosure within one's medium, which is itself dependent on a negative definition: we are not the "power structure" because of our art.

One could quite easily dismiss any comparison of Berlioz and Springsteen on the grounds that the former is "genuine" negation, the latter merely an angry rock song on a record album whose very popularity with a mass audience disqualifies it as a vehicle of sincere social criticism. But if we reject the record because of its mass-produced status, membership in the negation category would appear to be based more on conditions of distribution and consumption—consequently inevitably favoring the avant-garde—at which point adherence to the proper mode of signifying practice, not social discontent, takes highest priority. Avant-garde textuality may indeed be founded on a poetics of resistance, but to suggest that, as such, it is the only course of resistance (and therefore the only "authentic" art) reveals a profoundly disturbing elitism.

Ironically, one of the most convincing arguments against the mass culture critique is the existence of numerous mass culture texts that construct fantasy visions of the state remiscient of those imagined by the Frankfurt School. The need to make distinctions between "authentic" expression and inauthentic schlock is ubiquitous within popular culture, nowhere more explicitly than in Queen's "Radio Gaga" music video. "Radio Gaga" differentiates between real and kitsch rock through an elaborate "hybrid" mise-en-scène that combines images from Lang's *Metropolis*, shots in which the members of the group are "inserted" into the diegesis of Lang's film, and images modeled after those in the original film (specifically the famous clock scene with marching workers who now walk in lock-step to the new undifferentiated, inauthentic, non-spontaneous kitsch rock that enslaves them).

Paul Verhoeven's *Robocop* (1987) provides another example of a mass cultural text expressing the standard mass culture critique. In this film, set again in a not too distant future already begun, the state police force is

controlled by a corporation (depicted complete with a master boardroom high atop their skyscraper headquarters) intending to rebuild old Detroit as its own planned city. To eliminate the criminal element that resides there, the corporation "builds" a robot cop out of the corpse of a former policeman, and then programs him into an obedient and benevolent killing machine. The central features of the mass culture critique are firmly in place: a cabal of business executives orchestrating entire societies for the sake of their own greed; the commodification of all facets of human life, including human life; the destruction of individual will; the inability of the mass media to provide anything other than idiotic advertisements (the television programs in the film are either imbecilic "happy talk" news programs, commercials, or a recurring slapstick comedy program where a clown surrounded by showgirls leers at the camera saying, "I'll buy that for a dollar"). Faithful to the mass culture scenario, the Robocop frees himself from the Corporation-State programming only by recovering the authentic memories of his former life as a "real," pre-high-tech individual with a specific identity (a point emphasized in the film by having the robocop's point-of-view shots appear as video images with visible scan lines except for his "memories," which are on film, thereby appearing as "natural," unmediated vision). In constructing such visions of society, *Robocop* and "Radio Gaga" could be seen as evidence of the validity of the mass culture critique; but the very presence of such auto-critiques circulating within patently mass cultural institutions such as the shopping mall movie theater complex and the MTV network suggests that that critique is in need of serious reconsideration regarding function, homogeneity, and overall orchestration of mass culture. Regardless of whether we as cultural critics award a given text genuine resistance status, the fact remains that the Berliozian vision of the artist as revolutionary and the Frankfurt School attacks on mass culture have been appropriated by popular as well as avant-garde texts.

The issue of whether one can discuss the gestures of Berlioz, Springsteen, or Cage in the same context, obviously should be a matter of ongoing debate; but what must be addressed is the indisputable presence of texts such as Springsteen's that adopt the alienation scenario wholly within the heart of the heart of mass culture. Complicating the matter still further are the appearances of so many different texts representing different institutions, generations, facets, etc., all adopting the same position of the alienated, enlightened outsider opposing the dominant culture—from Springsteen songs to science fiction crime films to Jimmy Swaggart's evangelical television programs to William Bennett's diatribes against the radicalization of American university education. The appropriation of that scenario may well be judged inappropriate or just plain bogus by mass culture critics everywhere, but their co-presence in the same culture, in often mutually contradictory versions of the oppositional-dominant culture scenario (that receive varying levels of recognition from fragmentary audiences), should force a thorough reconsider-

ation of all our critical presuppositions regarding the uniformity of mass culture, the binary oppositions used to characterize alternatives to it, and the imagined centrality of the very culture that produces it.

Checking Out of the Grand Hotel

Within the past decade, an emerging body of critical work has begun to question the central tenets of the mass culture critique and to suggest other ways of characterizing cultural production and consumption in contemporary societies. The appearance of anthologies such as Colin McCabe's *High Theory/Low Culture*,[20] Tania Modleski's *Studies in Entertainment*,[21] and Tony Bennett, Colin Mercer, and Janet Woollacott's *Popular Culture and Social Relations*,[22] as well as Umberto Eco's *Travels in Hyperreality*,[23] Ien Ang's *Watching Dallas*,[24] and Dana Polan's *Power and Paranoia*,[25] signals a profound shift in our conceptions of "culture." This is not to suggest that there were no alternatives to the mass culture critique before these works appeared; the "Liberal Pluralist" approach, for example, has produced a significant body of work within American mass communication departments.[26] (But the Liberal Pluralist vision of culture as one vast laissez-faire smorgasbord of "free" choices solves few of the problems that plague the mass culture critics—since it fails to see any significant tensions among discourses as they compete for shifting, fragmentary audiences, and therefore fails to question the impact such tensions have on the consumption of texts or on the center-based metaphors for culture as a whole.)

The significance of this emerging school of cultural analysis comes from its recognition that all cultural production must be seen as a set of power relations that produce particular forms of subjectivity, but that the nature, function, and uses of mass culture can no longer be conceived in a monolithic manner. This perspective is summarized by Umberto Eco:

> Once upon a time there were the mass media, and they were wicked, of course, and there was a guilty party. Then there were the virtuous voices that accused the criminals. And Art (ah, what luck!) offered alternatives, for those who were not the prisoners of the mass media. Well, it's all over. We have to start again from the beginning, asking one another what's going on. (p. 150)

Anything like a comprehensive account of the diverse ways mass culture is being reassessed is obviously beyond the scope of this book, but certain key distinctions have already been formulated that can serve as a foundation for a more sophisticated understanding of culture and how it works in contemporary societies.

One of the most important steps in this starting-over process is the realization that the mass culture scenario vastly oversimplifies the semiotic complexities of meaning production in mass-mediated cultures. In his perceptive essay, "Theodor Adorno Meets the Cadillacs,"[27] Bernard Gendron makes the crucial point that texts are not like other commodities such as cars, and to assert, as Adorno does, that they may be produced and consumed under the same conditions reveals a simplistic economism that fails to recognize certain fundamental differences among sign systems. Eco has stressed that the very modes of dissemination and circulation of messages in mass media makes any notion of a controlled or orchestrated semiotic environment hopelessly antiquated. He questions the delimitations concerning what constitutes a mass medium by using the example of a polo shirt—a firm produces shirts with alligators on them and advertises them in various media. A generation begins to wear the shirts; a television program, to be realistic, shows young people wearing them; viewers buy more alligator shirts in order to have the "young active look." Eco contends that,

> Here we have not one but two, three, perhaps more mass media, acting through different channels. The media have multiplied, but some of them act as media of media, or in other words, media squared. And at this point who is sending the message? The manufacturer of the polo shirt? its wearer? the person who talks about it on the TV screen? Who is the producer of ideology? Because it's a question of ideology: You have only to analyze the implications of the phenomenon, what the polo-shirt manufacturer wants to say, and what its wearer wants to say, and the person who talks about it. But according to the channel under consideration, in a certain sense the meaning of the message changes, and perhaps also its ideological weight. . . . Power is elusive, and there is no longer any telling where the "plan" comes from. (p. 149)

The variations in channel and the context in which it resonates can differ quite drastically even in regard to the alligator shirt. If I give this kind of shirt to my father on his birthday he will regard it as a sign of my affection for him. If he gives me one as a gift both of us will regard it as a joke since these shirts signified, especially during my teenage years, all that was different between my father's generation and mine, signifying not "young active look," but "middle-class, middle-aged golfer." The shirt remains an ideological sign in such a context, but its specific meaning cannot be said to have been produced solely by the manufacturer of the shirt. The crux of the matter here is not that any sign can mean anything to anyone so intentionality must be abandoned as a communicative category, but rather that intentions are multiple and do not work uniformly.

When the punk rocker tears holes in her jeans and closes them with safety pins, or when the fashion designer adds a mink collar to a purposely faded

denim jacket, both construct specific signs with quite divergent ideological values—but in each case, the meaning produced is predicated on the violation of the sign's earlier incarnations (e.g. as cowboy work clothes, or cheap, casual dress). Intentionality does not disappear, but multiplies without any central coordination to justify these differences, thereby making signs anything but uniform in their formation and function.

The reconsideration of the semiotic complexity of contemporary cultural production has been complemented by an equally important re-examination of the categories of "the popular," and by extension of "the people." The British culturalist school (Raymond Williams, Stuart Hall, Tony Bennett, Janet Wollacott, John Fiske) has argued convincingly that these categories are never stable in regard to content nor fixed in regard to the values they supposedly represent. Tony Bennett's "The Politics of 'the Popular' and Popular Culture"[28] examines the Marxist constructions of both categories in the work of Georg Lukacs, Richard Hoggart, and Adorno and the Frankfurt School, and diagnoses the problems besetting such work—that "the people" have been conceived as cultural dupes, as a romanticized, universal body that while somehow redeemable is still infinitely inferior to past or future versions of itself, having abandoned the "true culture" for the "schlock" of mass culture. The "popular" suffers from similar oversimplification, specifically in regard to what Bennett calls its "double lack":

> Conceived as a fall from an earlier phase of cultural production in which "the people" took part more directly in producing the forms through which they culturally recreated themselves, the allegedly standardized, pre-packaged uniformity of popular culture is also represented as a lack in relation to the more critical and individuated nature of traditional bourgeois high culture. (p. 16)

The specious distinctions between "folk" and "popular" cultures will be discussed at length in Chapter Five, but a central myth used to distinguish the two—that "the people" took part in the former but not the latter—is effectively exploded by Bennett, Christopher Morley, and Charlotte Brunsdon et al. They argue that even when the people do not actually engage in the production of mass media texts, they do articulate the texts in specific ways, therefore participating very actively in the production of any meanings these texts might have as they circulate in society. The end result is a fragmentation of a monolithic public into multiple formations that articulate the same texts in quite different ways.

Eco's radical reconsideration of the semiotics of mass media coupled with Bennett's reformulation of "the people" and their ability to take part in the production of meaning overturns the supposed *passivity* of mass culture and its subjects. Recent feminist analyses of mass media have emphasized the active

relationship that these supposedly lobotomized individuals have with cultural messages surrounding them. Patrice Petro has exposed the sexist presuppositions of the traditional art/mass culture dichotomy by arguing that "it is remarkable how theoretical discussion of art and mass culture are almost always accompanied by gendered metaphors which link 'masculine' values of production activity and attention with art and 'feminine' values of consumption, passivity and distraction with mass culture."[29] Andreas Huyssen acknowledges this same gendering of the opposition in his essay "Mass Culture as Woman,"[30] locating its origin in "Nietszche's ascription of female characteristics to the masses which is always tied to his aesthetic vision of the artist-philosopher-hero, the suffering lover who stands in irreconcilable opposition to modern democracy and its inauthentic culture" (p. 194). Tania Modleski sees the continued aversion to mass culture by "serious" male critics who participate in an updated version of this club of outsider heroes resulting directly from their basic inability to theorize pleasure, even among the Post-Structuralists who claim to be fascinated by it.[31]

The contention that the audiences of mass culture, especially women, are passive recipients of texts that program them into insensibility is effectively laid to rest by the specific analyses of both women's genres and the actual decoding of those texts by women. In her important essay on *Stella Dallas*,[32] Linda Williams details the multiple perspectives from which the final scene of the film may be viewed, arguing that previous analyses that have seen Stella's place in the street solely in terms of subordination to a dominant patriarchal order vastly oversimplify the double viewing—Stella before the window, the female spectator before the screen. She concludes her analysis by insisting that,

> For all its masochism, for all its frequent devaluation of the individual person of the mother (as opposed to the abstract ideal of motherhood), the maternal melodrama presents a recognizable picture of women's ambivalent position under patriarchy that has been an important source of realistic reflections of women's lives. This may be why the most effective feminist films of recent years have been those works . . . that work *within and against* the expectations of female self-sacrifice experienced in maternal melodrama. (p. 23).

The very ambivalence represented in these films (and in the women spectators who recognize its veracity) obviously problematizes the traditional claims regarding the function and uniformity of mass culture, as well as the passivity it allegedly instills in its audience.

The desire to see mass culture texts and their decodings as expressions of contradiction, ambivalence, and all-purpose discontent marks a significant move away from the elitist denunciations of the Frankfurt School. By

emphasizing the multiple functions that popular texts serve for diversified audiences, the British culturalists and American feminists discussed above have effectively rescued an enormous segment of cultural production from the oblivion consigned it by the academy, thereby arriving at a more comprehensive understanding of the relationship between culture and subjectivity than had been previously theorized. The need to award "progressive" or "aberrant" status to particular texts and readings, however, suggests that the break with the Frankfurt School has not been thorough enough. Despite their rejection of most of its premises, "progressive" popular culture critics have often held onto the Frankfurt School's notion of culture as a cohesive, centered master system.

The strengths and weaknesses of the "progressive" popular culture argument are crystallized by Robin Wood's recent essay on the contemporary American horror film.[33] Wood subdivides this centre into "reactionary" and "apocalyptic" texts. The former are largely indistinguishable from the rest of American cinema, which he asserts merely reproduces the "bourgeois patriarchal Establishment." The latter category, exemplified by *The Texas Chainsaw Massacre* (Tobe Hooper, 1974) and *The Hills Have Eyes* (Wes Craven, 1977) Wood considers "progressive" because "they struggle for recognition of all that our civilization represses and oppresses." Wood argues that genre film should not be seen as an undifferentiated category and demonstrates convincingly that the critical function of avant-garde art can be performed by even the least esteemed of American genre films. But in claiming that horror films should be valued because they can do what we previously attributed only to the radical avant-garde, Wood still allows the dominant ideology thesis to dictate the terms of his analysis. This is perhaps most explicit in his assertion that "*The Texas Chainsaw Massacre* . . . achieves the force of *authentic art*" because as an apocalyptic film it offers "a spirit of *negativity*" (p. 214, emphasis mine). The binary oppositions remain fully in place along with the same criteria for recognizing real art—i.e. horror films are outside the circle, but the rest of American genre films are firmly within and are therefore mere mass culture.

Within Wood's defense of the horror film, then, the "dominant" remains a given, a transcendent ideology that exists outside of representation, utterly supra-discursive, existing everywhere at once like the will of God. But upon close examination this "dominance" is invested with widely divergent values. Wood claims that certain horror films in the seventies posit a repressive, reactionary, and militantly pro-heterosexual dominant ideology. Yet other films produced throughout the seventies, notably the Clint Eastwood films in their various guises, posit a dominant ideology at work that is permissible, liberal, and, if anything, homosexual. In Don Siegel's *Dirty Harry* (1971) Harry is the lone voice of reason in a city overrun with sexual degenerates; the State, in the form of the mayor's office and the police force is pathetically

liberal and ineffectual. The "negation" of this dominant ideology is developed in far more elaborate terms in Eastwood's later films, *The Outlaw Josey Wales* (1976), *Bronco Billy* (1980), and *Pale Rider* (1985), all directed by him. In these films the voice crying out in the wilderness has established his own *ad hoc* counter-community that is easily as well-articulated and formalized as anything found in Wood's horror films. At the beginning of the first film, Josey Wales is a Confederate cavalry officer who has led guerilla campaigns against the conquering Union troops. Wales refuses to end his opposition to the Union and is tracked by loathsome soldier-bounty hunters who eliminate any dissension for reward money. Wales leaves "civilization" and founds his own community composed of all the have-nots and marginal figures of the society he has abandoned—Indians, the elderly, women, other Southerners, etc. Finally, in the desert, his counter-community gains a degree of independence from the evil government in Washington.

But if films like *The Texas Chainsaw Massacre* and *The Outlaw Josey Wales* characterize the "dominant" in virtually antithetical terms, where and how do we locate that "dominant"? Both films were extremely popular and were made within two years of each other, so deciding which is the "accurate" representation of the State for a mass audience is highly problematic. If one argues that the popularity of Eastwood and apocalyptic horror films depends on different sectors of a heterogeneous mass audience, then it follows that the "dominant" might be just as heterogeneous and diverse.

Raymond Williams has tried to account for such variations through the categories of "residual and emergent" cultures which may or may not be incorporated into the "dominant."[34] They may become "alternative or oppositional forms of social life and culture in relation to the effective and dominant culture," but they exist at the margins of that culture where they are "at least left alone (if they are made available, of course, they are part of the corporate organization)" (p. 40). By allowing for such "subcultural" activity only in isolated pockets of non- or pre-corporate cultural production, Williams appears to rely on the traditional folk culture/mass culture dichotomy in which corporations produce only bogus non-art of the most homogeneous sort. "Dominant culture" remains a transcendent category, since even when it incorporates these alternative practices "the dominant culture itself changes, not in its central formation, but in many of its articulated features" (p. 45). But if its articulation changes, that central formation must change as well—unless it exists outside its representations. If that is indeed the case, what constitutes the "central formation" must be investigated more closely. If it refers to a body of shared opinions, perspectives, and values, the form their articulation takes necessarily has a massive impact on their meaning; or if it refers to an economic "base" (i.e. the institutional framework that transmits these values), the ideology of those institutions has to be primary—at which point the "central formation"

becomes hard to locate beyond the individual industry engaged in producing texts.

The variability of that central formation, its basic decenteredness, is most evident in the shifting nature of residual and emergent cultures. The very terminology here suggests that we should be able to measure both against a dominant that functions as an easily identifiable standard, a kind of cultural Greenwich mean time from which all departures may be gauged. But all too often, those discourses we would call residual insist on presenting themselves as emergent. The rhetoric of the Reagan campaign, for example, consistently presented itself as an emergent political philosophy, even while invoking visions of a once-great America that could be reclaimed. In much the same way, the Great Books Let-Us-Reclaim-the-Legacy camp in the education reform movement represents its return to a "classical" education as an emergent, avowedly oppositional force that must do battle with the "dominant" in American education—i.e. feminists, semioticians, Marxists, etc. That this latter coalition is seen as the new "dominant" by anyone, of course, comes as quite a shock, since those critical languages are still in some ways considered emergent and oppositional by the individuals who utilize them. The variability in application of terms like "dominant," "emergent," and "residual" is not only possible but inevitable when the central formation ceases to be a cohesive center for anything other than the discourse at hand, a discourse that rearranges social and cultural hierarchies as well as the political spectrums with the greatest of ease.

Recognizing conflicts at the moment of reception in the decoding of the texts by diversified, fragmentary audiences and limiting conflict at the point of production to isolated pockets of progressive texts creates a lopsided perspective of all cultural activity. The insistence on a fundamental heterogeneity in audience and a fundamental homogeneity in the production of mass culture texts leads to a somewhat perplexing characterization of culture which relies on the traditional oppositions with only slight revisions. The potential contradiction inherent in such characterizations are epitomized by John Fiske's description of what constitutes the British culturalist approach:

> Despite the cultural pessimism of the Frankfurt school, despite the power of ideology to reproduce itself in its subjects, despite the hegemonic force of the dominant classes, the people still manage to make their own meanings and to construct their own culture within, and often against, that which the industry provides for them. Cultural studies aim to understand and encourage this cultural democracy at work.[35]

While Fiske's desire to explore the possibilities of a cultural democracy is potentially very productive in its move away from the monolithic scenario of

Adorno and Horkheimer, the ghost of the mass-culture-as-mass-conspiracy argument still lingers in the midst of this new formulation. The category of "folk culture" is implicitly retained but applied only to the reception of texts where their articulations (especially non-academic ones) can be seen as spontaneous, organic outgrowths of "real folk." As for the actual construction of texts, that same culture would appear a "mass" one because those texts are largely undifferentiated products of the dominant culture. How these "folks" manage to articulate texts in significantly different ways appears dependent on allegedly non-textual factors such as class, gender, and nationality (as if these categories could exist a-discursively). The role that different messages might play in creating anything but a pan-cultural, unified subjectivity seems insignificant.

The problems in this gap between "folk" and "mass" halves of the communication exchange come into sharp relief when examined in relation to Mikhail Bakhtin's notion of heteroglossia.[36] According to Bakhtin, every utterance

> enters a dialogically agitated and tension-filled environment of alien words, value judgments and accents, weaves in and out of complex interrelationships, merges with some, recoils from others, intersects with yet a third group; and all of this may crucially shape discourse, may leave a trace in all its semantic layers, may complicate its expression and influence its entire stylistic profile. (p. 276)

Bakhtin's description of the impact of this tension-filled environment on all communication would obviously explain the differences in reading constructed by reading/viewing audiences, but this same environment must shape the very formation of texts as well as their articulations. The "mediation" of text begins at its inception, and its original structure is itself shaped by that environment.

The British culturalist school has developed an elaborate theoretical framework for understanding the diversified nature of audiences and the functions of those audiences in articulating meanings and thereby surpasses the Frankfurt School in its theorization of "mediated" life in the 20th century. Whereas the Frankfurt School concentrates on developing alternative artistic programs to rescue culture from the "ills" of mass media, the British culturalists concentrate on sensitizing general audiences to how media "works" them and how they can "work" the media. The most serious shortcoming of the British culturalist approach is its lack of a coherent theory of conflictive textual production in tension-filled environments (see Chapter Three for a fuller discussion of this point). To bracket the issue of production simply on the grounds that the dominant culture controls it or that discussions about production necessarily lead us into the murky realm of authorial

intention, oversimplifies the complexity of that semiotic environment. As Mary Louise Pratt says of all such reception criticism,

> Just as there are ways of talking about reception that go beyond individualized "affect," so there are ways of talking about production that go beyond individualized intention . . . just as reception takes place within and determined by shared norms of interpretation, so production takes place within and is determined by productive communities or norms of production.[37]

To restate Pratt's argument in relation to Bakhtin, the impact of these productive communities and norms must be acknowledged when they begin to multiply relative to institution, genre, and media within the same culture, thereby intensifying their force on the formation of texts.

But if we accept Bakhtin's notion of culture as tension-filled and heteroglot, we must fundamentally re-evaluate the monolithic construction of the category of the "dominant." In his study of 19th-century French counter-discourse,[38] Richard Terdiman argues convincingly that the very "multi-accentuality" of the sign theorized by Bakhtin and V.N. Vološhinov allows for the dissonant voices that inevitably spring up in opposition to any dominant discourse, making impossible their complete eradication or foreclosure. But the ramifications of Bakhtin's conception of conflictive semiotic environments are potentially even more radical, especially if we apply them to contemporary situations. Within the specific context of Terdiman's study—French culture of the latter half of the 19th century—binary oppositions between dominant and counter-discourses may be constructed. But can they be as easily constructed in all semiotic environments?

A cornerstone of Terdiman's powerful thesis is his contention that "engaged with the realities of power, human communities use words not in contemplation but in *competition*. Such struggles are never equal ones. The facts of domination, of control, are inscribed in the signs available for use by all members of a social formation" (p. 38). While discursive struggle may exist, then, they are still "hierarchized" according to Terdiman, making the tensions between the dominant *discourse* and the "*discourses* of resistance" (emphasis mine) relatively easy to locate. Such unequal struggles may characterize 19th-century French culture (or, for example, contemporary Latin American cultures where state control over mass media makes such binary oppositions explicit). But the vision of cultural domination they are predicated on cannot be applied to all social formations any more than the Mass Culture scenario can—especially when "oppositional" discourses do not all line up neatly on the Left.

In effect, two types of heteroglot cultures may exist—one traced so lucidly by Terdiman in which culture is a field of struggle, but the struggles are unequal and hierarchized, and another represented by contemporary North

American culture, in which those struggles between discourses destabilize the very category of "the dominant" by asserting multiple, competing hierarchies. In the former type the dominant and resistant can be differentiated with assurance because some kind of supra-discursive formation makes all discourses comparable within the same system. In the latter types of the heteroglot environment, individual forms of discourse construct their own hierarchies that fail to coalesce into one master hierarchy.

The varying status accorded "television aesthetics" within competing but simultaneous hierarchies in the same culture is a case in point. Within traditional academic discourse "television aesthetics" ranks very near the bottom of its hierarchy (if it even registers as "academic"—many universities deny its very status as an object of study), yet within the discourse of "Cultural Studies" television aesthetics is clearly "cutting edge" and hardly could be ranked more highly (evidenced by the proliferation of new anthologies and special issues of journals devoted to the subject, as well as conferences, specifically that at the Center for Twentieth-Century Studies at the University of Wisconsin—a sure sign that television aesthetics has arrived as a theoretical object). The situation is even more complicated if we consider the status of "academic discourse" within television. Academic discourse retains a certain weight and propriety on news and arts programs, but within the situation comedies and dramatic programs of prime-time fiction it is constantly equated with pomposity, chicanery, and outright deception. Within the hierarchy of languages constructed by these television discourses, academic discourse often seems to rank somewhere below used-car sales pitches. The co-presence of such contradictory hierarchies, each legitimized by discourses with considerable institutional frameworks to define and disseminate them, makes "the official hierarchy" difficult to identify, especially since all three could assert in quite different ways their claims to that position, or even more interestingly, just as easily assert their claims to "oppositional" status in relation to the other two.

Terdiman argues that "the varieties of counter-discourse are related only in that they construct the dominant. There will be no necessary homology between them" (p. 68). But what happens when there is no homology in the "dominants" constructed by the varieties of discourse? The "dominant" as a monolithic category disappears, but domination only intensifies as the sites of conflict multiply, as the hierarchies proliferate. The library, for example, asserts its status as the center of assembled knowledge, but still covers its walls with posters like "Fight Prime Time—Read a Book." Certain institutions and discursive modalities are, of course, dominant within the university or television programming in particular periods, but which of the two often contradictory discourses represents the "dominant" within American culture? One can easily construct arguments justifying either, but in so doing we would have to establish who and what is being dominated and in the

process re-examine the category of domination itself.

The most satisfying attempts at developing a coherent theory of conflictive textual production that might complement the reformulation of audience have been developed by certain theorists of Post-Modernism.[39] Much of what is written about Post-Modernism—particularly by its Modernist detractors—insists that the term is synonymous with chaos, entropy, and cultural apocalypse, but there exists another Post-Modernism as well. This other Post-Modernism, developed in a variety of media—architecture, film, literature, performance art, and photography—constructs a vision of cultural production that is decentered without being anarchic, heterogeneous without being "democratic."

As a specific type of textual practice, as a milieu, and as a mode of production, Post-Modernism's greatest fault, according to its Modernist detractors, appears to be its complete willingness to reconsider not only the functions of mass culture, but to throw into question some of the most basic distinctions between popular and high culture. Chief among these question-able distinctions is the very binary division between the two, since one of the unifying threads of Post-Modern textuality continues to be the juxtaposition of popular and high art coding within the same text which forces a re-examination of their interrelationships and a reconsideration of how both function as types of discourses. The radical destabilizing of such distinctions has far-reaching ramifications for cultural analysis (as well as cultural production) because it exposes the impossibility of any kind of cultural orchestration that somehow could assign functions and audiences to specific discourses in one grand system. Conceived this way, Post-Modernism provides not only a way of understanding the disintegration of culture as Public Sphere, but also a theory of the formation, deformation, and reformation of such spheres in present and future cultures.

To return to the metaphor of culture-as-Grand-Hotel (as envisioned by mass culture critics), we might say that the British culturalist scenario redesigns the interior but leaves its structure basically intact. The floors may be subdivided according to class, gender, ethnicity, etc., producing different strategies of decoding, but the production of popular texts is still manipulated by the dominant, which subordinates everyone and everything to the master plan, thereby insuring the centered cohesiveness of the entire system (except specific types of oppositional yet marginalized texts produced by various minorities). While we need to retain this British culturalist conception of audience as diversified and active, we must also come to terms with the lack of uniformity of the messages those audiences negotiate. Instead of redesigning the interior, theorists must reconceive culture not as one Grand Hotel that has fixed ontological status transcending its representations, but rather as a series of hotels, the style changing according to the way it is imagined by the discourses that represent it. Where the Frankfurt School envisions the state as

a Victorian monstrosity with an ideologically correct International Style hotel under construction next door for self-exiled critics and artists, the British culturalists envision the same Victorian edifice, but disdain the need for an avant-garde alternative, opting instead for a Gramscian reconstruction of the interior that would make common areas sites of conflict and negotiation.

The Post-Modernist version of this might be a cluster of buildings, their styles and configurations changing according to whichever building one uses as a point of reference. One knows for certain only that the building one is in is centered and somehow superior to the others—until, of course, one moves to another building where the configuration changes again and a new center appears: culture does not have one center or no center, but multiple, simultaneous centers. Our knowledge of what constitutes "our culture" at any given moment depends on the accumulation of views provided by each of these structures which, by their very incompatibility, force us into making the kind of critical discriminations that they themselves do by their very architecture. The resulting configurations do not form a planned or well-managed pluralism, but a discontinuous, conflicted pluralism, creating tension-filled environments that have enormous impact on the construction of both representations and the subjects that interact within them.

In the following chapters I will analyze how specific Post-Modern texts make the decentering and recentering of cultures the basis of a new textuality, but the importance of Post-Modernism for this project is not simply the formal and ideological distinctiveness of that activity. To appreciate these forms of textuality they must be understood as responses to the complexities of contemporary cultural arenas, as responses to semiotic environments far more congested and conflicted than anything envisioned by Bakhtin. We must begin to examine how these environments became decentered, how the hierarchies of discourses and audiences within them destabilized and dispersed. The radical eclecticism so prevalent in Post-Modernist texts like James Stirling's Stuttgart Museum (1984), Manuel Puig's *The Kiss of the Spiderwoman* (1978) or Ridley Scott's *Blade Runner* (1982) depends upon the juxtaposition of discourses (architectural, psychological, narrative, etc.) that are not only recognizable and discrete, but possessed of specific aesthetic/ ideological values by which they assert their privileged status as representations of experience. The tensions and conflicts within the semiotic environments that are the focus of so many Post-Modernist texts result, in large part, from the struggles of individual discourses to "clear a space" within a field of competing discourses and fragmented audiences. To write the "pre-history," as it were, of Post-Modern cultures and examine the origins of these conflicted environments, we need to understand better the ideological nature of discourses not as vehiculations of a "dominant ideology," but as a process of self-legitimation necessitated by the absence of any such cultural orchestration.

Detecting the Difference: "Who Watches the Watchmen?"

Few forms of narrative have enjoyed more widespread popularity than detective fiction over the past two centuries, and few if any have been seen so consistently as some kind of proof positive that popular culture enforces the values of a dominant ideology. With the figure of the detective we have supposedly a prime example of mass culture as henchman of the State, set loose to kick potentially discontented subjects back into line like some kind of "house dick" in the Grand Hotel. But since their appearance in the middle of the 19th century, detectives have been opposed as consistently to the state police force as to criminals. This doubly adversarial role makes detective fiction an interesting test case for the various scenarios of cultural production discussed above. Detective fiction is often characterized as mass culture at its most oppressive and reactionary. It can also be seen as one of the first and most significant manifestations of decentered cultural production, one of the surest signs that what constitutes "reading" (in regard to both subject matter and audience) has changed fundamentally. Dennis Porter's *The Pursuit of Crime: Art and Ideology in Detective Fiction*[40] is representative of this tendency to characterize detective fiction as repressive; his analysis of the genre's cultural significance rests squarely on Louis Althusser's notion of *ideological state apparatuses*[41] and Michel Foucault's *Panopticon*.[42] Porter's approach exhibits the limitations of these models of centralized society when applied to specific aesthetic discourses. He states unequivocally that the socio-economic order establishes a code of behavior that the detective novel simply reaffirms. Its primary function as a discourse is to further re-establish the centrality of the State. Following Althusser and Foucault he states,

> What is particularly notable about detective stories, however, is that they only exceptionally raise questions concerning the code; the law itself is accepted as a given. As a result, from a contemporary Marxist perspective the detective story may be understood as a branch of that ideological state apparatus called culture. It is, moreover, a branch whose particular mission involves the celebration of the repressive state apparatus or at least that important element of it formed by the police. Detective fiction is part of "the discourse of the Law" that for Foucault was indispensable in the creation of the new "disciplinary society," which emerged in Europe in the post-revolutionary decades. (p. 121)

The visions of the state advanced by Althusser and Foucault both presuppose a rigorous integration and subordination of all cultural activity to the needs of a central power source. According to Althusser, ideological state

apparatuses may be "multiple, distinct, 'relatively autonomous,'" but in the long run their unity "is secured, usually in contradictory forms by ruling ideology, the ideology of the ruling class" (p. 49). All such apparatuses—religion, literature, mass media—express only the interest of the ruling class, and while Althusser allows for the possibility of contradiction, his essay gives no indication of where it might come from since this uniform set of apparatuses constructs a uniform subjectivity so integrated and all-encompassing that its reiteration makes us "always already" thoroughly interpellated subjects of the system.

If the degree of cultural orchestration presupposed here recalls the image of the Grand Hotel, Foucault's "panopticon" is the very quintessence of a center-based metaphor for cultural production. Jeremy Bentham's model for the ideal prison becomes for Foucault the spatial metaphor for life in modern society. "The Panopticon . . . must be understood as a generalizable model of functioning, a way of defining power relations in terms of the everyday life of men." As in Bentham's prison model, the State is conceived as a monolithic structure with a specific center for observation and carefully arranged subdivisions all coming under the direct control of the center. Just as individual cells have no contact except with the central tower, Foucault's modern State sees no fundamental tensions among different apparatuses, their existence seemingly defined entirely in relation to the center. He describes the effect in the following way:

> Each individual, in his place, is securely confined to a cell from which he is seen from the front by the supervisor; but the side walls prevent him from coming in to contact with his companions. He is seen, but he does not see; he is the object of information, never a subject in communication. The arrangement of his room, opposite the central tower, imposes on him an axial visibility; but the divisions of the ring, those separated cells, imply a lateral invisibility. And this invisibility is a guarantee of order. (p. 200)

Within this highly structured world a multiplicity exists, but one "that can be numbered and supervised." Here again one finds the fascination with homogeneity: "The Panopticon is a marvellous machine which, whatever use one may wish to put it to, produces *homogeneous* effects of power" (p. 202, emphasis added). The problems with these assumptions are the same as those growing out of Althusser's model for the ideological state apparatuses (hereafter referred to as ISAs). While Foucault in much of his other work concentrates on individual discourses as modes of domination (thereby emphasizing discontinuity and refraining from the will to homogenize all cultural production into one totalizable system), in *Discipline and Punish*—as Mark Poster[43] and Michel de Certeau[44] have observed—Foucault "regresses to a totalizing logic in which the panopticon becomes the model for all forms

of domination." (Poster, p. 65) Neither Foucault's nor Althusser's models can account for any tensions *among* different apparatuses or "rooms," so specific discourses can never question their connections with other discourses or their relation to the centralized State. Both posit an objective entity, the State or the Base, existing outside its representations no matter how contradictory these might be within a given set of discourses. Both would, of course, deny the possibility of such contradictory characterizations of the State, since the State "supervises" all its representations as part of its omnipresent power. Both preclude the possibility that culture could ever be a tension-filled semiotic environment because signs could hardly be multi-accentual or utterances shaped by their interaction with competing forms of discourses if they are all so rigorously monitored in blindered isolation.

The two chief limitations of the Panopticon model for cultural analysis in general and for detective fiction in particular are its inability to conceive of the lateral *visibility* of discursive alternatives and its failure to see power as radiating outward from more than one source. A Panoptic subordination of everything to one centralized power fails to explain the existence of the detective in the first place. If the State is indeed a Panopticon, the independent investigator is not necessary, except perhaps as an occasional hired hand for the State police force—a role very seldom adopted in the history of detective fiction. Neither the unquestioning acceptance of the social order, nor the alleged celebration of those repressive state apparatuses explains the existence of the private detective—since acceptance should negate the need for such a figure. The presence of the detective novel involves, in varying degrees of severity and explicitness, a critique rather than a celebration of a given society's judicial system. As a genre, it affirms an alternative sense of justice, an alternative vision of law represented by a figure outside the state-established channels, thereby throwing into question the applicability of a Panopticon as a model for all societies—especially ones in which detective fiction enjoys widespread popularity.

This gap between a State-endorsed official justice and an alternative-sense justice is a constitutive element in countless detective novels, films, and television programs. It is summarized quite neatly in the novels of William McIlvanney (*Laidlaw* [1982], *The Papers of Tony Veitch* [1984]). The name of his detective, Laidlaw, appears to confirm the Foucault/Porter insistence on the law, i.e. here's the man who has "laid down the law." But the nature of the detective's law consistently opposes that established by the State—despite Laidlaw himself being a member of the police force. He tells his partner at one point:

> I don't know what you feel about this job. But it fits me as comfortably as a hair-shirt. All-right, I do it. Because sometimes I get to feel it matters very much. But not if I'm just a glorified street-sweeper. Filling up

Barlinnie like a dustbin. There have to be some times when you don't just collect the social taxes. You arrange a rebate. If all I'm, doing is holding the establishment's lid on for it, then stuff it. I resign. But I think there can be more to it. One of the things I'm in this job to do is learn. Not just how to catch criminals but who they really are, and maybe why. I'm not some guard-dog. Trained to answer whistles. Chase whoever I'm sent after. I'm not just suspicious of the people I'm chasing. I'm suspicious of the people I'm chasing them *for.* I mean to stay that way.[45]

Laidlaw's speech articulates perfectly the code of countless detectives throughout the history of detective fiction. The separation of detective from the State begins as early as Poe's "The Murders in the Rue Morgue" (1841) where C. Auguste Dupin expatiates on the limitations of the Parisian police. This condescension gives way to a more substantial separation even in a novel like Dorothy Sayers's *Clouds of Witness* (1927) where the policeman Parker is a sympathetic figure, but fails where Lord Peter Wimsey succeeds primarily because Lord Peter's desire for justice is motivated by familial rather than civic responsibility. Porter acknowledges this gap in the novels of Dashiell Hammett and Raymond Chandler and concedes that the detective is often "a law unto himself" (p. 168), but this conclusion fails to problematize his claim that, as a genre that wants to see justice done, detective fiction must necessarily be an ideological state apparatus. This gap between detective and policeman is developed even further in a recent novel like P.D. James's *An Unsuitable Job for a Woman* (1972) in which the detective helps falsify evidence so that "real" justice might be done.

The common denominator in each case is the emergence of a transcendent sense of justice that throws into question the accepted civil justice and the nature of "law" itself. The contention that detective novels affirm repressive state apparatuses is doubly suspect since not only does an alternative sense of justice often develop which problematizes implicitly or explicitly the nature of "law," but in each a private sense of justice throws into question the public one. The investigation serves only to validate that private, transcendent sense of justice and is seldom promoted within the texts as one for adoption by the State as its new code—largely because the very possibility of a State justice appears oxymoronic. Both as an investigation and as a discourse it succeeds on its own terms; the typical isolation of the detective at the end of the text is both physical and judicial. Rather than celebrating established law, the detective text emphasizes repeatedly, from Poe to P.D. James, the subjective nature of justice, its validity derived from the fact that it has little or nothing to do with the State at all.

The inability of most ideological analysis to conceive the detective (and by extension popular culture) as a third-term alternative to standard dichotomies arises from the rigid binarism of that analysis. Ernest Mandel's *Delightful*

Murder: A Social History of the Crime Story[46] insists on seeing the history of the genre in "Manichean" terms—the noble bandit of early crime literature becomes the "evil criminal" in the 19th century, and the police officer "is increasingly the defender of order at a most exalted level, the defense of private property as an institution" (p. 54). For Mandel, the ideology and narrative construction of detective fiction could hardly be simpler. "The detective story is the realm of the happy ending. The criminal is always caught. Justice is always done. Crime never pays. Bourgeois legality, bourgeois values and bourgeois society always triumph in the end. It is soothing, socially integrating literature despite its concern with crime, violence and murder" (p. 47). Yet this oversimplification completely fails to account for the presence of a third term that problematizes all of Mandel's facile assumptions. The noble bandit/evil policeman dichotomy does not simply become inverted in the 19th century as evil bandit/noble policeman. The detective emerges as a hybrid of both pairs from both periods, appearing simultaneously as the figure obsessed with justice and as the mysterious outsider whose "nobility" depends on a vision of justice to which his dual adversaries are blind.

The sudden appearance of the detective in the middle of the 19th century can be seen as a response to the increased need for law enforcement caused by the social problems and paranoia accompanying rapid urbanization. But the emergence of detective fiction and its continued proliferation a century later suggests less the need for the State to enforce the laws than it does a widespread lack of faith in the State to uphold or even define justice in the first place. Michael Denning, in his meticulously researched *Mechanic Accents*, argues that the crime stories found in the dime novels of the 19th century may "titillate, moralize and entertain, but as they do so they also form the heart of an ideological conflict over the meaning of crime and over different conceptions of justice."[47] Stephen Knight's *Form and Ideology in Crime Fiction*[48] likewise stresses how complicated "justice" becomes in various types of detective novels. The ambiguity concerning law, order, and justice has been all-pervasive in detective fiction—especially since the advent of the hard-boiled school in the twenties in America and the move toward espionage and psychologism within British crime-writing since the thirties. And while it is true that that still-flourishing subgenre, the British country-house mystery (à la Agatha Christie), presents a stable set of ideological and narrative values that seems to validate Mandel's perspective, it is also true that the limitations of this subgenre had already been exposed in the thirties and not only by hard-boiled novelists such as Hammett and Chandler, but by British novelists writing their own country-house mysteries: specifically Dorothy Sayers, Nicholas Blake, Michael Innes, and Eric Ambler, and then further splintered by the novels of Colin Wilson, P.D. James and Peter Dickinson in the sixties and seventies. (These novels will be discussed in detail in Chapter Two.)

The apparent necessity to render ambiguous any clear-cut notion of justice

within the discourse of detective fiction, even when it must rewrite the overly simplified formulations of earlier texts in its history, is nowhere more obvious than in Frank Miller's phenomenally successful continuation/rewriting of the Batman myth in his series of comic books, *The Dark Knight Returns* (1986). The character Batman, in his various incarnations, provides an especially useful example of this context. As the "caped crusader" who solves the crimes the police force is unable to counter, the Batman of traditional comic books and television programs is the perfect conflation of exotic outlaw and upholder of justice; but his role is that of guardian of Gotham city, and, as such, he does little to destabilize accepted notions of justice (evidenced of course by his membership in the "Justice League of America"). In these texts, the character serves a repressive function for the State virtually inseparable from that of the police and he validates unequivocally the perspectives of Porter and Mandel.

But Miller's Batman performs a quite different function. In the Gotham City of the very near future, Batman comes out of retirement to do battle with an army of Mutants that has come close to controlling the city. The mayor's office and police force attempt to work out compromises with this gang supplied with army surplus weaponry by a deranged general. Evil "psychologists" appear to be chief advisors to the indecisive city government and they eventually arrange to free Batman's old adversary, the Joker, who visits the David Endochrine (Letterman) television show and promptly kills Endochrine, Endochrine's psychologist, Dr. Ruth Weisenheimer and the entire audience with a deadly gas. Television provides endless "happy talk" newscasts which do little, other than report hideous street crimes and deliver condemnations of the criminal Batman. The Dark Knight subdues the Mutants and the Joker, but only while battling a fascistic, if inept police force that has made him a public enemy. Up to this point, Miller's Batman could be seen as a simple reactionary fantasy, a futuristic vision of a Charles Bronson vigilante film. But as the story progresses such a simple categorization becomes difficult. An incompetent, largely senile President Reagan enlists the help of Superman to kill the outlaw Batman. A nuclear war ensues, crippling Gotham City, at which point Batman charges through the city on horseback gathering a band of former street fighters as his confederates to battle the post-holocaust anarchy. Batman and Superman engage in a final combat during which the former castigates the latter as a mere lackey of the State: "You always say yes to anyone with a badge or a flag. We could have changed the world. Now look at us, I've become a political liability and you, you're a joke." That all of these events are depicted in a visual style that rivals virtually any "art film" produced in the last thirty years in the complexity of its spatial, temporal, and narrational strategies further complicates its categorization according to the standard oppositional-reactionary, mass culture-avant-garde distinctions.

Miller's development of the Batman character should not be seen as simple rewriting of the mythic figures for popular culture so prevalent over the

past two decades—in films like Robert Altman's *Popeye* (1980), Altman's *The Long Goodbye* (1973), and Herbert Ross's *Pennies From Heaven* (1981), or novels like E.L. Doctorow's *Welcome to Hard Times* (1975) or Thomas Berger's *Little Big Man* (1964). The common feature in all such texts is the demythologizing process founded in the sophisticated, "post-pulp" perspective of a "mature" present.[49] But Miller's *The Dark Knight Returns* remains a comic book, just as James's *The Skull Beneath the Skin* (1982) and Dickinson's *The Last House Party* (1980) remain country-house mysteries. Such rewritings are not limited to the contemporary context, but instead typify the operations of detective texts for the past sixty years in their relentless denial or rewriting of traditional categories of law and order; texts which would appear to acknowledge the structure Mandel delineates only to deny its validity. It is therefore very difficult to fix the "politics" of detective fiction as a set of unvarying social/judicial perspectives and narrative conventions when both have been rewritten consistently in a series of uneven transitional phases (in literature, especially between the late twenties and World war II; in film, between the shift from gangster to film noir in the early forties; in comic books, during the eighties, etc.). Mandel's set of assumptions need to be recast somewhat to account for his ongoing process of rewriting while still allowing for variability within the genre.

The detective story generally questions the possibility of a satisfying happy ending. Criminals of some kind are usually caught but not before criminality has been shown to be all pervasive in the human psyche and/or economic institutions which produce it. Justice is usually done, but only after the terms of what constitutes true justice have been established. Crime usually pays and almost always is redistributed. Bourgeois legality, values, and society fragment and are redefined during the course of the action. Because of its emphasis on crime, violence, and murder (and its redefinition of who and what are responsible for it being endemic to our societies) detective fiction is, more often than not, a discourse which forces contradictions rather than compromises; that is disruptive rather than integrative, because "justice" is characterized as provisional, incomplete, and virtually unenforceable by a State incapable of understanding its complexity. In the process, the "law and order" pairing is itself destabilized. Once law is subject to multiple definitions, order becomes relative as well, without a master system to coordinate those differences.

Most analyses of the genre fail to recognize the crucial point that detective fiction as a discourse labors to intensify those differences as a way of "clearing a space" for itself within conflictive semiotic environments. We cannot begin to appreciate the politics of detective texts without first investigating the ideologies they construct to legitimate themselves as privileged discourse within the field of competing discourses and heterogeneous audiences. Just as the detective must define his or her function over and against an imagined

"dominant" (usually the official police force), detective fiction labors to justify its discursive space over and against an imagined "dominant" (literary fiction, preceding forms of detective fiction, etc.). Just as the detective must rearticulate concepts of justice, law, and order within the diegesis and demonstrate that they are not the sole possession of the State, detective fiction must redefine those concepts discursively and demonstrate that they are not the sole possession of any kind of "official culture." If the detective is a "law unto himself" detective fiction becomes a discourse unto itself through which all social experience is filtered according to its own "laws."

To locate the politics of detective fiction solely in regard to its vehiculation of the dominant ideology is to ignore the work of that discourse on those politics. The detective text does not depoliticize socio-economic relations as much as it repoliticizes them according to its own discursive ideology. The process clarifies if we compare two novels, Sayers's *Clouds of Witness* and Chandler's *The Big Sleep* (1939), which appear to come from quite different political perspectives yet have a remarkably similar aesthetic ideology forming a sort of shared "deep structure." Their "surface" political structures are blatantly opposed. In the former, Lord Peter Wimsey must prove the innocence of his brother, the Duke of Denver, and save his sister from the clutches of a radical socialist and a *nouveau riche* playboy. An elaborate social hierarchy emerges, but one that operates according to the terms of that discourse. Lord Peter is set in opposition to socialists and wife-abusing tenant farmers, but also to other aristocrats, most of whom are stereotypical upper-class twits (Wimsey describes even his brother the Duke as "a good, clean, decent thoroughbred public schoolboy and a shocking ass"). Lord Peter's exalted status as an aristocrat within the text is translated into the terms of the discourse which makes his superiority contingent upon his uniqueness as a titled *detective*.

In *The Big Sleep* a remarkably similar valorization of detection occurs, despite a complete reversal of the social hierarchy within the text. In Chandler's novel, the detective, Philip Marlowe, is at best a middle-class individual who *works* for a living. The sources of evil and discord in society are not Socialists or *arrivistes*, but a decadent, wealthy family—the Sternwoods—who consort with any number of criminals but remain at large through their control of the police force. Marlowe repeatedly comments on the daughters' animalism: Vivian has teeth "that glittered like knives," and Carmen, trying to seduce Marlowe, has eyes "full of some jungle emotion." The two daughters are the offspring of a crippled old man full of "rotten blood," whose wealth comes from stinking oil fields below the family mansion. The family's moral depravity overwhelms even Marlowe. "To hell with the rich. They make me sick." While the social classes of the detective, client, and criminal are completely reversed in Chandler's novel, the "deep structure" remains the same. The class of the detective is considered morally superior to

the class of all the other characters, and membership within that class becomes linked to the activity of detection. This "deep structure" linking two texts with such different political orientations depends upon an elaborate *value transformation* in which a new economy emerges that privileges a different object of exchange—information. A new hierarchy based on who has information and, more importantly, who can get it by their own craft and cunning, replaces the traditional one based on social class. The traditional confrontation between the detective and the wealthy client/villain dramatizes this conflict of economies in which the power of the latter, guaranteed by the "dominant" order, eventually gives way to the power of the former, guaranteed by the new, more legitimate order based on action rather than inherited privilege. This is not to suggest, of course, that in this exchange of economies that socio-economic relations are ignored or depoliticized, but rather that they are consistently recast according to the demands of discourses engaged in clearing and maintaining a space within a competitive environment from which they cannot be even relatively autonomous.

Not surprisingly, then, some of the earliest texts in the genre involve elaborate justifications for their status as privileged forms of representation. Poè's "Murders in the Rue Morgue" begins with a virtual essay on the value of ratiocination which is nothing short of a hymn to the greater glory of detection. The first Sherlock Holmes texts, *A Study in Scarlet* (1887) and *The Sign of Four* (1890), open with chapters entitled "The Science of Deduction." In the former, the excerpt of Holmes's philosophical treatise "The Book of Life" attempts, according to Watson, to show that "an observant man might learn by accurate and systematic examination of all that came his way." Again, in the opening passage of "A Case of Identity" (1891), Watson and Holmes discuss not only the value of detection, but the inferiority of other forms of discourse, specifically journalism and realism. "We have in our police reports realism pushed to its extreme limits, and yet the result is . . . neither fascinating nor artistic. . . . Depend upon it, there is nothing so unnatural as the commonplace."

The Hollywood "women's films" of the thirties through the fifties—those films that are receiving so much attention from feminist critics (such as Linda Williams, Mary Ann Doane, Tania Modleski)—construct very similar value transformations in which an economy of emotion becomes primary. In Edmund Goulding's *The Old Maid* (1939) one set of values and power relations is posited as "dominant," only to be replaced by another transcendent one offered by the text. The action takes place in the American South of the 1860s and 1870s. Charlotte (played by Bette Davis), has fallen madly in love with Clem (George Brent), who must depart for his tour of duty in the Civil War and is quickly killed in action, but not before impregnating Charlotte. To atone for her "sin," Charlotte first runs an orphanage (where she can conveniently hide her illegitimate daughter), and then moves in with

her cousin Deliah (Miriam Hopkins), who has married well (having originally spurned Clem to do so). Charlotte convinces her cousin that the child must be raised as Deliah's daughter, and Charlotte assumes the role of "aunt" so that her daughter will not suffer the burden of illegitimacy in polite Southern society. Charlotte's obsessively puritanical guidance of her daugher/niece's life eventually secures the child's marriage into the local aristocracy, but only by securing the daughter's resentment toward Charlotte in the process. At the film's conclusion, Charlotte watches her daughter riding off to her new life knowing nothing about her mother's self-sacrifice.

On the surface the film appears to do nothing to challenge the dominant patriarchal order, but on a deeper level its reworking of that order within the terms of its discursive ideology involves a profound value shift. On the one hand, *The Old Maid* acknowledges not only the presence but also the power of the patriarchal order in Charlotte's willingness to sacrifice herself. But, on the other hand, Charlotte's self-sacrifice also functions as a kind of triumph over that order in its insistence that what really matters is the intensity of genuine feelings. Within the terms of that economy Charlotte reigns supreme over the insipid good girl Deliah and the even more insipid Clem. *The Old Maid* represents the complexity of this situation quite neatly; the patriarchal order is in place, but men are virtually absent from the film, representing an imagined dominant order, yet inconsequential in those arenas where the real (emotional) action occurs. It is no coincidence that in so many of the women's pictures like *The Old Maid* the self-sacrificing woman achieves an emotional apotheosis by herself, while the innocuous husband is either absent or so marginal as to be inconsequential—as emotionally unequipped to handle the intensity of the action as General Sternwood is physically unable to do what Philip Marlowe does in a detective novel. That the patriarchal order does not demand such self-sacrifice from men is evidence of both its power and its complete insufficiency since, within the economy of this discourse, intensity of feeling is the very basis of its emotional hierarchy. In "women's films" the patriarchal order is acknowledged but delegitimated, and "women's" discourse, like Charlotte's baby, is legitimated through self-sacrifice.

The accumulation of so many delegitimated "dominants" constructed according to the terms of various self-legitimating discourses actually has a far more widespread effect on the "dominant culture" than does an explicitly oppositional avant-garde alternative. Whereas the latter resists, the former invades: it disperses the centrality and cohesiveness of "dominant" culture. A significant factor in the decentering and recentering of contemporary Post-Modern cultures is the accumulation of delegitimated images of the "dominant" by self-legitimating discourses offering themselves as privileged alternatives, thereby intensifying the conflictive nature of these semiotic environments.

The failure to appreciate the impact of these discursive ideologies on our

conception of the "dominant" is due to the questionable notion of signification underlying not only Althusser's ISAs, but Adorno's "culture industry" as well. The question of heterogeneity or homogeneity of aesthetic discourses is, as Paul Hirst argues, ultimately one of the relative status of the signifier and the signified.[50] The basic homogeneity of ISAs is predicated on the primacy of the represented and the corresponding devaluation of the means of representation which determines the shape of the represented. Althusser's conception of the apparatuses presupposes not only a naive altruism about their intention, but also a "neutrality" concerning the set of signifiers each one uses. This failure to account fully for the power of the means of representation has profound implications for Hirst.

> If we consider the concept of representation and regard it as anything other than a complicated form of reflection, then it must entail means of representation which have a definite effect on the represented constituted by them. It is not too much to argue that once any autonomy is conceded to these means of representation, it follows necessarily that the means of representation determine the represented. (p. 72)

To reject Althusser's notion of representation is for Hirst to destroy the classic Marxist problem of ideology since

> This problem requires that there be a correspondence (the latter determines the former) and a non-correspondence (the former misrepresents the latter) between ideology and the reality it represents. If there is any determining action of the means of representation in constituting what is "represented" by them then these forms of correspondence/non-correspondence are shattered. Even if it is argued that the means have conditions of existence ... it does not follow that the action of those means is thereby determined. There is no necessary relation between the conditions of existence of the means of representation and what is produced by the action of those means, no necessity that they "represent" those conditions. (p. 72)

There can be no "neutrality" in the means of representation because those means are themselves determinants of the represented. To emphasize the represented at the expense of its means of representation is to deny the interaction of signifier and signified itself by attributing complete dominance to the latter over the former. But this domination within the construction of the sign is as illusory as the pan-cultural domination supposedly effected by the ruling class since in both cases one element—the signified or ruling-class interests—appear to exist independently of the signifiers that give it any form it might have.

In a field of discourses all attempting to account for human experience in

differing, even contradictory ways, neutrality thus becomes an impossibility. The relationship among different discourses and their correlation with the world of objects may be characterized by two interdependent statements:

1 No discourse may be considered innately superior in that it is more accurate, truthful, or scientific in its correlation with the world of objects;

2 Every discourse tried to deny this fact, and the assertion of its superiority is responsible for the creation of its own ideology.

By emphasizing the impact of the signifier on the signified and at the same time rejecting the notion of a unified ruling class with cohesive values that somehow must be represented in one way or another by all cultural activity, "determination" itself must be redefined. Chantal Mouffe, for example, has argued that while Hirst is quite correct in warning against the dangers of excessive economism, his critique "is done at the expense of abandoning historical materialism," specifically in his abandonment of economic determination in the last instance.[51] The crux of the matter here, it seems to me, is how one defines "economic." Traditional ideological analysis of fictional texts define economic determinism solely in terms of ruling-class interests which "trickle down" throughout all forms of cultural expression. If we define "economic" in terms of the economies of meaning production within tension-filled semiotic environments, "determination" can once again become a meaningful concept—since within this context no text can be even relatively autonomous from the impact of the conflictive environment.

The chief fault of most ideological analysis is its obsession with establishing an all-pervasive socio-economic order that allegedly determines everything, but then theorizing ways in which the fictional can be relatively autonomous, thereby ignoring in the process the ideological/semiotic arenas in which texts are thoroughly determined in the first as well as last instance. The economics of social life and cultural life are involved in ongoing, interdependent dialogic relationship, but they are not coterminous. To abandon the "dominant culture" as an archaic concept does not mean that cultural domination is not still at work or that dominant classes do not "really" exist in specific social formations. It simply means that domination is conducted by a multiplicity of agencies and the dominant social class has no monopoly over that process, that it has far less to do with the production of meaning than it has been given credit for in the past—which, if anything, obscures the actual politics of textual production.

While the diversified and conflictive nature of domination within decentered culture has enormous impact on textual production, the most significant ramification is ultimately in the realm of subject construction.

Althusser's conception of *interpellation* is paramount here because, as he correctly insists, "all ideology has the function (which defines it) of constructing concrete individuals as subjects."[52] *Interpellation* is the very basis of the conversion process in which individuals are hailed or called in by ideology. Althusser uses the example of Christian ideology to illustrate: If the individual reader's response to a phrase like " 'It is for you that I have shed this drop of my blood' " is " 'Yes, it really is me!,' it obtains from them the *recognition* that they really do occupy the place it designates for them as theirs in the world" (p. 178). Once this recognition is secured the individual becomes the subject constituted by and within that ideology. While Althusser makes an excellent case for the importance of *interpellation*, he does not explain in detail just why a given individual would want to "answer the call" as it were, and merge with the category of the subject. For Althusser, the individual/subject conflation is a foregone conclusion since he insists that the individual is "always-already" a subject. That is, individuals are already subject because their identity and understanding of the world are products of the dominant ideology which governs their entire existence.

Here again, the monolithic nature of Althusser's dominant ideology, in failing to acknowledge the conflictive, heterogeneous mixture of self-legitimating discursive ideologies, vastly oversimplifies the possible conflicts involved in the process of *interpellation*. The individual cannot be "always-already" a subject of each competing discursive ideology. Any and all individuals could hardly be the pre-constituted subjects of texts like Edmund Goulding's *Dark Victory* (1939), Dashiell Hammett's *Red Harvest* (1929), and Robert Heinlein's *Strangers in a Strange Land* (1961) since the "calls" emitted and the categories of the subject constructed by each discourse are mutually contradictory. The tension-filled environments affect not only the complex structure of the utterance, but the notion of the subject as well: individuals faced with a semiotic glut of signs all attempting to interpellate them simultaneously.

That individuals may be answering multiple "calls," thereby making highly problematic the "always-already" status of the subject is perhaps best understood in relation to specific contexts where those calls intersect. the Perry Henzell film *The Harder They Come* (1973), represents the effects of conflictive interpellation on "concrete individuals," particularly in regard to the character of Ivan (Jimmy Cliff), the Jamaican reggae singer/outlaw/revolutionary at the center of the text. The film begins with Ivan's arrival in Kingston and follows his urbanization and "acculturation" until his death at the hands of the police. The first ideological discourse that interpellates him is the Christian church where he sings for a time in the choir. He refuses to answer this "call" largely because he answers two different but complementary (to him anyway) "calls"—the American Western and reggae music. We see Ivan quite actively becoming the subject each discourse constructs, first by his

intensive watching of films and listening to the radio, and then in his assumption of the "Johnny Too Bad" role, where he quite literally "images" himself as a reggae desperado, having himself photographed in the appropriate poses and dress of each discourse. He cuts his own record, completing the *interpellation* process; the music industry has not only reproduced its own means of production by converting individuals into reggae-loving record buyers, it has made Ivan want to be an actual producer of that discourse. Ivan's very identity is the direct result of this conflictive *interpellation*, of refusing to answer some calls but answering others, of using one mode of subject construction to "de-interpellate" himself from another. Identity here is seen as both a construct of specific discourses (to the point where Ivan models his own death on the Western gunfight) and a kind of *bricolage* of his own devising. Both processes—discourse-specific *interpellation* and its ad hoc arrangement by individuals—reflect a profound lack of cultural orchestration and the absence of a unified "dominant" that might eliminate such discrepancies.

Within this conflictive *interpellation* the ruling class, even within the "culture industry," is unable to control the production of texts and/or their impact on individuals. The owner of the record company fits the Frankfurt School stereotype of culture czar perfectly. He decides who records, which records will be promoted as hits, etc., insisting all the while that he, and not the people, makes the hits. Here we have record-making as mass culture, divorced as far as possible from any kind of folk culture. But when Ivan records the song "The Harder They Come," his music genuinely expresses the anger and frustration of the urban poor, emphasized by the intercutting of images of Jamaican slums with shots of the recording studio, (the film's director, in effect, explicitly validating the song's message). The rigid distinction between folk culture and mass culture collapses when it becomes evident that ownership does not guarantee unity of effect (a point emphasized in the film by having the police force working with the record promoter at first, but then engaged in an adversarial relationship once Ivan's song becomes popular), thereby diminishing the record industry's role as "state apparatus" as much as does Ivan's avowedly oppositional song. That such a song could be produced within the industry and become a "hit," despite efforts by the record company owner to bury it, suggests that control over the means of production does not entail control over the creation of meaning or the mode of consumption. The production both of texts and subjects appears to defy unification or homogenization—regardless of who controls individual institutions—when discursive formations refuse to coalesce into one grand master system.

Such conflictive *interpellation* is not limited to Third World contexts where "culture industries" may not be quite so powerful and specific subcultures like Rastafarianism enjoy widespread acceptance. The point here is that a unified

"culture industry" with a cohesive set of interests is as much a methodological fiction as a "ruling class"; if anything, the larger and more sophisticated culture industries become, the more diversified they are in regard to institutions, discourses, and audiences, and the less they tend to produce homogeneous modes of textuality and unified forms of subjectivity. Recognizing the complexity of this situation should not automatically lead to characterizing the situation as pure entropy. The decentering processes at work in Post-Modern cultures are accompanied by recentering activity of individual forms of discourse. To take up the architectural analogy developed above, the Grand Hotel is not replaced by the Wasteland, but by a multiplicity of structures all insisting on their ability to perform certain vital functions for the same social formations.

In the following chapters, I will examine the discursive activity that has contributed to this fundamental restructuring of culture as a series of "wholes." In order to understand better the impact of this restructuring on the constitution of texts and subjects, I will concentrate on those aspects of textuality most affected by this conflictive semiotic environment. After investigating specific forms of intertextuality, semantic differentiation, enunciation, and reader/spectator positioning, I will in the last chapter try to develop an integrated theory of Post-Modernism as a situation and as a specific form of textuality that attempts to represent that situation.

Two

Life in the Arena: Intertextuality in Decentered Cultures

In the previous chapter I argued that discursive ideologies are, in large part, a response to the heterogeneous field of aesthetic discourses that all compete for overlapping segments of an equally heterogeneous reading public. Since the kind of neat homology among specific types of discourse and the corresponding social classes is very difficult to locate after the end of the 18th century, we have to account for competition *among* aesthetic discourses whose appeal is no longer limited (if it ever was) to clearly delimited categories of consumers. The constant jockeying for position in which individual discourses provide their own cultural hierarchies and texts define themselves over and against other forms of discourse (i.e. texts in other genres or precursors within their own genre) necessitates a new conception of "intertextuality." The accepted theories of intertextuality are woefully inadequate in accounting for the active manipulation of those intertextual relations.

In the past decade countless studies have examined reader and/or spectator positioning, yet relatively little attention has been paid to how texts position themselves in relation to other texts. Just as a given text may posit a model reader, it may also create a model field of discourses into which it is supposedly inserted. The model field is decidedly not co-terminous with any actual field of discourses. Instead it is a constructed arena within which it does battle with other texts according to its own ground rules. In other words, a given text labors to create a fictional universe and also an accompanying fictional arena which surrounds it. A text's relation to other texts and to its reader is never unmediated, if for no other reason than the fact that the text constantly tries to affect that mediation on its own terms by supplying an already mediated set of circumstances as its own intertextual arena.

Towards a Theory of Intertextual Arenas

Since the term intertexuality has undergone a variety of permutations and is used in relation to radically different notions of textuality, certain preliminary distinctions need to be made. In its broadest sense, it has been used to describe a free-floating intersubjective body of knowledge which, according to Jonathan Culler, may be considered "the general discursive space that makes a text intelligible."[1] In its most restricted sense, it has been used to examine the explicit presence of other texts within a given work by focusing on the processes of citation, reference, etc. The chief issue that differentiates users of the term is the degree of perceptibility of intertextual relations. Roland Barthes insists on their inherent imperceptibility in his claim that intertextual codes are a "mirage of citations" and that "the quotations of which a text is made are anonymous, untraceable, and nevertheless already read."[2] Julia Kristeva, on the other hand, insists "that every text is from the outset under the jurisdiction of other discourses which impose a universe on it," but is also intent on investigating which discourses come to bear on a given text, going so far as to specify "what editions of Pascal, Vauvenargues, and La Rochefoucauld Ducasse could have used, for the versions vary considerably from one edition to another."[3]

The degree of perceptibility is fundamentally a matter that depends upon the presuppositions governing artistic production. Perhaps the most opposed viewpoints concerning intertextuality are those of Pierre Macherey and Harold Bloom. Macherey contends that

> To explain the work is to show that, contrary to appearances, it is not independent, but bears in its material substance the imprint of a determinate absence which is also the principle of its identity. The book is furrowed by the allusive presence of those other books against which it is elaborated; it circles about the absence of that which it cannot say.[4]

Intertextuality for Macherey is part of a much wider project to devaluate the Romantic conception of the artist as master-creator. Instead, the author is the producer of a text which is composed of a host of unspoken citations to those texts which precede and surround it.

That the intertextual dimensions of a given text may be structured in a purposeful manner by that text cannot be adequately accounted for by Macherey. Harold Bloom's *The Anxiety of Influence*[5] is virtually the only significant study of intertextual relations which presupposes the manipulation of antecedent material to be a central process in the construction of a given text. For Bloom, poetic history is "indistinguishable from poetic influence" since what he calls "strong poets" constantly wrestle with "strong precursors" in order to "clear imaginative space for themselves" (p.5). He is not interested

in "weaker" talents, since they "idealize" precursors instead of "fighting to the end to have their initial chance alone. (p. 8)

Bloom develops six different "revisionary ratios" that describe the possible relations between poet and predecessor. Like Macherey, Bloom insists that a text is constituted only in relation to a host of antecedent texts, but Bloom's ratios, unlike Macherey's "furrows," are predicated on active awareness and exploitation by the poet. Clearly, Macherey's conception of artistic production could not admit such terms as "author," "originality," etc. (just as Bloom is clearly untroubled by "discourse," "écriture," etc.); but Macherey's desire to decenter radically the givens of literary criticism has thus resulted in a rather impoverished notion of the author (whether it be author as individual, as discourse, or whatever) as manipulator of intertextual arenas. Certainly the furrowing that Macherey speaks of goes on continually throughout the history of a given text's consumption, but it need not preclude attempts to control that furrowing in a purposeful manner, nor does it need to posit a conception of the author as some kind of *idiot-savant*, unaware of both literary history and the contemporary situation.

Bloom's claim concerning the intertextual conflicts between strong and precursor poets engaged in battle like "Laius and Oedipus" may at first seem completely irrelevant to the discussion of intertextuality in popular narrative discourses. Macherey's insistence on a text's lack of independence would appear to describe perfectly detective fiction, for example, which through its invocation of an entire series of pre-existent structures foregrounds its dependency on other texts. Bloom himself would probably relegate all writers of detective novels to the category of "weaker talents," since their very decision to observe the formulas and conventions of a familiar genre would appear to be diametrically opposed to a strong poets' need to clear an imaginative space for himself. The supposed lack of originality that typifies popular discourses, like the detective novel, the Western, etc., would preclude the "wrestling" with precursors that Bloom privileges. This attitude concerning the absence of originality in popular fiction is epitomized by Tzvetan Todorov's assertion:

> One might say that every great book establishes the existence of two genres, the reality of two norms: preceding literature, and that of the genre it creates. Yet there is a happy realm where this dialectical contradiction between the work and its genre does not exist: that of popular literature. As a rule the literary masterpiece does not enter any genre save its own; but the materpiece of popular literature is precisely the book which best fits its genre. Detective fiction has its norms; to "develop" them is also to disappoint them: to "improve upon" detective fiction is to write "literature," not detective fiction.[6]

There are several problems in this passage. First, it indicates a highly static

notion of what a "given" is and will be, as if once fixed it must remain forever the same text. But genre texts, and particularly detective texts, continually redefine what a genre is by altering their intertextual relations with earlier works within the genre and works outside the genre. A genre text does not *have* norms, it continually *remakes* norms which are then remade again. Todorov's description of a masterpiece fits an alarming number of genre texts which affirm a given discourse by writing within it, yet simultaneously criticize its limitations and demonstrate their differences from other texts within the genre. The desire to do both—perpetuate and transgress—is responsible, for instance, for the various series of novels that have been a constant feature of detective fiction throughout its history. The existence of the Lord Peter Wimsey novels or Lew Archer novels is frequently pointed to as undeniable proof of both the importance of repetition in detective fiction and the low premium put on originality of any kind. But how does this explain the simultaneous consumption of series novels featuring detectives like Lord Peter, Lew Archer, Philo Vance, Travis McGee, Kate Fansler, Nigel Strangeways, etc? Each series of detective novels simultaneoulsy advertises its similarity to earlier texts and differences from other competing texts—i.e. "This is another Nigel Strangeways book. This is *not* another Lew Archer, Travis McGee, etc." The incredible diversity within the detective genre is evidence enough of this perpetuate/transgress dynamic. Finally, and perhaps most important, Todorov's distinction between detective fiction and literature is simply untenable since so many detective texts try actively to undermine the traditionally accepted hierarchies of literary discourse through a highly sophisticated process of intertextual manipulation.

P.D. James's *The Skull Beneath the Skin*, for example, is a mainstream detective novel whose intertextual relations expose the shortcomings of Todorov's assertions, and in so doing demonstrate the need for a theory of intertextual activity in generic discourse which combines Macherey's emphasis on dependency and Bloom's emphasis on originality. James's novel is, in many ways, very similar to Agatha Christie's *And Then There Were None*, which would at first appear to be evidence for Todorov's vision of genre texts. But a comparison of their intertextual arenas demonstrates radical differences. Christie's novel includes only a handful of passing references and the only extended intertext is the nursery song "Ten Little Indians" which serves as a game plan for the murderer and as a centerpiece for the novel. Aside from the song, there are only a few Biblical quotations and one brief quotation from Byron.

James's *The Skull Beneath the Skin* uses *And Then There Were None* as one of its main intertexts, but constructs an elaborate arena to surround the novel. The James text never refers to *And Then There Were None* explicitly, but borrows its setting and action almost wholesale from the Christie, as one of the characters points out. "We are here together, ten of us on this small and

lonely island. And one of us is a murderer." In addition, the island itself virtually concretizes British detective fiction. The House is a huge Victorian monstrosity (designed by E.W. Godwin) which provides the archetypal setting for the country-house murder. In its library, the detective Cordelia Gray reads Sherlock Holmes stories in their original editions. The murder is, as one character describes it, "a storybook killing." But James invokes the tradition only to expose its limitations, referring at one point to "one of those thirties murder mysteries, the sort where the ingenue is called Bunty, the hero is Clive, and all the men wear long tennis flannels and keep dashing in and out of French windows." Later, when confronted with an actual murder, the critic Ivo admits, "Reviewing Agatha Christie at the Vaudeville is poor preparation for the real thing." The stereotypical qualities of the Christie detective novel are foregrounded by the characters' awareness of the clichés of the form: "That's something I've learned from popular fiction. Never be the one to find the body."

While James is highly critical of the classic White Glove form, she is even more vehement in her attack on contemporary detective novels. The intertextual arena is further enlarged by the positioning of the novel over and against sensational popular fiction masquerading as detective fiction. One of the main characters of *The Skull Beneath the Skin* is the author of such a novel—*Autopsy*. Cordelia, the detective, buys

> the paperback, as had thousands of others, because she had tired of seeing its dramatic cover confronting her in every bookstore and supermarket.... It was fashionably long and equally fashionably violent ... [she] found it difficult to put down, without being able to remember clearly either the plot or the characters.... You could, she supposed, call it a crime novel with a difference, the difference being that there· had been more sex, normal and abnormal, than detection and that the book had attempted with some success to combine the popular family saga with mystery. The writing style had been nicely judged for the mass market, neither good enough to jeopardize popular appeal nor bad enough to make people ashamed of being seen reading it in public.[7]

The open contempt for the commerciality of such fiction is obvious in the ironic emphasis on the terms "popular," "fashionable," and "mass market." *Skull* attempts to force detective fiction in a different direction by departing from the stereotypical Christie model, yet steering clear of the excessive vulgarity of the modern thriller.

The third major component in the intertextual arena manufactured by the text is Elizabethan revenge tragedy. The murderer sends letters with quotations drawn from Shakespeare, John Webster, and Christopher Marlowe. In each case the lines concerning death and revenge are perfectly

relevant to situations in the 1980s. The novel's title is itself a reference within a reference which insists on the perspicacity of these Renaissance playwrights. The title is drawn from T.S. Eliot's "Whispers of Immortality," which in turn refers back to Webster: "Webster was much possessed by death / And saw the skull beneath the skin; ... He knew that thought clings round dead limbs / Tightening its lusts and luxuries." The novel appears to be the next step in an ongoing process of invocation, one more whisper to become immortal.

The James-Eliot-Webster chain is doubly significant. First, it indicates an attempt to create a sense of continuity between the three, a set of common interests and perspectives which are the links in the chain of some Great Tradition of literary texts. Second, the reference within a reference foregrounds intertexuality as a guarantor of some sort of truth value. Other texts may base their claims of truthfulness or validity on how "life-like" they are, but there is another criterion for validity at work here—one which is grounded in how "book-like" this text is; "book-like" not in a general meta-fictional sense, but rather in a very specific, clearly delimited manner which indicates a given text's appeal to a form of discourse as a source of value unto itself.

The highly sophisticated intertextual arena constructed by *The Skull Beneath the Skin* repeatedly demonstrates its insistence on "clearing a space for itself" which explodes Todorov's conception of static genres, as well as his distinction between detective fiction and "literature." In order to account for this intra-discursive (between texts within the same discourse) positioning we need a notion of intertextuality which considers this "clearing a space" as much a "given" as its constant furrowing by other texts. Umberto Eco's notion of "intertextual frames"[8] in some ways allows for a middle course between the extremes of Macherey and Bloom. Like Macherey, he argues that "no text is read independently of the reader's experience of other texts," but insists that "intertextual knowledge ... can be considered a special case of overcoding and establishes its own intertextual frames (frequently to be identified with genre rules) (p. 21). In reference to Eugène Sue's *Les Mystères de Paris* (1842–43), Eco asserts that "every character (or situation) of a novel is immediately endowed with properties that the text does not directly manifest and that the reader has been programmed to borrow from the treasure of intertextuality" (p. 21). Eco's intertextuality comes the closest to a compromise between the two critics, since he acknowledges the furrowing that Macherey argues for, at the same time allowing the Bloomean manipulation of the possible intertexts by which a given genre effects a kind of closure of the frames to be activated. The main limitation of Eco's work for the current argument is the virtually infinite number of these frames, which fails to account for explicit manipulation of an intertextual arena. His notion of intertexuality at this point is quite similar to Barthes's "mirage of citations."

The chief advantage of Eco's emphasis on intertextual frames is that it neutralizes a problem haunting much intertextual analysis. When does a reference to another text become an intertext? What degree of presence justifies the use of the term? Eco's intertextual frame apparently includes within it any implicit or explicit reference to another text, whether it is an allusion, quotation, outright modeling, or borrowing of significant facets— anything that activates one text's relations to another. For Eco, the problem of the degree of presence is rendered secondary to the main question: why certain texts are invoked and not others. Regardless of the degree of presence, the fact remains that a specific text has activated specific relations with another text or set of texts instead of other equally available texts. Whether it is a brief allusion or a significant model for the text, both work to establish that text's relations with the field of discourses surrounding it.

For example, one might concede that Shakespeare's *Hamlet* provides a recognizable model for Michael Innes's *Hamlet Revenge* (1937), and still regard the ubiquitous quotes from Shakespeare in so many British detective novels as merely amusing word play or signifiers of "breeding" that further define the social class of a particular character. But those seemingly "passing" references are indicators of another presupposed hierarchy, that of literary discourses. The ubiquity of Shakespeare quotation in British detective novels indicates a process of association that tries to establish the applicability of Shakespeare to the situations that arise within that genre of fiction—a connection which "naturally" suggests a certain commonality between the two. In Innes's *The Long Farewell* (1958), for instance, each major section of the novel begins with an epigraph drawn from Shakespeare. The end result of such quotations is "class" by association, the detective text positioning itself as closely as possible to bona fide Serious British Literature. It is as if by studding themselves thoroughly with fragments of High Class literature these detective novels could acquire a similar status. Absolutely crucial in this process of association is the acknowledgment of a hierarchy of literary discourses only to restructure it—since the ultimate aim of these references is a final merging of detective fiction with Serious Literature as a whole.

The White Glove Novel: "Breeding" by Association

This attempted conflation of detective fiction and High Class literature begins to be most pronounced in the 1930s when the British detective novel went through a kind of "identity crisis," in which a significant number of texts expressed a need for fundamental changes in the genre. Throughout the decade, in novels like Nicholas Blake's *The Beast Must Die* (1938), Innes's

Hamlet Revenge, and Eric Ambler's *A Coffin for Dimitrios* (1938), one finds a highly self-conscious re-evaluation of the status of detective fiction as a whole. This new self-consciousness and desire to evaluate the status of the genre becomes particularly apparent if we compare Dorothy Sayers's introduction to the *Omnibus of Crime* (1929) and her novel *Gaudy Night* (1936). In the former she insists that detective fiction cannot ever be considered among the greatest literary achievements, but in *Gaudy Night* she explicitly rejects this position and labors furiously to prove the opposite—that detective fiction can attain the "highest levels."

The intertextual arena of *Gaudy Night* is carefully constructed to elevate the status of detective fiction in relation to the Great Tradition of British Literature. There are three dominant intertextual frames activated by the text: Joseph Sheridan Le Fanu and the classic mid-19th-century English detective novel; the entirely "fictional" intertext of Harriet Vane's earlier detective novels; and the ethereal world of Renaissance and Metaphysical poets. Sayers activates the first frame through Vane's attempt to write a scholarly study of Le Fanu's work during her stay at Oxford. But she is decidedly not interested in the Le Fanu who, in his *Uncle Silas*, inherited the Radcliffean tradition. Instead she reveres the Le Fanu who, she claims, helped inaugurate the Great Tradition of the English detective novel, and makes explicit comparisons between his work and that of Wilkie Collins. Activating this frame suggests Sayers's desire to place her own novel within this tradition, and, at the same time, through Harriet Vane's explicitly scholarly study, to legitimate that tradition by placing it within the realm of acceptable literary history and having it written at the very site where canons are established and maintained.

The second intertextual frame, Harriet Vane's earlier detective novels, constitutes an even more pointed critique of detective fiction as practiced in the twenties. The frame is entirely "fictional," since the novels are the creation of a fictional character; yet they also allude to Sayers's own novels before *Gaudy Night*. This frame functions as an auto-critique, then, of her own earlier work and, by extension, of the state of detective writing in England in the late twenties and early thirties. "The books were all right, as far as they went; as intellectual exercises they were even brilliant. But there was something lacking about them; they read now to her as though they had been written with a mental reservation, a determination to keep her own opinions and personality out of view." This intertextual frame further clarifies how the text situates itself within the Great Tradition, yet the frame also suggest Sayers's attempt to take the detective genre into new territory, beyond simple games of mathematical deduction.

The third frame provides the final coordinate in the text's clearing a space for itself by constructing its own arena for discursive interaction. The continual references to Shakespeare, Spenser, Michael Drayton, and others, particularly in the epigrams that head each chapter, may seem to evoke

conflicting rather than complementary discourses (a frame further elaborated by Vane's own sonnet writing within the text). The significance of this frame must be considered in relation to its status as an "Oxford" novel. The epigraphs in each case demonstrate a shared interest, a common ground with the novel at hand (as any epigraph normally would), but here the claim is particularly striking due to the diversity of the discourses involved. The novel acknowledges the traditional classical/popular art distinctions only to dissolve them, thereby increasing the stakes of the intertextual struggle. The references to Shakespeare, Spenser, and company represent the cultural foundation, the very core of what Oxford stands for as the bastion of British culture that transcends time. While Harriet Vane may concede that Oxford's isolation is superficial, the novel itself still appeals to a timeless core, within which it attempts to include itself by demonstrating that its concern with murder and psychology were always at the heart of the best that had been thought and said in British culture.

The world of the White Glove detective text becomes increasingly "literary" in the thirties and after Word War II; as a result the intertexts are incresingly foregounded. Crime itself begins to occur in a highly literary atmosphere. While the country house as scene-of-the-crime is one of the standard clichés of the British tradition, colleges and public schools become almost as ubiquitous beginning in the early thirties. For example, Edmund Crispin's *The Moving Toyshop* (1946) and J.C. Masterman's *An Oxford Tragedy* (1933), as well as *Gaudy Night* (1936), all take place at Oxford; Amanda Cross's *Death in a Tenured Position* (1981) and Nicholas Blake's *The Morning After Death* (1966) at Harvard; Michael Innes's *The Weight of the Evidence* (1943) at a smaller English college; and Blake's *A Question of Proof* (1935) and Crispin's *Love Lies Bleeding* (1948) at high class public schools. It comes as no surprise, then, that the detective and professor often conflate. Crispin's Gervase Fen is.an Oxford Professor of English and Cross's Kate Fansler teaches English at Columbia. In Cyril Hare's *An English Murder* (1978), the learned old scholar Wenceslaus Botwink successfully solves the crime while Parliament and Scotland Yard fail—and precisely because he spends his time studying 18th-century manuscripts in the family library. This tendency becomes even more pronounced in Martha Grimes's *The Dirty Duck* (1984), in which a series of crimes cannot be solved until the mystery surrounding Christopher Marlowe's murder in 1593 is resolved by literary detection in the present.

The library itelf is repeatedly the scene of the crime and/or the scene of its resolution. The foregrounding of the library as a privileged space creates a world completely "circumscribed" by books. As early as Edgar Allen Poe's "The Murders in the Rue Morgue" and "The Purloined Letter" (1844), a great deal of attention was being paid to the detective's book closet. The repeated emphasis on Dupin's and the narrator's ability to solve cases in armchairs as they read before the fire obviously had and has profound

ramifications for reader positioning and involvement (a topic which will be discussed in Chapters Three and Four). But the privileging of the library is itself an essential step in the move to encircle the diegesis with a wall of books, thereby creating a "reality" which is primarily discursive. Likewise in detective fiction, the book very often becomes an object of desire—not only worth stealing, but worth killing for in texts as different as Innes's *The Long Farewell*, Robert Parker's *The Godwulf Manuscript* (1973), and Umberto Eco's *The Name of the Rose* (1980). In each case—the valorization of the university, the professor's library, or the book—the world is transformed into a literary phenomenon, a realm where reading and writing are the essential occupations.

This desire to upgrade the status of detective fiction through the foregrounding of a highly literary intertextual arena reaches its zenith immediately following World War II, particularly in the work of Edmund Crispin. In novels like *The Moving Toyshop* and *The Case of the Gilded Fly* (1954) both the murder and investigation are literary events. The detective man of letters becomes a new hybrid. Gervase Fen, professor of English Language and Literature at Oxford is an obsessive amateur detective, and Richard Freeman, Chief Constable of Oxford, publishes scholarly studies on Shakespeare, Chaucer, and Blake. In both texts the murderer and suspects are all either actors, professors, or students in the humanities. In *The Moving Toyshop*, for instance, the crimes revolve around a woman's fascination with putting Edward Lear's limericks into "action." Alice Winkworth's attempt to transform the world into literary texts mirrors perfectly Crispin's same desire to make nature appear to imitate art so that the literary text becomes both an antecedent model for "reality" and, as a result, the only authentic means of representing that "reality."

But Crispin's literary universes are not simple paeans to High Class literature. Where Sayers and Innes revere Shakespeare, Crispin makes finer distinctions, as in Fen's threat: "I'm preparing a new anthology, 'Awful lines from Shakespeare.' " Crispin's profuse intertextual references create an arena in which all texts, classical or popular, become part of an ongoing discursive game. In *Toyshop*, for instance, Fen's best friend, Richard Cadogan, is "by common consent one of the three most eminent of living poets . . . lengthily eulogized in all accounts of twentieth-century literature." Yet Cadogan abandons a secure life in St. John's Wood in search of mystery because "I crave, in fact, for romance." Fen, too, appears motivated by similar instincts. "I'm an adventurer manqué; born out of my time." That both figures move so gleefully between the world of letters and the world of romance epitomizes the dissolution of the boundaries between them. The title of the novel may come from "The Rape of the Lock," but the adventures within also take the characters through a movie theater where an American crime film is being shown and the tough-guy dialogue is intercut with Fen's and Cadogan's conversation. This ability to make Alexander Pope and *film noir* lie down

together is made possible by an all-out attack on any kind of pomposity or excessive seriousness in literature. Several of the major British writers of the 20th century come under fire—"Like a scene from a Graham Greene novel, Cadogan thought as he peered in: somewhere there must be someone saying a 'Hail Mary.' " At one point Fen and Cadogan are picked up by a truck driver.

> "Industrial civilization," said the driver unexpectedly, "is the curse of our age." Cadogan stared at him. "We've lorst touch with Nachur. We're all pallid." He gazed with severity at Fen's ruddy countenance. "We've lorst touch"—he paused threateningly—"with the body."
> "I haven't," said Fen acrimoniously, jogging Wilkes.
> Enlightenment was upon Cadogan. "Still reading Lawrence?" he asked.
> "Ar," said the driver affirmatively. "Thass right." He felt about him and produced a greasy edition of *Sons and Lovers* for general inspection, then he put it away again. "We've lorst touch," he continued, "with sex—the grand primeval energy; the dark, mysterious source of life. Not," he added confidentially, "that I've ever exactly felt that—beggin' your pardon—when I've been in bed with the old woman. But that's because industrial civilization 'as got me in its clutches."[9]

The games Fen and Cadogan play at slow points during the investigation foreground an unqualified deflation of established classics. One is called "Detestable Characters in Fiction":

> "Well, let's get on with the game," said Fen. "Ready, steady, go."
> "Those awful gabblers Beatrice and Benedict."
> "Yes. Lady Chatterley and that gamekeeper fellow."
> "Yes. Britomart in *The Faerie Queene.*"
> "Yes. Almost everyone in Dostoevsky."
> "Yes. Er-er-."
> "Got you!" said Fen triumphantly. "You miss your turn. Those vulgar little man-hunting minxes in *Pride and Prejudice.*" (p. 56)

Later in the novel they begin another even more telling game.

> "Let's play 'Unreadable Books,' " he suggested.
> "All right. *Ulysses.*"
> "Yes. Rabelais."
> "Yes. *Tristram Shandy.*"
> "Yes. *The Golden Bowl.*"
> "Yes. *Rasselas.*"
> "No, I like that."
> "Good God. *Clarissa,* then."
> "Yes. *Titus-*" (p. 83)

The presence of these games throughout the text indicates a far more significant process at work in Crispin's text than mere comic relief. the fictional is pushed to such self-consciously literary extremes that it inevitably becomes self-reflexive. In *Gilded Fly*, for example, Fen boasts, "In fact I'm the only literary critic turned detective in the whole of fiction." Later Sir Richard complains, "Really, Gervase: if there's anything I profoundly dislike, it is the sort of detective story in which one of the characters propounds views on how detective stories should be written." These rather coy references to the fictionality of the entire enterprise becomes quite explicit in *Toyshop*. During one of the lags in the investigation Fen and Cadogan have the following exchange:

> "Murder Stalks the University," said Fen. "The Blood on the Mortarboard. Fen Strikes Back."
> "What's that you're saying?" Cadogan asked in a faint, rather gurgling voice.
> "My dear fellow, are you all right? I was making up titles for Crispin."
> (p. 81)

This direct reference to the author by a character within the novel signals the complete exposure of the fictionality of the text. Fen transforms the supposedly "real" diegetic events into fiction as he proceeds with the investigation. The multiple titles suggest the different narrative possibilities and the basically arbitrary relationship between events and their presentation. When the name of the author is invoked, Crispin's own novels become a self-reflexive intertext for themselves—the diegesis being nothing but an intertext, "reality" being nothing but discourse.

The upwardly mobile "literary" intertexts of White Glove authors like Sayers and Innes reach their natural conclusion in Crispin's novels after World War II. In Crispin the diegesis finally collapses under the weight of its own intertextual references. The very fabric of the fictional world of the text is composed not of characters, settings, etc., but the constant interweaving of a profusion of literary texts. The constant furrowing which Macherey sees happening to and around the text is here an activity undertaken by the text from within. The creation of an intertextual arena becomes an end in itself to which all else (characters, locations, narrative action, etc.)—becomes subservient. The self-promotion of detective discourse reaches it zenith at this stage insofar as it becomes the primary manifest content of the text and renders the diegesis little more than the intersection of intertextual frames.

The Hard-Boiled School: Popular Art with a Vengeance

The American hard-boiled school represents a fundamentally different type of intertextual manipulation reflecting an entirely different hierarchy of discourses. Its avowedly anti-literary traditions might at first lead one to expect that intertextual manipulation would be actively avoided rather than actively exploited, yet intertextual manipulation is just as central to hard-boiled texts as to the most literary British detective fiction. Both construct a distinctive hierarchy of discourses that reveals the variability of the overall discursive field, the absence of any master hierarchy that could fix the function and audience of each discourse.

The attitudes expressed in Raymond Chandler's "The Simple Art of Murder" (1950) represent an ambivalent attitude toward the "literary." Much of the essay functions as a diatribe against British detective fiction.

> The English may not always be the best writers in the world, but they are incomparably the best dull writers. There is a very simple statement to be made about all these stories: they do not really come off intellectually as problems, and they do not come off artistically as fiction. They are too contrived, and too little aware of what goes on in the world.[10]

At the same time, Chandler labors to justify detective fiction as great literature. He insists that the hard-boiled school belongs to the British realist tradition that begins with Tobias Smollett and Henry Fielding. His final litany of what a detective should be ("He is a relatively poor man," "He is a common man") is as mannered as the most excessive British novel. "Great Traditions" would appear to be as varied as the popular discourses that construct them as their direct antecedents.

One finds in Chandler's fiction the same ambivalent, often even schizophrenic attitude toward Serious Literature. In *The Big Sleep* (1939), for instance, the detective Marlow gives contradictory signals concerning his attitudes toward High Class literature. At times he displays nothing but ignorance and/or hatred for it. When Vivian mentions Marcel Proust, Marlowe responds, "Who's he?" He goes to the public library to check out information on a first edition only for the purposes of the investigation. In an apparent reference to Sayers's Lord Peter he reads "a stuffy volume called *Famous First Editions*.[11] Half an hour of it made me need my lunch." The word "stuffy" here epitomizes his attitude toward the material that Lord Peter finds subject for adoration. Furthermore, the First Editions shop turns out to be a front for pornographic books; the upper-class clientele may express an interest in the Classics, but what they really want is smut. This point is reiterated later in the text when Vivian describes Proust as a "connoisseur of degenerates."

The connection between aberrant sexual tastes and cultured individuals is a recurring feature of Chandler's fiction. In *Farewell, My Lovely* (1940), he describes the living room of Harvard-educated Lindsay Marriot:

> There was plenty of nice soft furniture, a great many floor cushions, some with golden tassels, and some just naked. It was a nice room if you didn't get rough It was the kind of room where people sit with their feet in their laps and sip absinthe through lumps of sugar and talk with high, affected voices and sometimes just squeak. It was a room where everything could happen except work.

Here the attack on High Class culture is even more vituperative since appreciation of that culture is linked with a very dubious masculinity: to be cultured is to be a homosexual. Where the British detective novel of the pre-World War II era foregrounds its association and affiliation with literary traditions, the American detective novel of the thirties is predicated either on dissociation and denial of such traditions, or the invention of an alternative antecedent tradition.

These diatribes constitute only part of the intertexts activated by Chandler's novel. Amidst the assault on the "literary," we find sophisticated references to other quite literary texts. In his description of Mrs. Regan's legs, he says they have "enough melodic line for a tone poem." How does a man who only goes to the library to read stuffy books for the purposes of his investigation know what a tone poem is? Later in the novel he tells Carmen, "We're a scream together, two stooges in search of a comedian." Marlowe doesn't know Proust, but does he know Pirandello? Particularly striking in these references, beyond their contradiction of other references within the same text, is their degree of *integration* into the text. Neither is directly foregrounded as reference; each is translated into the terms of detective discourse by its insertion into a radically different context—tone poems and legs, Pirandello and stooges. This integration sometimes can be taken to purposely ludicrous extremes, as in Mickey Spillane's *Kiss Me, Deadly* (1952). Velma begins a striptease for Mike Hammer, but stops, saying, "Now you know how Ulysses felt," to which Hammer responds, "Now I knew. The guy was a sucker. He should have jumped ship."

These intertexts indicate an attempt to deny the importance of literary trappings, yet still insist on demonstrating a thorough knowledge of what must be rejected. Perhaps the essential difference between the White Glove and the hard-boiled traditions is that the former promotes itself in an upwardly mobile fashion, attempting to thrust itself through intertextual association into the realm of High Class literature, while the latter promotes itself by trying to discredit High Class literature. Both strategies labor to alter an imagined hierarchy of discourses, but the White Glove maintains the superiority of literary discourse in an effort to become one with it, while the hard-boiled

tries to dissolve the hierarchy by denying its validity and offering its own as the only genuine alternative.

The anti-literary strain in novels by Hammett, Chandler, Spillane, and others, can, of course, be seen as a manifestation of the anti-intellectual traditions at work in American society—particularly within the Populist movement to which the hard-boiled tradition is clearly related. Chandler insists in "The Simple Art of Murder" that what he and Hammett are doing is part of the American realist tradition that has always shunned literary pretentiousness. This begins to explain some of the difference between the British and American detective novels, but it fails to account for the place of detective fiction in the overall field of discourses in each country in the twenties and thirties.

The lack of an established canon of High Class literature in American fiction has always allowed for more fluid interrelations between popular and more "sophisticated" modes of discourse. America's foremost literary stylists during the period, Ernest Hemingway and William Faulkner, both produced texts that appropriated hard-boiled discourse—"The Killers (1927)," "Fifty Grand (1927)," *Sanctuary* (1931), etc. In England, on the other hand, the field of fictional discourses has been far more polarized in the 20th-century, due to two factors: a long-established tradition of High Class literature and the supposed failure of Modernists to continue that tradition. Sayers's *Clouds of Witness* includes appropriate references to Shakespeare, but it also contains highly critical intertextual references to James Joyce and D.H. Lawrence, who represent a kind of lunatic fringe within the novel.

British detective fiction of the period labors to convince its public that there has been a breakdown in the ongoing tradition of Great Literature, and only the detective novel can perpetuate that tradition. It is through this supposed power vacuum in the field of fictional discourse that detective fiction can claim a new status. The British detective novel of the thirties "cleared a space" by attempting to appropriate an allegedly abandoned space: the Great Tradition in the 20th century. Within this destablized hierarchy of discourses, where Serious Fiction was no longer considered a legitimate continuation of the best that had been thought and said, the detective novel's self-legitimation is predicated on its supposed ability to fulfill an essential function that was only being perverted.

Because of hard-boiled novels' apparent self-contentment as an inherently popular discourse, one finds in these texts references to other types of popular fiction and entertainment that are relatively rare in the novels of Sayers or Innes. Arthur Lyons's *Castles Burning* (1982), for example, repeatedly activates two intertextual frames—American films and American popular music. His narrator frequently draws similarities between his situations and those in films: "I felt like Ronald Coleman in *Lost Horizon*," "Like Stewart Granger in *Harry Black and the Tiger*," etc. Song lyrics become as ubiquitous as

quotations from Shakespeare in a White Glove novel, and the title of the book itself is taken from a Neil Young song. The narrator Asch also makes reference to popular artists: "like something from a Maxfield Parrish print." His client is an artist whose huge, mostly pornographic canvasses are described as a mixture of "illustrative art and photo-realism." That both Parrish and the client are illustrators who sell their work to the mass market is crucial because as illustrators they are popular artists extraordinaire.

The changes in the intertextual arenas constructed by hard-boiled texts of the seventies and eighties indicate fundamental shift in the status of detective fiction within the larger field of discourses. Just as the increased complexity of the intertextual frames of Crispin's novels in the forties marked a significant transition in the history of the White Glove tradition, Robert Parker's novels represent a similar transition in the hard-boiled approach, a similar response to an even more overcrowded semiotic environment. In novels like *The Promised Land* (1976), *Looking for Rachel Wallace* (1980), *A Savage Place* (1981), *Valediction* (1984), and *Pale Kings and Princes* (1987), the intertextual arenas juxtapose a wide variety of popular and High Art texts, but the latter is not made subservient to the former. Rather than the radical integration of High Art into the terms of detective discourse, so prevalent in Chandler and Spillane, one finds Parker foregrounding the distinctiveness of popular and High Art intertexts, thereby emphasizing their contradictory interaction.

On the one hand, these novels abound with references to popular music, films, and television shows: "I was irritated, bored, restless, edgy, useless, frustrated, battered, bewitched, bothered and bewildered." "My aren't we epigrammatic. Spencer Tracy and Katharine Hepburn. Repartee." "Surveillance? Christ, you been watching *Police Woman* again?" On the other hand, quotations from Shakespeare and other acknowledged masterpieces are just as prevalent: "You've always been sicklied over with a pale cast of thought." " 'Okay, Jane Eyre, I got you.' 'Like Mephistopheles 'got' Faust.' " *A Savage Place* focuses on Hollywood, yet the title is borrowed from a long epigraph quoting Coleridge's "Kubla Khan." Such references not only contradict each other, but also contradict the established preconceptions concerning hard-boiled fiction. The tough-guy private investigator has become such an aggressively anti-intellectual figure by the seventies that the violation of the codes is consistently acknowledged by the novels themselves: "You have all these muscles and yet you read all those books." " 'Have you read all these Books?' 'Most of them, my lips get awfully tired though.' " " 'I don't think I've ever met a bodyguard before.' 'We're just regular folks,' I said. 'If you cut us, do we not bleed?' 'Literary, too,' Linda Smith said."

Perhaps most significant about the intertextual arenas that Parker's novels construct is the relative absence of references to Raymond Chandler or any of the other hard-boiled authors who developed the very model of the tough guy investigator that Parker is obviously perpetuating. He makes passing,

humorous references to S.S. Van Dine ("So I'm not Philo Vance, so what?"), but for the most part the intertextual arenas include few detective texts or authors. The absence is significant, because for Parker the pertinent intertextual antecedent is chivalric romance: " 'What he may not even admit to himself is that he'd like to be Sir Gawain. He was born five hundred years too late . . .' 'Six hundred years,' I said." "You're employed to help keep me alive, not to exercise your Arthurian fantasies." "Everything you do becomes some kind of goddamn quest for the Holy Grail." Even the detective's name—Spenser—invokes the chivalric tradition.

Just as a White Glove text might posit Revenge tragedy as an originary intertext and then try to demonstrate a field of continuity between detective fiction and the Great British Novel, Parker novels insist on chivalric romance as the originary intertext for the hard-boiled novel, and then labor to create a similar field of continuity with the Great American Novel. Thoreau's works are one of the primary intertexts in *The Promised Land*, and in *A Savage Place* Spenser makes a point of buying a copy of *The Great Gatsby* because, "I hadn't read it in about five years and it was time again." A few paragraphs later Parker makes the interconnections between his novel and Fitzgerald's explicit: in describing the world of Hollywood he says,

> The last hallucination, the dwindled fragments of—what had Fitzgerald called it?—"the last and greatest of all human dreams." It was where we'd run out of room, where the dream had run up against the ocean, the human voices woke us. Los Angeles was the butt end, where we'd spat it out with our mouths tasting of ashes.

Quotations (direct and indirect) from *The Great Gatsby* and "The Lovesong of J. Alfred Prufrock" crystallize Parkers' attempt to situate *A Savage Place* in a tradition of tragic visions of American experience that leads back to Fitzgerald and T.S. Eliot. The paraphrasing of lines from the Eliot poem (rather than direct quotation) is particuarly important, since it indicates the text's attempted conflation with the earlier one—as if their messages were so similar that their lines can intermingle in one master discourse that Parker, Fitzgerald, and Eliot speak in one voice.

The privileging of Arthurian romances and American literature within the intertextual arenas of Parker's novels promotes detective fiction as a new hybrid form of Serious Literature predicated on the collapse of any simple distinction between popular and High Art. Parker's novels try actively to account for the ongoing competition of disparate discourses within a given society. His detective Spenser moves through a world where he is constantly bombarded by different forms of cultural phenomena. Wherever Spenser goes, there always seems to be a record playing, a television on, a film being shown, or books being read. Just as Spenser must continually pass judgment

on each cultural product in order to further define his identity and establish his uniqueness, Parker novels as a whole labor to establish their own identity and demonstrate their own essential difference in a world of competing forms of cultural production.

Post-Modernist Intertextuality: Culture as Library, Library as Arena

Even though White Glove and hard-boiled detective novels use divergent, at times even contradictory strategies in order to destabilize an imagined, dominant hierarchy of discourses in ways which enhance the status of detective fiction, the common denominator remains the construction of intertextual arenas that re-hierarchize culture according to the terms of that discourse. While the construction of these arenas reflects the conflicted nature of the semiotic spaces in which they circulate, the terms of the struggle are, for the most part, sharply delimited by the self-legitimation process which can, ultimately, valorize only one discourse. Within the past decade, explicitly Post-Modernist texts have appeared which thematize the very construction of intertextual arenas, wherein texts become virtual microcosms of the overall field of competing discourses. Throughout novels such as Italo Calvino's *If On a Winter's Night a Traveler* (1979), D.M. Thomas's *The White Hotel* (1981), and Manuel Puig's *The Kiss of the Spiderwoman* (1978), and films such as Hans Syberberg's *Parsifal* (1984), Fernando Solanas's *Tangos, the Exile of Gardel* (1985), and Ridley Scott's *Blade Runner* (1982), collisions among quite different forms of discourse become basic structuring principles of those texts. These collisions share a common purpose—to demonstrate that our cultures are so thoroughly discourse-based that we cannot even hope to encounter "real life" unless we investigate the ways discourses fundamentally shape our experience. This emphasis on the primacy of discourse has led to the facile objection that Post-Modernist texts are not interested in the "real," but only representation as an end in itself. Since the texts mentioned take as their subject matter such "unreal" topics as the holocaust, sexual repression, political exile, the commodification of human life, etc., any avoidance of the "real" seems hard to justify. These Post-Modernist texts consistently emphasize that the "real" is always discursive and that tensions among discourses are not mere formalist squabbles, but have enormous impact on the constitution of individual identity and culture.

For the sake of continuity, I will restrict my analysis to two texts that are clearly inspired by the traditions of detective fiction—Jean-Jacques Beineix's *Diva* (1981) and Umberto Eco's *The Name of the Rose* (1983). Beineix's film very self-consciously plays up its connections with recent detective films. The

plot revolves around a mysterious tape that the police and a variety of criminals all hunt for throughout Paris. The configuration of characters involves several familiar figures: the corrupt police officer, the psychopathic hit man, the victimized prostitute, the innocent who blunders into the struggle between mob and police. Likewise, the film foregrounds the same inconography—car chases, staccato street language—that are associated with the representation of crime since World War II. The camerawork and non-diegetic music during the chase scenes bear a remarkable similarity to the post-*French Connection* (1971) crime film in its flashy virtuosity.

To a large extent *Diva* appears a clear-cut example of detective/crime film, yet within the film the detective discourse is set in opposition to another radically different discourse—19th-century opera. The two could hardly be more different—a popular, contemporary cinematic narrative opposed to what is commonly considered an elitist, antiquated musical narrative. The film invokes the opera as explicitly as the detective fiction, opening with a voice recital where the spaces of the diegetic and non-diegetic spectators are integrated through the camera's placement at different points in the crowd. When the protagonist Jules hears the American black soprano Cynthia Hawkins sing "Ebben, Ne andro lontana" (an aria from Catalani's *La Wally*) he becomes "transported," mirrored perfectly by a long, graceful tracking shot that stops only when the music does. Later, when Jules plays his recording of the aria for Alba, a Vietnamese girl who befriends him, the camera repeats its tracking, again as if transported by the music. Jules narrates the story of the opera for Alba at this point, which epitomizes the larger, more ambitious project of narrating his own life through the discourse of Italian Grand Opera. He assigns categories to people he meets according to whether they are Bel Canto, Lyric, Dramatic, and so forth. His attempts to transform actual experience into the terms of the opera culminate in the film's final scene, when he "orchestrates" his final meeting with Cynthia. Jules places her on stage and provides the music, once again the same aria from *La Wally*. They embrace "on-stage" in highly dramatic gestures accompanied by her aria. His life finally becomes an opera; his life at last is thoroughly transformed into discourse.

The opposition of High Art to popular culture forms has been for nearly four decades a cliché of the musical film. Especially in the MGM films scripted by Betty Comden and Adolph Green (*The Band Wagon* [1953], *Singin' in the Rain* [1952], etc.), the conflict between the two levels is systematically used to valorize the popular forms, thus reversing the culture's common tendency to privilege High "Art" over popular "entertainment." What distinguishes *Diva* from these texts is that both of the conflicting discourses are given equal footing.[12] Neither is subsumable and neither emerges triumphant in the film. Jules's arias are juxtaposed to his adventures with the police. In the former the camera tracks effortlessly, and in the latter it

cuts with rapid-fire precision accompanied by a completely different style of music. A shot of the Paris Opera in all its High Art glory is matched by its photographic image on Alba's plastic mini-skirt in all its Pop Art glory. This separate-but-equal situation concerning the two discourses becomes apparent in the status given to the character Gorodish as the most powerful figure in the text. He is able to save Jules's life on two occasions, to outwit the head of the Mob, and to provide money, cars, and safe houses whenever they're needed. He becomes the chief "investigator" in the film but his acute understanding of the world springs from his knowledge of both sides; his mastery over opera and detection allow him to move freely from one discourse to another. Just as Jules transforms his life into discourse, Gorodish "narrates" his meeting with the villain Saporta and structures the actual meeting according to the parameters of detective fiction. His loft apartment, like Jules's, is a composed "stage" wherein their lives become discourse.

Umberto Eco constructs an even more elaborate series of juxtapositions of discourses in *The Name of the Rose*. Like *Diva*, Eco's novel explicitly invokes established features of detective discourse. The Sherlock Homes stories, in particular, form the central intertext. The "detective" hero is an English monk, William of *Baskerville*, his exploits recorded by the devoted, but hopelessly pedestrian aide, Adso, whose attitudes and style of narration mirror Dr. Watson's. The plot adopts the form of the classic investigation—the generating of ongoing enigmas, some resolved along the way, but the central enigma preserved until the conclusion which provides the narrative closure. William of Baskerville, in pure Holmesian style, compares himself to the Chief Inquisitor at one point, claiming that the Inquisitor concerns himself only with burning the accused, but that he, William, takes greatest pleasure in unravelling "the knot" of the crime.

But the Sherlock Holmes story is only one of a wide range of discourses invoked by the text. Eco intersperses A. Conan Doyle with Roger Bacon, William of Occam, and a host of diverse medieval works, along with frequent "flash forwards" to contemporary figures (e.g. the monastery's chief librarian Jorge of Burgos, or, Jorge Borges). But the single most important intertext is "fictional" and ironically serves as the justification of the interpenetration of detective and philosophical discourses. The key to the mystery within *The Name of the Rose*, responsible for so much murder and mayhem, is Aristotle's legendary "lost" study of comedy, and it is this fictive text which serves to accentuate the power of discourse in and of itself. In the final confrontation between William and Jorge of Burgos, *in the library*, Jorge's guilt is exposed; their dialogue is essentially a debate over the status of culture. Jorge wants to suppress the Aristotle study because he sees it as the key to the downfall of civilization due to its admiration for "frivolous" activities—comedies, parodies, joke-books, etc. For Jorge, comedy has no place among the more "serious" discourses like tragedy, theology, philosophy. Its presence would only dilute

the power of these greater texts; therefore, for Jorge, it has no place in the library or civilization itself. William's argument for its presence serves as an argument for diversity within the library, for what deserves the label of art, and, finally, what deserves to be included within the confines of culture.

Not coincidentally, these murders and investigations revolve around the largest library in the Western world. The library becomes here the perfect visualization of intertextuality, the actual site where texts intersect. Here heterogeneity is the foundation of the entire Aedificium which contains works from diverse periods, cultures, and discourses. The library becomes the field of competing discursive ideologies in physical form. Long passages throughout *The Name of the Rose* catalogue the different sections of the library and the conflicts between them. In the process, the library takes on far greater significance than a mere warehouse of books. At one point Adso writes:

> "True," I said, amazed. Until then I had thought each book spoke of things, human or divine, that lie outside of books. Now I realize that not infrequently books speak of books: it is as if they spoke among themselves. In the light of this reflection, the library seemed all the more disturbing to me. It was then the place of a long centuries old murmuring, an imperceptible dialogue between one parchment and another, a living thing, a receptacle of powers not to be ruled by human mind, a treasure of secrets emanated by many minds, surviving the death of those who had produced them or had been their conveyors.

But this emphasis on the library does not have the same function in *Rose* as it did in the White Glove detective novel of the thirties. There is a similar foregrounding of the library as a privileged site, but there is no attempt to valorize the "literary" as a whole. Rather than being an evaluative process, this novel's emphasis on the library reveals how all texts interact with other texts. It is not a matter of one-to-one comparisons—x is just like y or x is better than y. Instead, x is juxtaposed to y, z, and a host of other "letters" in an attempt to stress the tensions between them. In the White Glove tradition, one discourse subsumes or conquers another in wholesale fashion, but in Eco's novel the integrity of each is maintained and their differences accentuated.

Alain Robbe-Grillet's *The Erasers* (1953) and Eco's *The Name of the Rose* are useful examples of each strategy. In the Robbe-Grillet novel, the detective discourse is subsumed into the discourse of the *nouveau roman*, which effectively demonstrates the limitations of detective fiction in its efforts to replace classical narrative with a new conception of narrative discourse. In *The Name of the Rose* the detective form retains its validity and force, but is juxtaposed to other forms of discourse—the historical chronicle, philosophy, literary criticism, theology, etc. At the end of the novel, Adso insists that his own manuscript is composed of the diverse fragments left from the library. "I

had before me a kind of lesser library, a symbol of the greater, vanished one: a library made up of fragments, quotations, unfinished sentences, amputated stumps of books."

The approach to intertextuality found in *Name* and *Diva* is one based on the *simultaneous* presence of traditionally contradictory discourses, epitomizing Post-Modern textuality. The Post-Modernist text is constructed in the face of this heterogeneity of cultural production and endeavors to reproduce that heterogeneity within the text not only to decenter High Art or problematize modes of representation, but also to demonstrate the highly discursive nature of contemporary culture. Narratives like *Diva* or *The Name of the Rose* neither reject ongoing conflicts between self-promoting discourses nor transcend such conflicts in the form of a new synthesis of discourses. If anything, the ideology that Post-Modernist texts promote is a greater sensitivity to that heterogeneity, as if it were only through the consideration of a multiplicity of discourses that we may recognize both primacy of discourse and the impossibility of a central hierarchy or master system that might coordinate their differences.

Three

Speaking in Tongues: The Languages of Popular Narrative

If the study of cultural production in decentered societies requires a new theoretical framework to account adequately for its heterogeneity, different notions of "semantics" and "style" must be introduced to measure that heterogeneity and to elucidate further the factors that produce it. If we can no longer take for granted the homogeneity of culture, neither can we continue to take for granted any kind of homogeneity in the languages produced within those cultures. While previous chapters concentrated on the function of discursive ideologies in regard to intertextual positioning, their impact on the "semantic differentiation" in various narrative discourses still needs to be explored. The consideration of the diverse languages used by discourses must involve re-examining *interpellation* as well, since those languages "call-in" individual readers in different ways. To ignore the effect of such differences among languages on the constitution of the subject severs interpellation from signification and in the process presupposes the homogeneity of all ideology and of cultural production.

From a Unitary Culture to Unitary Discourses

The most thoroughgoing study of the history of narrative languages is Mikhail Bakhtin's "Discourse in the Novel."[1] In this extended essay, Bakhtin sets forth his philosophy of language which then serves as the foundation for his history of the novel. The cornerstone of Bakhtin's argument is that society, and by extension the modern novel, is characterized by a fundamental "heteroglossia," since

> language—like the living, concrete environment in which the conscious-
> ness of the verbal artist lives—is never unitary. Actual social life and

historical becoming create within an abstractly unitary national language a
multitude of concrete worlds, a multitude of bounded verbal ideological
and social belief systems. (p. 288)

He distinguishes two basic tendencies within this multitude of languages: the
centripetal and the centrifugal. "Alongside the centripetal forces, the
centrifugal forces of language carry on their uninterrupted work; alongside
verbal-ideological centralization and unification, the uninterrupted processes
of decentralization and disunification go forward (p. 272). A single national
language is therefore stratified not only by languages of different social
groups, but also by professional, generational, and generic languages.

According to Bakhtin, the novel is fundamentally heteroglot because it
embraces the diversity of languages and makes the differences among them
explicit. Unlike poetry, which he considers the willful reduction of differences
in pursuit of an artistic language, the novel creates a tension which cannot be
resolved. The voice of the narrator is only one among many in the novel, but
the voice of the poet is unitary and "marked" as a special type of language
apart from everyday speech. Consequently, for Bakhtin, the emergence of the
novel as the dominant language of narrative signifies the victory of an
egalitarian aesthetic over an aristocratic one. The novel becomes, then, the
consummate popular art form, and only "literary" discourse, especially poetry,
maintains its unitary quality.

Bakhtin concludes his history of narrative at that point; but in a world
where the novel and its latter-day counterpart, the feature film, are radically
subdivided and differentiated, the novel as a narrative mode is itself a tangle
of competing languages. How does a specific genre drive through that tangle,
except through the explicit differentiation of its language over and against
other languages of popular fiction?

Throughout the history of detective fiction, one finds this acknowledgment
of the diversity of languages within a given society, but more importantly, one
finds the purposeful assertion of one type of language above all others. On the
surface, detective texts appear excellent examples of the heteroglossia Bakhtin
describes. The first major works in the genre—Wilkie Collins's *The Moonstone*
(1868) and *The Woman in White* (1860), and Dickens's *Bleak House*
(1852–53)—all employ multiple narrators speaking languages that indicate
distinct differences in their verbal-ideological perspectives. The emphasis on
popular street language in the hard-boiled text is just as dramatically
heteroglot in its refusal to acknowledge any dominance of a literary/aristo-
cratic language.

In *The Pursuit of Crime*, Dennis Porter relates the detective novel's emphasis
on street language to an all-pervasive colloquial movement in American
literature inaugurated by Mark Twain and brought to fruition in the 1920s.
For Porter, Hammett's and Hemingway's prose is distinguished by its desire

"not simply to remove the quotation marks in the text from non-standard speech. It was also to confer the dignity of print on what sounded like the language of ordinary people."[2] Through a subtle comparison of the prose of Agatha Christie and Dashiell Hammett, Porter demonstrates the very clear differences between them, as well as the latter's predilection for the rhythms of common speech.

While Porter carefully and convincingly delimits the differences between the languages of White Glove and hard-boiled texts, he does not examine the differences in the languages found within them. In the hard-boiled text, one does indeed find an emphasis on common street language; but one also finds that language set in conflicting relationships with other languages present within the same text. This is nowhere more obvious than in the opposition between Nero Wolfe's and Archie Goodwin's languages in Rex Stout's novels, especially in the foreword to *Too Many Cooks* (1938):

> I used as few French and miscellaneous fancy words as possible in writing up this stunt of Nero Wolfe's but I couldn't keep them out altogether, on account of the kind of people involved. I am not responsible for the spelling, so don't write me about mistakes. Wolfe refused to help me out on it, and I had to go to the Heinemann School of Languages and pay a professor 30 bucks to go over it and fix it up. In most cases during these events, when anyone said anything which for me was only a noise, I have either let it lay—when it wasn't vital—or managed somehow to get the rough idea in the American language.
>
> Archie Goodwin

While the differences between Wolfe's and Goodwin's modes of self-expression are generally "played for laughs," nonetheless an interesting tension exists between them, since Wolfe's is the language of authority within the text, but Goodwin's is the language of transmission, and by extension the language supposedly spoken by the reader.

In Hammett's and Chandler's novels, where the common street language appears at its purest, the conflicting relationships between divergent languages are even more far-reaching. Throughout these novels, the detective's speech is repeatedly set in opposition to that of his clients and/or the criminals. The language of Sam Spade, the Continental Op and Philip Marlowe comes from the street and has a directness and sincerity that the more refined, more cultured language of the detectives' clients lacks. Spade's verbal fencing matches with Brigid O'Shaughnessy and Gutman throughout *The Maltese Falcon* (1930) are quintessential examples of this kind of opposition. Gutman tells Spade, "You're the man for me, sir, a man cut along my lines. No beating about the bush, but right to the point." Yet nothing could be further from the truth. Gutman's language is the antithesis of Spade's—polished but indirect,

verbose yet elusive. Hammett foregrounds this sort of conflict even more directly in *Red Harvest*. The client—in this case Elihu Willson, the czar of Personville—has the following conversation with the Continental Op:

> "You're a great talker," he said. "I know that. A two-fisted you-be-damned man with your words. But have you got anything else? Have you got the guts to match your gall? Or is it just the language you've got? . . . I'll talk you your sense. I want a man to clean this pigsty of a Poisonville for me, to smoke out the rats, little and big. It's a man's job. Are you a man?"
>
> "What's the use of getting poetic about it?" I growled. "If you've got a fairly honest piece of work to be done in my line and you want to pay a decent price maybe I'll take it on. But a lot of foolishness about smoking rats and pig pens doesn't mean anything to me."[3]

Willson recognizes that they not only speak conflicting languages, but that they "make sense" differently, and to communicate with the Op he must speak the other's language. The Op refuses to accept Willson's job as it is stated in Willson's "poetic" speech. Even the simplest of metaphors are rejected as an unnecessary obfuscation of the matter at hand. The Op accepts the job only when it is finally stated in his own language, a language that is not simply a matter of slang, but is a very specific verbal-ideological perspective.

The emphasis on the unresolvable tensions between languages within the world of the hard-boiled text, with one emerging as a privileged mode of expression, is the structuring principle of Vera Caspary's *Laura* (1942). The novel has three narrators: Waldo Lydecker, Mark McPherson, and Laura Hunt. Lydecker is the man of letters par excellence, a newspaper/radio critic at large, and an all-round connoisseur. As a cultured authority on the "art" of murder, his prototype is the upper-class detective heroes of the White Glove novel, specifically S. S. Van Dine's Philo Vance. His prose is exceedingly literate and by most standards, particularly this novel's, wildly pretentious. His newspaper column on crime is titled "And More Anon," and he is given to asking questions like "At college or *pour le sport?*" Lydecker has nothing but contempt for contemporary detective fiction.

> While a not inconsiderable share of my work has been devoted to the study of murder I have never stooped to narration of a mystery story I still consider the conventional mystery story an excess of sound and fury, signifying, far worse than nothing, a barbaric need for violence and revenge in that timid horde known as the reading public.[4]

Throughout his account of the events he steadfastly denigrates the popular and common while advocating more cultured literary values in a thoroughly rarefied language.

Mark McPherson's narration is the antithesis of Lydecker's. It follows Lydecker's in the novel and admits a knowledge of it, but McPherson's prose becomes a highly self-conscious negation of Lydecker's language as a style and as an ideological perspective. McPherson remains the consummate hard-boiled investigator, and when he takes control of the narrative in Part Two he immediately asserts the differences between them. He begins,

> When Waldo Lydecker learned what happened after our dinner at Montagnino's on Wednesday night he could write no more about the Laura Hunt case. The prose style was knocked right out of him I am going on with the story. My writing won't have the smooth professional touch which, as he would say, distinguishes Waldo Lydecker's prose. God help us if any of us tried to write our reports with style. (p. 83)

McPherson's remarks to the contrary, one style has replaced another, and his prose is as thoroughly replete with markers of its uniqueness and essential difference as Lydecker's was. He insists:

> This is my first experience with citizens who get their picures into that part of the funny papers called the Society section When these people want to insult each other, they say darling, and when they get affectionate they throw around words that a Jefferson market bailiff wouldn't use to a pimp. Poor people brought up to hear their neighbors screaming filth every Saturday night are more careful of their language than well-bred smart alecks. I know as many four letter words as anybody in the business and use them when I feel like it. But not with the ladies. Not in writing. It takes a college education to teach a man that he can put on paper what he used to write on a fence. (p. 83)

McPherson's attack reiterates a common theme in hard-boiled fiction: language that is cultured and literary may be decorous on the surface, but at base it must be either empty or depraved. As McPherson tells Lydecker of his column, "You're smooth all right, but you have nothing to say." Consequently, Lydecker's complex sentence structures, French phrases, and literary allusions are replaced by short direct sentences and similes like "My heart beat like the drum in a Harlem dance band." The end result is an ongoing cultural war fought across their radically opposed languages. At one point, Lydecker claims that "anyone who can't distinguish between Sibelius and Bach, my dear fellow, is fit for treason, stratagem and spoils." McPherson responds, "I'm a cluck, when it comes to music, Duke Ellington is my soup" (p. 46).

The cultural power struggle between the men makes the possession of Laura their single goal, as if her love would function as an explicit sign that one language system could triumph over the other. As the novel progresses, her

allegiance shifts slowly from Lydecker to McPherson. She begins as an aspiring social climber, but eventually "gets back to normal" by recovering her lost sincerity and simplicity with McPherson. As she moves from one sphere of influence to another she alters her priorities, at one point insisting "this is no way to write the story. I should be simple and coherent, listing fact after fact, giving order to the chaos of my mind." The appearance of Laura's narration after the two men's establishes her role as the ultimate arbiter of their respective values. McPherson "gets the girl" in the long run not only because they are from the same social class, but because they can speak the same language.

The opposition between the two languages ends in the eventual cancellation of one by the other. By the end of the novel, the languages differ not only in regard to word choice, prose style, and verbal-ideological perspective, but finally in their ultimate purpose as well. When Lydecker is unmasked as the perpetrator of the first mistaken killing as well as the would-be murder of Laura at the end of the novel, his language is exposed for what it is—the language of pure deception and pure depravity, the language of a murderer. McPherson's, on the other hand, emerges as the language of truth, that which provides clarification and, ultimately, Laura's salvation. The victory of one mode of expression over the other could hardly be more complete or more final. McPherson takes over the narration for the concluding section and quite literally has the "last word." He not only wins the woman, but the cultural battle with Lydecker, the man of words. Only McPherson, and eventually the reader, are able to see through Lydecker, who "considered himself an heir to the literary tradition."

All these examples of verbal-ideological conflict within hard-boiled texts emphasize one simple, but fundamentally important point concerning the heteroglossia found in popular narratives. While a diversity of voices actively engage in dialogue throughout these texts, no linguistic "separate but equal" policy is in operation. A variety of languages may be built into the text, but their relative positions are determined by a systematic privileging of one language over the others. The languages of Gutman, Willson, and Lydecker take prominent places within each novel, yet there can only be one "language of truth": the hard-boiled language of the detective which differentiates this discourse from all other forms of popular narrative. Each novel discussed above acknowledges the existence of the basically heteroglot nature of society, but also, just as certainly, labors against any linguistic egalitarianism by eliminating the possibility that alternative modes of expression could also be languages of truth.

In the face of the ongoing competition among various languages within a given culture, the individual popular discourse must demonstrate its alleged superiority in order to survive. To accomplish this, a discourse must emphasize its difference and exploit its points of divergence with other

languages, resulting in the creation of a "unitary language"—one not accounted for by Bakhtin. According to his history of prose narrative, the novel from Cervantes onward represents the ever-broadening rejection of unitary languages. His analysis of Dickens and Dostoevsky shows that their multiplicity (representing different classes, occupations, genres, etc.) is to be found not only within the overall configuration of characters, but also within the voice(s) of the third-person narrator. For Bakhtin, to espouse a theory of heterogeneity necessarily means rejecting the idea of a specifically literary language for prose, and, by extension, the idea of any unitary language for narrative.

But the problem here lies directly in the conflation of literary and unitary. Why can't a given *popular* discourse (as opposed to literary) be unitary? If anything, the absence of an established literary language has produced competition among various narrative discourses (science fiction, detective, etc.) that necessitates the assertion of their essential differences. Bakhtin's argument for the basically heteroglot nature of the novel is always located within one kind of novel. He never investigates the heteroglossia of *novels*, the heterogeneity of different genres all falling under the heading of novel.

As long as the novel remains the hodgepodge of various voices and discourses that it is from, say, Cervantes to Dickens, the absence of a unitary language may indeed be its defining characteristic. But once the novel as a narrative mode reaches a level of development in the 19th century where it has sub-divided into a variety of specific popular genres, unitary languages begin to reappear. The lack of an isolatable literary language for the novel generates a proliferation of unitary languages, some aggressively non-literary (the hard-boiled), some just as aggressively literary (the White Glove). The absent center of that which was literary prose results in the fragmentation of voices, a new heterogeneity in which specific voices compete and become mutually exclusive.

This competition among various genres within the category of the novel has resulted in a highly fragmented heteroglossia not accounted for by Bakhtin. He constructs an elaborate argument for two lines or stages of development within the European novel. The "Sophistic" (medieval novels, novels of gallantry of the 15th and 16th centuries, the Baroque novel, novels of the *philosophes*, etc., that held sway until the end of the 18th century) is "characterized by sharp and relentless stylization of all its material, that is, by a purely monologic—abstractly idealized—consistency of style" (p. 372). The "Second Line," to which "belong the greatest representatives of the novel as a genre . . . [Rabelais, the picaresque, Cervantes, Dickens, etc.] incorporates heteroglossia *into* a novel's composition, exploiting it to orchestrate its own meaning and frequently resisting altogether any unmediated and pure authorial discourse" (p. 375). This Second Line's presentation of "brute heteroglossia" reflects a desire to deal with "concrete" experience and is

therefore the key to its being an "authentic" discourse. While Bakhtin concedes that toward the beginning of the 19th century this sharp opposition between the two stylistic lines of the novel comes to an end, he insists that the mainstream modern novel is a combination of the two, in which the Second Line has gained ascendancy—if for no other reason than as a combination it becomes truly heteroglot.

The domination of this Second Line within the mixture of the two lines that Bakhtin obviously takes for granted is highly debatable beyond the middle of the 19th century. One could just as easily argue the reverse; the two lines do indeed intermingle, but in a world where the novel is a field of competing, mutually exclusive popular genres, *of course* the First Line dominates. When we reduce Bakhtin's two lines to their essentials—1) stylization of material through consistency of style vs. 2) pure heteroglossia unmediated by authorial or discursive stylization—where do we situate texts in which the following prose styles are commonplace?

> The gun in the guy's hand spit out a tongue of flame that lanced into the night and the bullet's banshee scream matched the one that was still going on behind me. He never got another shot out because my fist split his face open. (Spillane, *Kiss Me, Deadly*, 1952)

> I looked upon the scene before me—upon the mere house, and the simple landscape features of the domain—upon the bleak walls—upon the vacant eye-like windows—upon a few rank sedges—and upon a few white trunks of decayed trees—with an utter depression of soul which I can compare to no earthly sensation more properly than the after-dream of the reveller upon opium—the bitter lapse into everyday life—the hideous dropping of the veil. (Poe, "The Fall of the House of Usher," 1839)

> It's a port city. Here fumes rust the sky, the General thought. Industrial gases flushed the evening with oranges, salmons, purples with too much red. West, ascending and descending transports, shuttling cargoes to stellar centers and satellites, lacerated the clouds. (Samuel Delany, *Babel-17*, 1966)

Each of these passages, drawn from radically different, yet exceedingly popular texts involves not only a consistency of style, but a very high degree of stylization. Each resembles the First Line far more than the Second Line. Bakhtin claims, for instance, that chivalric romance (as an example of the First Line) "sets itself against the 'low,' 'vulgar' heteroglossia of all areas of life and counterbalances to it its own specifically idealized, 'ennobled' discourse" (p. 384). Despite all three of the above passages appearing well after the Sophistic novel was laid to rest, all three seem remarkably close to that description of chivalric prose, in that each presents a very specific "ennobled"

discourse that replaces brute heteroglossia. The key point here is that "ennobled" discourse is not co-terminous with "literary" discourse. During the Middle Ages or the Renaissance, "ennobled" may well have meant "literary"; but in the three passages above, one finds a similar privileging of one discourse and subjugation of all other languages to it, but without an expressed allegiance to an explicitly "literary" tradition.

To use Bakhtin's own centrifugal/centripetal metaphor, popular discourses (like the detective, Gothic, or science fiction) can all act as centrifugal forces because each one marshals centripetal forces in order to maintain its integrity. In other words, the centrifugal forces at work within a given culture are, in large part, due to the centripetal forces at work within each discourse. It is precisely the unitary quality of each discourse that makes a unitary culture an impossibility. The centrifugal/centripetal metaphor is therefore useful, but only up to a certain point, since it still posits a basic centrality for culture as a "whole." The situation is more than a matter of inward and outward movements, each discourse revolves around its own center which claims to be the only *valid* center for the entire culture. The multiplicity of ennobled discourses produces a radically decentered culture by insisting on so many centers simultaneously.

The shift from centrality to centralities, from a unitary culture to unitary discourses each representing an imagined whole culture differently, is perhaps best understood by examining the shift from the *picaro* to the detective as the principal figure in crime literature. The *picaro*, as a product of the 16th and 17th centuries, functioned as a complete negation of the chivalric romances and, by extension, of the entire literary tradition in narrative. At this point, such a tradition was still isolatable and distinctions between an endorsed "literature" and an unofficial popular culture were still in force. The picaresque, like the *picaro* himself, was an outlaw discourse at its inception, signifying its rejection of literary standards. Bakhtin sees the *picaro* as the descendent of the fool or simpleton of the satirical novella that rejected any "straightforward" discourse through its basically parodic nature. The *picaro* is precisely a figure of negation whose presence violates the "Law" of an official "Culture." But the *picaro* can retain subversive power as an outsider only in a society where inside/outside, official/unofficial, High Art/low art distinctions are clear-cut.

The appearance of detective fiction in the 19th century and its increasing popularity in the 20th runs concurrently with the decreasing force of those distinctions. (Not that those distinction are no longer being made by academics during this period [ca. 1850–1940], but rather that the reading/viewing public seems to pay less and less attention to them.) The detective, like the *picaro*, is consistently the outsider, but his or her presence does not signify a negation of the "Law." Unlike the picaresque, detective fiction is not parodic, but very much a "straightforward" discourse. Rather

than a simple inversion of the "literary," the detective novel proceeds by the assertion of its difference among proliferating discourses where "official" and "unofficial" no longer have the same regulatory power. Where the *picaro* violated the law, the detective creates an alternative law that rejects the superiority of any law other than his or her own. Where the picaresque could rely on the negation of a central "Culture," the detective novel must individuate itself in relation to decentered *cultures* in order to *enforce* its own laws.

From "Purity" to *Bricolage:* Reconceptualizing the History of 20th-Century Narrative

Bakhtin's history of narrative, as comprehensive as it is, needs to be expanded in order to account for two more stages of narrative in 20th-century narrative. A third stage emerged in which the novel subdivided into a multiplicity of conflicting narrative discourses, each producing their own "ennobled" languages to be recognized and appreciated by increasingly fragmentary audiences. Narrative discourse within this third "Modern" stage gravitated towards one of two strategies—either an "italicized heteroglossia," in which a multiplicity of languages intersect within the text but one language assumes a definitive ascendancy as a privileged means of expression; or a rejection of heteroglossia altogether, in the creation of a new "poetic" (in Bakhtin's sense of the term) narrative discourse through a consistent stylization of all languages within the text according to one rarefied perspective. The best example of the former are texts like the hard-boiled detective novels discussed above; the best examples of the latter are the High Art novels of the 20th century, culminating in the *nouveau roman* in the fifties and the "meta-fiction" of the sixties, and characterized by the same "sharp and relentless stylization of all its material" that Bakhtin saw as the distinguishing feature of narrative before the 18th century.

Clement Greenberg links the beginning of Modernism precisely to this kind of discursive closure.[5] He argues that Modernism emerged in the middle of the 19th century when the arts were in danger of being assimilated into entertainment, at which point

> The arts could save themselves from this leveling down only by
> demonstrating that the kind of experience they provided was valuable in
> its own right and not to be obtained from any other kind of activity. Each
> art, it turned out, had to affect this demonstration on its own account. . . .
> Each art had to determine, through operations peculiar to itself, the
> effects peculiar and exclusive to itself. By doing this, each art would, to be

sure, narrow its area of competence, but at the same time it would make its possession of this area all the more secure ... each art would be rendered "pure," and in its "purity" find the guarantee of its standards of quality as well as of its independence. "Purity" meant self-definition. (p. 68)

Ironically, Greenberg's penetrating analysis of the distinguishing activity of Modernist art describes the discursive self-definition and legitimation undertaken by conflicting forms of mere entertainment within the same Modernist period. In this sense, texts as seemingly different as Hammett's *The Glass Key* (1931) and Robbe-Grillet's *La Jalousie* (1957) as Goulding's *Dark Victory* (1939) and Michelangelo Antonioni's *L'Eclisse* (1962), may be seen as comparable responses to the same fragmentation of both narrative discourse and audience that resulted in this renewed emphasis on stylization as both popular and literary discourses struggled for semiotic space.

A fourth stage, which for the sake of simplicity I will refer to as the Post-Modernist, has appeared within the past two decades and is as much a reaction against the stylistic purity found in the Modernist stage as the realist novel of the Second Line was a response to the purity of the Sophistic narrative. This is not to suggest that Post-Modernist narratives simply "revert back" to the heteroglossia of the Dickensian novel, or that the history of narrative should be seen as a series of pendulum swings. Post-Modernist narratives differ from the popular and literary texts produced during the Modernist stage in that they replace "poetic" stylization with a *bricolage* of diverse forms of already well-established aesthetic discourses. This process of juxtaposing what had become almost "walled" discourses (self-isolated by style and institution) radically undermines the "purity" that defines both generic and avant-garde textual production in the Modernist period. But this Post-Modernist *bricolage* also differs from the heteroglossia of the Second Line realist novel in that its combinations of discourses seldom represent a "brute" heteroglossia (in which multiple languages intersect within the same text as in Dickens or Balzac). This "new" heteroglossia is thoroughly Post-Modern in that it is typified by narratives that bring together languages that have become so discrete within the Modernist period that they can no longer intermingle as they did. In this *bricolage* of discourses with well-defined borders, the tensions and gaps among them are foregrounded rather than dissolved. Where the narrative discourses of the Modernist era define themselves over and against other forms of discourse as privileged modes of representation, the narratives of this fourth—Post-Modern—stage are founded on the recognition that no one discourse can be sufficient, whether pulp romance or Freudian theory.

This is not to suggest that all narratives have suddenly become radically eclectic or that the intensive self-legitimation characterizing narrative

discourses during the Modern period has stopped. What distinguishes the Post-Modern stage is, if anything, the presence of Modernist and pre-Modernist forms of textuality alongside the explicitly Post-Modern—since Post-Modern eclecticism is a response to exactly that simultaneity. The beginnings of Post-Modernism as a movement are often limited to the "Pop Art" movement of the sixties which worked against the deification of Modernist art by appropriating the mass-produced images of American popular culture. Whilst Post-Modernism may well have depended on such binary oppositions in its early stages, its distinctive features as a specific type of textuality depend upon an assertion unthinkable in High Modernism—that both the avant-garde and popular culture are nothing more than discursive formations, configurations of stylistic features linked to specific audiences by institutional networks that justify their various functions according to their own hierarchies of cultural production.

That the popular and avant-garde have a semiotic equality within Post-Modernist textuality may be seen in Laurie Anderson's *Home of the Brave* (1986). A brief comparison of the mise-en-scène of this film with that of a quintessentially Modernist work like Robert Wiene's *The Cabinet of Dr. Caligari* (1919) reveals the theoretical distinctions that separate these two types of textuality. In *Caligari*, everything within the image is shaped by the all-pervasive design principles of German Expressionism. When Caligari goes to city hall to apply for a permit for his act, for example, all of the elements of the mise-en-scène—from the painting of the walls to the construction of the table and stools, to the placement, costuming, and make-up of the actors—are determined by the same graphic design. This relentless stylization (exceeding even the hard-boiled prose discussed above) involves a discursive "self-enclosure" of that avant-garde vision which eliminates even the slightest traces of other visual languages. The assertion of its difference as a vision, then, depends upon the overt rejection of any kind of heteroglossia.

The mise-en-scène of *Home of the Brave*, on the other hand, works explicitly against this kind of self-enclosure by visualizing the comparability of popular and avant-garde discourses. In the "Language is a Virus" sequence, both are so inextricably intertwined within the narration and mise-en-scène that their separation appears impossible as their co-presence would be in *Caligari*. The sequence begins with a series of deformations/defamiliarizations common to avant-garde textual practice. Anderson's "tie" is a keyboard on which she plays a series of notes and her voice is distorted by a synthesizer. The avant-garde nature of this opening is directly confronted by the Anderson, who says "Good evening, welcome to the Difficult Listening Hour, the spot on your dial for that relentless and impenetrable sound of Difficult Music. So sit bolt upright in that straightback chair, button that top button, and get set for some Difficult Music."

At this point Anderson begins a short narrative and the avant-garde disc

jockey turns into a stand-up comic, combining phrases and images drawn in equal measure from the vernacular and the avant-garde—the former represented by quotidian phrases like "Hey pal, who tore up all my wallpaper samples?," "Holy Smokes," etc., and the latter by enigmatic phrases like "language is a virus from outer space," and "hearing your name is better than seeing your face," and then their fusion into a single image, "and when he smiled he had big white teeth like luxury hotels on the Florida coastline." This narration concludes with a fade to black and the "Language is a Virus" quotations appears projected on a rear screen, complete with attribution to William Burroughs, a crown prince of the American avant-garde. The musicians take the stage in highly stylized gestures reminiscent of avant-garde dance, but the assembled band is yet another mixture of musical and visual languages—the white avant-gardists joined with the black back-up singers so essential to the call-and-refrain structure of soul music, the fedoras and wayfarer sunglasses combined with the musical "ties" and stark white stylized dress of Anderson (who eventually dons wayfarers as well), etc.

This *bricolage* of seemingly incompatible discourses involves a degree of stylization, but a stylization based on interaction rather than self-enclosure, an artistic text that speaks a number of languages simultaneously, like the culture surrounding it. The lack of self-enclosure is emphasized by the lyrics of the song itself: "Hey, are you talking to me or just practicing for one of those performances of yours?" This confusion concerning what is "talk" (i.e. mere communication) and what is "performance" (i.e. artistic self-expression) is the kind of ambiguity that the self-enclosed discourses of the traditional avant-garde actively discouraged. Authentic art could never pass for conversation, because as a mode of expression it had to erect a wall of signifiers between itself and common speech.

All four of these stages in narrative history—the Sophistic, the Heteroglot, the Modernist, and the Post-Modernist—must be seen as part of a continuum with transitions produced by interconnected networks of discursive, social, and technological changes. Detailing the complexity of the technological changes is well beyond the scope of this study, but the general contours of this evolution need to be outlined briefly in order to make obvious the evolutionary rather than the cyclical nature of these transitions. The first shift, from the Sophistic to the Heteroglot, was made possible by increasing literacy as well as the cheaper methods of printing and disseminating texts (in magazine form, public lending libraries, etc.). As the reading public broadened, the novel became increasingly heteroglot, thereby reproducing its readership (and the languages they spoke) within the world of the text. In the transition from the second to the third stage, from the Heteroglot to the Modernist, the shift from an amorphous, "unknown" public to fragmented, specialized audiences ran parallel with the proliferation of narrative discourses and institutions responsible for their production. (I am referring here not just to the

emergence of mass-publishing houses and Hollywood, but also to the "High Culture" industry; in this stage, popular and avant-garde texts both operated within their own institutional frameworks complete with critical support mechanisms like the fanzine or the university.

The shift from the Modernist to the Post-Modernist stage has also been accompanied by major socio-technological changes, changes that have had a widespread impact on the production and consumption of texts. The proliferation of aesthetic discourses, coupled with the increasing sophistication of mass media (especially television) that can make possible the simultaneous co-presence of texts drawn from a mind-boggling array of periods, national origins, etc. has produced a semiotic glut—as well as individual affiliations with a number of different fragmentary audiences. Post-Modern textuality is perhaps best understood as a reaction to that glut. The juxtapositions Post-Modernist texts have constructed are attempts to come to terms with an overcrowded semiotic space, one where previously discrete, "pure" discourses have become push-button choices.

Semantic Closure and the Foregrounding of Difference

The conflictive and interactive relationships among discourses defining Modernist and Post-Modernist textuality are predicated on a conception of culture that is always discourse-sensitive, and therefore in a state of perpetual redefinition. The fragmentation of a unitary culture into unitary discourses has a profound impact on many of the basic issues in literary semantics and reception theory. That impact needs to be examined in greater detail, especially since the majority of the work done in both areas may acknowledge stratification in styles and audience, but still presuppose the unitary nature of culture as a "whole."

Literary semantics has traditionally centered on issues that ignore the tangled intersection of languages constituting "a culture" at any given time. A great deal of attention has been devoted to questions concerning the distinctiveness of literary as opposed to non-literary languages; the internal structured semantics of specific texts; the nature and function of figures of speech, especially irony and metaphor, etc. In confronting these and other related questions, critics have applied a variety of approaches, ranging from speech act theory to transformational grammar to enunciation theory. In the process, a great deal of light has been shed on intensely complex problems, but the impact of competing discourses on the construction of utterances has yet to gain sufficient attention so that anything like a thorough, comprehensive theory could be developed. The work of Emile Benveniste, J.L. Austin, and

their disciples has scrutinized the impact of the receiver (either actual or constructed) on the utterance, maintaining as a presupposition that the receiver is a constitutive element (no matter how explicit) of all utterances. What is needed, then, is a semantic theory that not only keeps one eye on the receiver, but the other on the surrounding tension-filled environments to determine its impact on the construction of the utterance.

Within the context of this particular study only the contours of such a theory can be adumbrated. However, some of its presuppositions may be made explicit at the outset. The importance of a surrounding field in the creation of the utterance has in many respects always been at the heart of linguistics, even if the conflicts and tensions within such a field have gone unnoticed or been minimized. Ferdinand de Saussure's insistence on the system was one of the basic tenets of his entire theory of language. That the meaning of a sign is established only in its differential relations with other signs, that there is no meaning without a system obviously provides a theoretical precedent for the consideration of the surrounding field of a given utterance. But the problem lies precisely in how we conceive of that field. For Saussure, that field as system is profoundly homogeneous, as if one culture communicated and thought "as a whole" in reference to one *langue*. The notion of system can still be useful, but only if it incorporates multiple, differentiated subsystems. One might well question whether system has any utility at all in such a society, were it not for the fact that these subsystems are not private, isolated "languages," but are constantly defining themselves over and against other discourses. In other words, the meaning of a sign within a given discourse is established by differentiated relations within that subsystem, but also in regard to how that discourse is itself set in differential, if not oppositional relations with other discourses in the same semantic space.

The highly stylized quality of hard-boiled language epitomizes this emphasis on differentiation which sets it apart from a purely "neutral" common speech. Dennis Porter's argument—that the prose of Hammett and Chandler is part of an overall emphasis on everyday speech in American literature from Twain onward—is valid, but somewhat misleading in its failure to recognize the important stratifications and differentiations within that master category. While they may have many stylistic features in common, Chandler and Hammett are not just urban Hemingways. While Hemingway appears content with relatively neutral common language, Chandler and Hammett assert a lack of neutrality, a separation from *just* common speech as a specialized subsystem that is somehow superior to other common languages. But while the language of the hard-boiled writers insists on its uncommoness, it simultaneously stresses that it is common or shared language between text and reader.

There was no town, nothing but the rails and the burned-over country.

The thirteen saloons that had lined the one street of Seney had not left a trace. The foundations of the Mansion House hotel stuck up above the ground. The stone was chipped and split by the fire. It was all that was left of the town of Seney. Even the surface had been burned off the ground. (Hemingway, "The Big Two-Hearted River")[6]

His real moniker is Al Kennedy. He was in on the Keystone Trust knock-over in Philly two years ago, when Scissors Haggerty's mob croaked two messengers. Al didn't do the killing, but he was in on the caper. He used to scrap around Philly. The rest of them got copped, but he made the sneak. That's why he's sticking out here in the bushes. That's why he won't never let them put his mug in the papers or on any cards. That's why he's a pork-and-beaner when he's as good as the best. (Hammett, *Red Harvest*, p. 67)

The second passage is different not only in its verbal construction, but also in its presuppositions regarding its relations both with other semantic fields and its readers. The term presupposition must be clarified here since my usage is not entirely consistent within traditional linguistics. Edward Keenan makes a useful distinction between two basic types of presupposition, the logical and the pragmatic.[7] The former, which revolves around logical consequences and truth values, is perhaps best exemplified by the classic question, "When did you stop beating your wife?," i.e. the "you" in question was beating his wife. The pragmatic notion of presupposition, on the other hand, involves the "culturally defined conditions or contexts" that must be satisfied for an utterance to be understood. The key issue for Keenan in this second type of presupposition is not logical consequence, but "appropriateness": "An utterance of a sentence pragmatically presupposes that its context is appropriate." He discusses this appropriateness of context in relation to sex, relative age, and status relations among the participants, so that they take on the status of operative categories—much like iteratives, aspectuals, or temporal subordinate restrictions do in constituting the circumstances for logical presuppositions. Keenan argues convincingly that while pragmatic presupposition may not be as easily specifiable as those of the logical variety, they are just as fundamental to our understanding of how certain preconditions make the creation of meaning possible in specific situations.

The prose styles of Hammett, Chandler, and Spillane all clearly depend on pragmatic presuppositions, but they also involve yet another quite particular type of presupposition. Each of those passages cited above pressupposes the appropriateness of its context by the very affirmation of that language over and against rival forms of discourse. Keenan is concerned primarily with presupposition in verbal communication, where appropriateness is a matter of subtle give and take. But in a literary text, the one-sided quality of the transmission and the lack of sensitivity shown by the text to various readers

result in a kind of semantic imperialism. The hard-boiled text can insist on its appropriateness in any context since it alone is the "language of truth," emphasized by its direct opposition to other languages in the text (as in the *Laura* example discussed above). The text presupposes that it is not only appropriate, but absolutely essential, by presuming that its readers recognize its peculiar qualities and have either already learned its language, or are ready and willing to do so in the course of reading the text.

This affirmation of its superiority as a means of communication involves another kind of "truth value." While the "truth values" of logical presuppositions are determined by relations within sentences or between contiguous sentences, the "truth values" of pragmatic presuppositions are determined at the level of discourse—specifically the juncture between them. In a field of competing discourses all claiming to be languages of truth, this pragmatic "truth value" becomes inevitable since it serves as the fundamental presupposition of the entire discourse—its readers must recognize its special status as the privileged mode of expression. Just as "When did you stop beating your wife?" presupposes that someone was beating that wife, a statement like "He stuck a pill in his kisser and lit it with a Ronson" presupposes that other types of languages, specifically literary languages, are no longer languages of truth and that the hard-boiled discourse is, seemingly, the only alternative.

This presupposition of superiority depends entirely upon processes of differentiation that set a discourse apart from its surrounding field. The central activity is a kind of semantic closure which establishes the boundaries of a given discourse by trying to create a limited semiosis (as opposed to an unlimited one in which signs generate other signs ad infinitum) in which a discourse may define itself according to itself. In other words, infinite semantic recursivity (as outlined by Eco[8]) may well be a fundamental principle of language, but specific discourses labor to construct a finite semantic recursivity in which one sign is used to define another, but only within a closed circle of interpretants. The end result, particularly apparent in the novels discussed above, is the formation of two categories, the language "inside the walls," formed by the circle of interpretants, and the inferior languages outside those "walls." The foregrounding of distinctive markers in and of themselves is only one facet of semantic differentiation. Even more important is the construction of an adjacent field, composed of a relatively closed set of interpretants which further delimits the boundaries of that discourse.

The function of this circuit of interpretants is perhaps best understood if we look at a passage without any sort of closure beyond the level of the individual sentence.

Spade took a gander down the alley and saw the big mucker with a gat in

his hand that looked like the hind-leg of a quarter horse. His eyes were like deep pools of animal lust that glowed longingly, throbbingly through the night. "Come out of there, you varmint, and loose that shootin' iron or you'll be riding shotgun on the stage to hell." This seemed to make little or no impression on the young knight errant of the street since he resolved to keep said "gat," realizing, no doubt, that the market for miscreants *sans armes* is always sluggish at best.

Each sentence taken by itself is internally consistent, thoroughy differentiated as a specific type of discourse, and more or less comprehensible. The overall sense of narrative action is also understandable from sentence to sentence. Yet the lack of closure due to the simultaneous presence of so many semantic possibilities (each demanding a different set of interpretants) makes the passage virtually nonsensical. In order to understand the construction of utterances, then, we must focus simultaneously on intra-sentence relations, which are responsible for internal consistency and the foregrounding of certain markers, and on inter-sentence relations, which construct the circle of interpretants which create a "web of sense" around each statement.

Many linguists would account for semantic closure through notions of frame and competence. According to Eco, George Lakoff, and others, the participants in any act of communication select the appropriate frame called for by a situation from a master encyclopedia or set of stored competences.[9] Eco, in particular, has argued that certain texts try to monitor this selection process by "blowing up" certain choices and narcotizing others.[10] The contention that an individual may store multiple frames and that texts must activate specific frames within that set is especially important, since it predicates the creation of meaning on differentiation between frames and, by extension, acknowledges the real heterogeneity of cultural production. The one serious shortcoming of the frames/competences model has been a failure to account fully for the tensions between those frames in specific situations. The stored-competence theorists tend to see the relationships between frames as a rather neutral affair, as if the determination of the appropriate frame by text and reader occurred in some sort of edenic state. Yet the vast majority of the fictional passages discussed above do not simply blow up certain semantic possibilities and narcotize others. In texts like *The Big Sleep*, *Red Harvest*, and *Laura*, the assertion of one frame involves the active denial of the possible alternative frames. Eco's categories of "blowing up" and "narcotizing" must be supplemented by "denigrating" in order to appreciate the tensions between frames, particularly different discourse frames. The activation by the text of one stored competence over another, or the cultivation of such a competence is the necessary condition of the simultaneous presence of rival discourses which leads to the "de-neutralization" of such choices within specific, "pragmatic" situations.

Style and Interpellation: Or Many Are Calling But Few Are Chosen

In a world of decentered cultures, where narrative discourses compete in a tension-filled environment, and several different languages assert their status as the "language of truth," the notion of "style" itself needs to be re-examined. While "stylistics" has been and always will be a focal point of critical debate, style as a concept has become increasingly impoverished over the past decade. The recent work of Stanley Fish epitomizes the radical devaluation of the entire study of stylistics, and is symptomatic of a highly retrogressive conception of cultural production as a whole. According to Fish, stylistics is doomed to failure since it makes assertions about the "formal patterns" in literary texts as if they actually had some sort of existence outside the interpretation of a given critic.[11] For Fish, "Every description is always and already an interpretation," and therefore no convincing evidence can be offered as "proof" that any formal patterns are produced by the literary text at hand. To prove this point, Fish labors long and hard to show how different interpretations establish different formal patterns; from this, he concludes that the origin of such patterns must be in those interpretations rather than the "host" text.

While this conflation of style with interpretation may, as Fish asserts, free mankind from the hazards of formalism, it does so by neutralizing language, literary production, and culture as a whole (or as a series of wholes). This conflation can exist only by refusing to see "formal patterns" as patterns of signifiers produced by very particular types of discourse over and against other types of discourse. Is the following passage really devoid of any formal properties other than those ascribed to it by interpretation?

> I was wearing my powder blue suit, with dark blue shirt, tie and display handkerchief, black brogues, black wool socks with dark blue clocks on them. I was neat, clean, shaved and sober, and I didn't care who knew it. I was everything the well-dressed private detective ought to be. I was calling on four million dollars. (Chandler, *The Big Sleep*)[12]

Fish denies the possibility of "truth" or "proof" in stylistics since everything is arbitrary interpretation, yet in the passages discussed throughout this chapter we encounter texts that constantly insist on their status as "languages of truth" and offer, no matter how false or "rigged," their own kind of "proof," founded on their demonstrable differences, on their highly observable formal properties which distinguish them from other, lesser forms of discourse. Fish would have us believe that the creation of formal properties is arbitrary, yet

literary texts from a wide range of discourses argue that their particular style of creating meaning is not the slightest bit arbitrary. One of his favorite examples is a very simple one "drawn from life." When a sportswriter asked former Baltimore Oriole Pat Kelley about two home runs that he hit in a particular game, Kelley corrected him, saying they weren't home runs, but acts of God. Fish sees Kelley's statement as proof positive that literal meaning can never exist outside the interpretive community (in this case Kelley's fundamentalist church). Here the Christian interpretation supposedly has become the literal or natural meaning, and its baseball meaning has been discarded.

Robert Scholes sees in this baseball example the central problem with Fish's "born again" receptionist stance. He argues that this example "illustrates perfectly the major problem in Fish's theory: his refusal to see any difference between the primary system in which the text is encoded, and secondary systems that can only be brought to bear by an interpreter who comprehends the system."[13] In other words, would Kelley have considered striking out three times in a particular game as divine inspiration? In this context, Kelley's interpretation of the home run as divine is based upon the already coded nature of the home run within the system of baseball—it is already marked with a special quasi-divine status in the primary system without which the home run could have no meaning, no special prominence that could be attributable to a higher power.

Precisely this conflation of encoding and decoding of fictional texts undermines Tony Bennett's otherwise quite useful notion of reading formations.[14] Like Fish, Bennett contends there is nothing "pre-given" to the reader, and that reading is a process of "productive activation" since the reading formations alone "structure the interaction between reader and text." Bennett rejects the notion of a "text-in-itself" in order to understand better the variation of its reception, arguing, for instance, that "academic" reading formations and popular reading formations activate the same text so differently that the same text cannot be said to be operative in both cases. While his argument acknowledges the lack of a unitary culture within the realm of reception, Bennett's insistence on the inherent passivity of neutrality of the fictional texts presupposes a basically tension-*less* environment in the actual production of texts.

The rejection of a "text in itself" epitomizes the counter-extremism of so many of the reader-dominant models used to describe the relations between texts and their readers/spectators. Bennett is quite correct in claiming that a text's reception changes over time and that reading formations are in a constant state of flux. He quotes Stephen Heath to elucidate this point:

> It is possible with regard to a film or group of films to analyze a discursive
> organization, a system of address, a placing—a construction—of the

spectator. . . . This is not to say, however, that any and every spectator—and, for instance, man or woman, of this class or that—will be completely and equally in the given construction, completely and equally there in the film. . . . (p. 9)

But in his insistence that there is no text in itself Bennett appears to have ignored the first half of Heath's statement. It is one thing to assert that a given construction of the spectator produced by particular discursive organization or construction will not match up with all spectators everywhere, but quite another to claim that such organization or construction does not exist in any kind of purposeful manner. Clearly such processes constitute a certain "in-itselfness" in that they pre-exist any reading formation and indicate a text's attempt to shape the terms of its reception. A given text will inevitably be met with different reactions, but it does not necessarily follow that variation of reception means the text does not try somehow to control its eventual reception. To claim that nothing is offered by the text simply because its acceptance is not absolutely uniform is linguistically and ideologically problematic.

Bennett's rejection of the text as a mechanism of power with the ability to shape the terms of its reception contradicts his own emphasis on the specifically *discursive* nature of text-reader interactions. He comes close to replacing a sender imperialism with a receiver imperialism inconsistent with the notions of discourse outlined by either Benveniste or Foucault. For a discursive relation to exist (in Benveniste's notion of the term) both sender and receiver are necessary constitutive elements for the creation of meaning in a given utterance. Likewise, Foucault's sense of the term "discursive" involves the existence of certain signifying practices bound together for a specific purpose with accompanying rules and prohibitions about what can and cannot be said within a given context. This would involve a certain pre-given quality, to say the least, since discourses as mechanisms of power in their own right attempt to control what can be said, in which ways, by which speakers.

The fundamental problem underlying all such attempts to conflate style with interpretation by insisting that a text is nothing but its various articulations is that they presuppose a tension-less environment, a neutralized culture where conflicts arise only between literary critics of varying levels of professionalism. But within tension-filled, decentered cultures a fictional text must itself be an articulation of its own difference within a field of competing discourses. If texts must "clear a space" for themselves in order to survive, their attitude toward stylistics can hardly be one of indifference or postponement just so they may offer themselves to the critic in all their glorious purposelessness, saying only "make of me what you will."

The contention that there is no in-itselfness to the text is based not only on a questionable notion of discourse, but even more fundamentally, on a

highly suspect series of linguistic presuppositions concerning the creation of meaning. Bennett states, "Whilst it is true that a text always effects a certain embedding of meaning within a discursive formation—it consists not just of signifiers but of a definite order of relations between signifiers—that meaning can always be disembedded and re-embedded in alternative discursive formations." Here the dis- and re-embedded would appear an acknowledgment of a certain intentionality on the part of the text that is anterior to any reader formation that might come along. Once he acknowledges that the text establishes a "definite order of relations between signifiers" no other premise is possible. If a text sets the relationship between signifiers, certain factors must be responsible for establishing those relations other than mere grammar of syntax. Mary Louise Pratt has made the essential point that Bennett and other passive text theorists acknowledge a context for the creation of meaning at the receiving end, but not at the point of origin.[15] But in any culture where a variety of different discourses try to assert their statuses as "languages of truth," the tensions among them must become constitutive elements of their construction. The processes involved in semantic differentiations indicate quite clearly that the combination of signifiers that make up a given discourse is always done over and against other possible combinations.

Style, then, as a configuration of distinctive, recognizable formal patterns is thoroughly interconnected with *interpellation*, not only because differences between various interpellations are often stylistic, but also because interpellation as a set of processes is not just a matter of open pronoun slots. Instead of producing simple "gaps" to be filled by would-be subjects, interpellation involves the assertion of an entire discourse as a superior form of representing experience, which the individual must recognize as *the* "language of truth" if he or she is to "answer the call." If there were only one interpellation process at work, then purposeful differentiations among discourses would be unnecessary since all would contribute to a unitary dominant ideology. But once conflicting, often contradictory interpellations are at play simultaneously within a given social formation, stylistic differences as visible signs of differences between discourses are themselves *interpellative*.

It is precisely this interdependency of a discourse's recognizable style and its interpellation process that traditional reader criticism has virtually ignored. The criticism devoted to Gothic fiction, in particular, demonstrates the limitations of standard approaches to reader involvement. Rather than investigating an entire range of processes involved in the interpellation of the reader (i.e. the conversion of individual readers into Gothic subjects), the consideration of text-reader relations has been restricted to "identification." Norman Holland's and Leona Sherman's work on the Gothic is a case in point.[16] They stress, for example, the castle as a motif that "admits a variety of our projections" since it "becomes all the possibilities of a parent or body." The process of "Gothic identification," then, is never differentiated from

"identification" in general, and, as a result, we learn little about how different discourses encourage different types of identification. Perhaps the following passage best illustrates Holland's and Sherman's approach: "For texts do not determine responses—it would be closer to the truth to say experiences determine texts." Clearly the major point of interest here is not Gothic textuality, but the individual reading habits of Holland and Sherman, at which point the "primary text" becomes the psyche of the reader and the fictional text merely a parasite, a secondary elaboration.

Tzvetan Todorov, unlike Holland and Sherman, tries to show how the narration of the fantastic text, and not just the narrated events, can have a definite impact on the reader's involvement.[17] This is a critical step in itself, but Todorov still privileges character as the source of the involvement. His sense of identification between reader and character is dangerously close to Holland's and Sherman's notions of projection. The "moment of doubt" has replaced the "castle" as an identification center for a reader who seemingly projects continually at the nearest target. This insistence on identification and, by extension, projection as the basis for a reader-oriented approach to the Gothic has resulted in the isolation of certain moments or icons within the Gothic text. The question that needs to be confronted is what makes that identification possible, how does a particular discourse succeed in convincing the reader to answer *its* "call" instead of another's? Interpellation depends not only on isolated, haphazard moments of identification, but on an acceptance of that discourse's ability to express a special vision of the world that will, especially in the case of supernatural fiction, allow for the individual "je suis bien mais quand meme . . ." reaction.

Once individuals are exposed to multiple interpellations the "always ready" phenomenon that Althusser speaks about cannot be taken for granted, and interpellation becomes inseparable from self-legitimation. Their interdependency becomes especially evident in a work like Bram Stoker's *Dracula*, which insists on the special power that certain texts have to reveal "truths" about the world, "truths" unknown to most other discourses. In Stoker's novel, the act of writing and compiling a manuscript is privileged to such an extent that it becomes the sole means of self-preservation. Jonathan Harker's journal begins as a simple travel diary complete with notes to himself about obtaining recipes for chicken paprika. But once Harker realizes that the supernatural does indeed exist within the world, the act of writing becomes invested with far greater significance. After a particularly horrifying confrontation with the Count, Jonathan writes, "Up to now I never quite knew what Shakespeare meant when he had Hamlet say:—'My tablets! quick, my tablets! Tis meet that I put it down,' etc., for now, feeling as though my own brain were unhinged or if that shock had come that must end its undoing, I turn to my diary for repose."[18] Throughout the novel, virtually every main character emphasizes the link between writing and self-preservation, in each case

reiterating Harker's admission that "As I must do something or go mad, I write this diary."

The act of writing becomes essential for individual writers, but the writings themselves do not acquire any force until they are collated late in the novel. At that point, when the different writings come together to form a text, the manuscript acquires a special power. Just as Dracula turns all those he bites into his minions, Gothic discourse becomes a kind of all-devouring monster that subsumes all other forms of writing to form one master discourse. The greatest proof of this power as the sole "language of truth" is the monster's own fear of the manuscript. Harker and company return to their lodgings to discover

> "He had been there, and though it could only have been for a few seconds, he made rare hay of the place. All the manuscript had been burned, and the blue flames were flickering amongst the white ashes; the cylinders of your phonograph too were thrown on the fire, and the wax had helped the flames." Here I interrupted. "Thank God there is the other copy in the safe." (p. 291)

Once collated, the various journals and letters become the principal means of destroying the monster. The writings slowly but surely "circumscribe" the monster by pulling him within the confines of their discourse. The eventual stake-driving and beheading are anti-climactic, since Dracula's fate is already sealed when the group discourse is formulated; in it, he is narrated into and out of existence.

Dracula is not content, however, with the valorization of writing in the face of the supernatural. The act of reading this particular discourse becomes an equally important activity within the text. This is stressed by Mina Harker's assertion that

> Now, up to this very hour, all the records we have are complete and in order. The Professor took away one copy to study after dinner, and before our meeting, which is fixed for nine o'clock. The rest of us have already read everything; so when we meet in the study we shall all be informed as to facts, and can arrange our plan of battle with the terrible and mysterious enemy. (p. 242)

At this point in the novel all the characters have become readers as well as writers, and it is by reading the manuscript that discoveries are made about the true nature of Dracula. To read is to become masterful; to enjoy a privileged perspective; to recognize the limitations of other types of discourse, emphasized by the inclusion of newspaper accounts, ship's logs, etc.,—all of which fail miserably in trying to account for the strange occurrences. The end result, then, is a text which not only legitimates its creation, but also its consumption.

The conversion of individual readers into Gothic subjects makes possible the identification that Holland and Todorov describe, but it is accomplished only by promoting, implicitly and explicitly, the value of Gothic discourse as a whole. One could stress, for instance, that the I-You pronoun structure of many of the entries serves as an explicit interpellation process. The prominence given these pronouns makes these entries perfect examples of *discours* in the Benvenistean sense, and their highly personal, soul-baring content obviously creates a sense of intimacy between text and reader. This involvement is further strengthened by the emphasis placed on collective action, particularly in the last third of the novel, where the success of the project appears to depend upon the participation of all readers, both diegetic and non-diegetic. But while these various textual mechanisms that might *encourage* reader involvement hinge on the successful interpellation of individual readers, the actual *conversion* depends, in a world of multiple interpellations, on the individual's belief that a given discourse has the ability to produce a satisfying vision of the world as it is or as they would like it to be, at least on occasion.

Style, or more specifically, the semantic differentiation discussed above, is intrinsically bound up with interpellation whenever more than one call is being emitted within a specific culture. When a unitary culture gives way to fragmentary cultures in which discourses have no fixed audience or body of pre-existent subjects, competing discourses must differentiate themselves according to style and function. To paraphrase a precept drawn from the discourse Althusser uses as his model of interpellation: many are calling, but few are chosen. As long as "culture" is a tension-filled environment, competitive interpellation is inevitable—as is the construction of discursive, specifically aesthetic ideologies responsible for the valorization of each discourse. For without a means of converting individuals into subjects, no discourse can hope to survive.

Four

Discursive Ideologies and Popular Film

The ideological complexity of textual production in fundamentally decentered cultures can be fully appreciated only through the development of a theory of discursive ideologies. While dominant classes may indeed exist within specific social formations and dominant paradigms may dictate what can and cannot be expressed within specific institutions and discourses during particular periods, a "dominant culture" that supposedly orchestrates both institutions and discourses in a cohesive system can no longer be taken for granted. In developing such concepts as value transformations, intertextual arenas, and semantic differentiation, I have used primarily literary texts. I have purposely postponed dealing exclusively with film until this point because popular films, especially Hollywood genre films, have had, for at least twenty years, the reputation of being the strongest advocates and exemplars of a centralized, homogeneous culture. According to film theory since the late 1960s, the enormous, widespread popularity of these films and their origins within an industry have made them the purest manifestations of how the American public has been led to think about itself by a highly sophisticated capitalist system. Popular film is allegedly the dominant or hegemonic ideology writ in celluloid. Nowhere has the failure to recognize the competition between narrative discourses for an ever-shifting audience been more apparent, nowhere have the ramifications of a monolithic conception of the State and its cultural production been so damaging.

The first attempts at developing a rigorous mode of ideological analysis for popular film emerged in the late sixties and early seventies. Jean-Luc Comolli and Jean Narboni, in their seminal essay "Cinema, Ideology, Criticism"[1] stated unequivocally that the need to explore the ideological features of both film and the criticism devoted to it was part of a broader investigation into the production, circulation, and consumption of commodities within capitalist societies. The pioneering work that appeared in *Cahiers du cinéma*, *Cinéthique*,

and *Screen* sought to expose the ideological nature of those aspects of the film that had hitherto been considered neutral or mere technological facts; the form and function of the cinematic apparatus, for example, were determined in fundamental ways by the bourgeois cultures which produced them. The significance of this work can hardly be overestimated, since it brought to film study an elaborate theoretical framework for understanding the relationship between texts and culture. But while "Cinema, Ideology, Criticism" must be credited for inaugurating a more profound mode of ideological analysis, it also represents the limitations of this approach, specifically in regard to the monolithic notions of mass culture it perpetuated. Comolli and Narboni categorize films in relation to their transmission or contradiction of the dominant ideology, thereby conceiving of film production in the most narrowly Althusserian sense. "Because every film is part of the economic system it is also part of the ideological system, for cinema and art are branches of ideology. None can escape; somewhere, like pieces in a jigsaw puzzle all have their allotted place" (p. 24).

Over the course of the past decade, a different vision of mass culture has begun to develop in which the production and especially the consumption of mass cultural texts are considered far more complicated affairs than Comolli and Narboni imagined. I have already discussed some representative examples of this approach—Linda Williams's analysis of *Stella Dallas*,[2] Robin Wood's examination of the horror film,[3] etc.—so I will not re-elaborate its very substantial merits here. While much of this work rejects a rigid Althusserianism, the Gramscian notion of hegemony that often replaces it acknowledges discursive differences, but still tends to equivocate about whether these differences alter the "ideological core" or the "central formation" (i.e. the dominant still sets limits and frames the terms of conflicts). Horace Newcomb, in his critique of the "hegemony school" makes the crucial point that "Hegemony theory in most mass media analyses then gestures toward the complexities of textual and social processes, but expands at will to explain complexity in conventional terms of dominance. Challenge and change are already accounted for with predefined concepts of accommodation and co-optation."[4] If the dominant is an ever-expanding net that somehow contains all cultural production—no matter how internally conflicted—the integrity of that which is culturally dominant and just what and how it dominates, all become decidedly problematic.

The limitations of this notion of the dominant as containment become most obvious in reference to the frequently invoked distinction among dominant, oppositional, and alternative—largely because of the very fluidity of those positions within different discursive formations. Raymond Williams tried to account for the existence of these alternative and oppositional practices alongside the dominant culture by insisting on their general economic insignificance within the society as a whole.[5] In the Soviet Union, he claims,

literature is considered an "important activity" by the State, which is therefore less tolerant of departures from dominant practice than a capitalist state would be. To the latter, literature is a relatively unthreatening activity. This difference is due to the fact that "in capitalist practice if the thing is not making a profit, or if it is not being widely circulated, then it can for some time be overlooked, at least while it remains alternative. When it becomes oppositional in an explicit way, it does of course get approached or attacked" (p. 43).

A lack of profit or circulation is hardly the case with the film industry, particularly since so many box-office successes construct "the State" in decidedly negative terms. One might object that the horror films Robin Wood holds up as "progressive" were made outside or at the fringes of Hollywood as an industry and therefore should be considered unthreatening outsiders. But this objection fails to explain not only the wide circulation and considerable profits of *The Texas Chainsaw Massacre*, but also, and even more importantly, how the director, Tobe Hooper, could have made the transition to working within the industry so easily. Hooper was contracted to direct *Poltergeist* (1982) by Steven Spielberg, a man synonymous with mainstream Hollywood filmmaking, yet the film is a thoroughgoing indictment of American go-go capitalism gone berserk, to the point where the dead actually destroy the development community that has been built over their graves. Moreover, Hooper directed a sequel to *The Texas Chainsaw Massacre* (1986) with no change in his industry status.

The lack of hard and fast differences between dominant, oppositional, and alternative practices suggests that we need to reconsider the basis of such distinctions if we are to come to terms with the complexity of cultural production in decentered cultures. Listing oppositional films *ad infinitum* is not the solution because it continues to posit the dominant as a given to be opposed, not moving beyond the confines of Comolli and Narboni's classifications. Simply increasing the percentage of oppositional films is only half the battle. To account for the heterogeneity of cultural production that exceeds binary us-them oppositions we need to develop the "alternative" category that Williams mentions—since so many very popular films present themselves as "alternative" within the de-centered field of competing discourses.

Chariots of Fire: Alternative Ideologies as Transcendent Values

Perhaps the most efficient way to explore the possibilities of this alternative category is to look first at one very popular film that might normally be

thought part of the "dominant," to the extent that the Academy of Motion Picture Arts and Sciences voted it Best Picture in 1981: Hugh Hudson's *Chariots of Fire*. The title music has been so thoroughly installed in the repertoire of popular music that it is now used as wedding music, background music for advertisements, etc. The film was also credited with inaugurating a trend toward the "British look" in men's fashion. The two main stars of the film, Ian Charleston and Ben Cross, were paid record sums to model a line of suits that epitomized "that *Chariots of Fire* look." The 1983 New York Times Fashion Forecast featured several pages of young men not only dressed in clothes strikingly similar to those in the film, but also engaged in a variety of sports on what were clearly supposed to resemble the playing fields of Oxford or Cambridge. *Chariots of Fire*, then, seems thoroughly ensconced in the "dominant culture," since it has been thoroughly incorporated into that culture's music, fashion, and award systems. Yet at the same time this film very self-consciously positions itself as an "alternative" to its own imagined "dominant culture."

On one level *Chariots of Fire* may be seen as a reflection of British society in the late seventies. While the film concerns the events leading up to the 1920 Olympics, the frame which surrounds these events is contemporary England. The opening narration establishes a definite source for the presentation of these historical events—a voice from out of the past that lives on in the present, but can only eulogize the dead. Lord Lindsay's statement, "Let us now praise famous men and our fathers that begat us," is followed by a dissolve from present to past that immediately establishes the dialogic relationship between the two periods. The statement epitomizes the glorification of the past and the sense of loss that pervades the present, particularly in the return to the frame at the film's conclusion.

This predominantly nostalgic perspective is responsible for the unabashed nationalism of the film. We are presented with an idyllic vision of life at Cambridge, complete with hallowed halls and Gilbert and Sullivan songs. The essentially English quality of Gilbert and Sullivan material is taken to its zenith in the song "He is an Englishman" that accompanies Abrahams's training scenes and concludes with Abrahams actually singing it on stage. But the nostalgic perspective is not limited to the mere evocation of the essence of English culture, since it also involves a decidedly anti-American dimension. When the reporters question the head of the English team, they repeatedly oppose the British to the Americans, supposedly the superpower of sports. The opposition of British to American becomes particularly dramatic in the two-shot late in the film in which Abrahams, the English sprinter, and Paddock, his American counterpart competitor, enter the stadium abreast of one another. Epitomizing the differences between the two teams, the Englishman is quietly determined, dressed as simply as possible, while the American acknowledges the cheers, clearly wallowing in the role of the star,

complete with sunglasses, sweater tied around the neck, and grandiose waves to the crowd. This opposition within the 1920 games obviously has far greater significance in relation to the time of the 1970s frame. The overwhelming nostalgia is for a time when England was not the "weak sister" of the United States, when it could still triumph over the superpower at its own game.

Such a reading might explain the film's popularity in England, but it hardly explains its immense popularity with the American public. Simply recalling past national glory cannot account for the film's international success, particularly in the United States, the nation that suffers so badly in comparison with Britain throughout the film. Other ideological mechanisms are at play in the film that complicate its status as a mere endorsement of a British "dominant culture." The first of these ideologies given transcendent value by the text is religion, which is consistently opposed to purely national interests throughout the film. Abrahams runs not for England or Cambridge, but for his Jewishness, his excellence functioning as a weapon against anti-Semitism. In his confrontation with the Cambridge dons he angrily rejects what he calls the "values of the British prep-school playground" in favor of his own private code. While Eric Liddell may be different in his choice of faith, his priorities are exactly the same as Abrahams's. He refuses to run on the Sabbath, despite the protests of the Olympic committee in a confrontation remarkably similar to that of Abrahams's with the dons. One of the committee members praises Liddell's decision, conceding to another that the Scottish runner had them beaten:

> "The lad, as you call him, is a true man of principle and a true athlete. His speed is a mere extension of his life, his force. We sought to sever his running from himself."
> "For his country's sake, yes."
> "No sake is worth that Effie, least of all a guilty national pride."

The film's endorsement of Liddell's position is perhaps most evident during his outdoor sermon in the rain. He begins to preach in a steady downpour, but by the time he finishes transmitting the word of the Lord the rain has suddenly stopped and the sun breaks forth to bathe the assembled multitude in light from above.

Obviously, any text can promote the values of a given nation or faith, but another ideology at play in *Chariots of Fire* is responsible for generating value for itself and as a specific type of discourse. The film labors to create a set of values that transcend both nationalism and religion, and in the process establishing its essential difference as a particular form of discourse. For *Chariots of Fire*, the ultimate transcendent value is sport itself. Throughout the film, the act of running is given a kind of spirituality that overcomes differences in nationality or faith. While Liddell may put religion before sport,

the film reverses the priorities because the common denominator that links the heroes of the film is not religion, but devotion to their sport.

The famous opening and closing scenes of the runners on the beach epitomize this valorization of sport, and by extension, the sport film itself. We are shown individual runners in medium close-up, but the majority of these scenes are shot in long and medium long shot. In the distance, the runners are without any distinguishing characteristics in their pure white uniforms. The whiteness and their location are suggestive of two things. First, they resemble a flock of birds, a metaphor accentuated by white gulls flying before them as they run. Their running seems utterly natural, since they appear in such perfect harmony with their surroundings. Second, the stark whiteness suggests a certain angelic quality, as if in their purity they run, rather than walk, on water. These long shots, coupled with the elegiac theme music gives a decidedly spiritual overall effect. The placement of these shots at the very beginning and end of the film accentuates this, since they exist outside of the present-day frame in the church. All of these events in the past are bounded on either side by the framing eulogy in the present, but the shots on the beach seem to exist outside of time, neither past nor present, but in some sort of mythical time where their running has gained an eternal status that transcends human history.

The running sequences are consistently privileged throughout the film through the use of specific visual and sound cues. The film is quite traditional in its mise-en-scène, editing, and use of sound, except during the racing sequences, which are radically set apart from the rest of the text. The races are repeatedly shot in slow motion, and the sound track shifts from naturalistic to extreme isolation and amplification of heart beats, grunts, etc. These scenes begin in long shot, but quickly move to extreme close-up, so that facial features are treated to the same sort of isolation and amplification. Just as the opening and closing beach shots are outside the course of time, the races also seem outside everyday reality. They become not moments of simple excitement, but of apotheosis in which the runner succeeds or fails as a human being. This sanctification of running is further intensified by Eric Liddell's voice laid over the shots of the trial heats at the Olympics. His voice is part of the sermon he is delivering at a church across town in which he conflates the language of sport and the language of faith, yet his words, when detached from that locale and placed within the stadium serve to emphasize the religiosity of sport.

Films—like *Chariots of Fire*—that formulate alternative positions such as these undermine a unitary notion of "dominant culture" more explicitly than do oppositional films. They do not oppose a "dominant," but instead suggest a transcendent set of values which, in effect, denies the validity of the specific "dominant" they construct, thereby rendering it a non-system rather than a corrupt system. *Chariots of Fire* is not unique in its foregrounding of the

conflict among various ideologies. National, professional, ethnic, religious, artistic ideologies cross-cut fictional texts in every media, and conflicts are closer to being the rule than the exception (Bakhtin's notion of heteroglossia is based precisely on such conflicts). What is significant about *Chariots of Fire* (and makes it representative of Post-Modern textuality) is its orchestration of these ideologies, the subordination of national and religious ideologies to the discursive ideology that is made to appear primary. Precisely such a lack of pan-cultural orchestration allows discourses to rewrite the history of a given social formation according to the paradigms of that discourse.

The multiplication of "alternative" ideologies, each envisioning the dominant in significantly different ways, forces the basic question: alternative to what, if everything is presented as an alternative to "x"—even those texts we might consider the very essence of "x"? The alternative or oppositional status a given discourse may claim for itself is obviously open to debate, and many such claims will be judged specious or bogus by cultural critics everywhere. Nevertheless, the impact of this decentering process is not adequately accounted for by recent film study in regard to genre theory or enunciation/spectator relations—largely because both presuppose the orchestration of all textual production according to one master system.

New Genre Theory: Six Guns and Homogeneity

The inability of film theory to account for the ideological complexity within popular cinema is especially apparent in genre study. Even in some of the more recent innovative approaches to narrative film one finds a host of presuppositions which perpetuate the notion of a centralized dominant culture. The recent studies of Will Wright[6] and Stephen Neale[7] have been among the most influential new approaches to genre film, yet neither questions the notion of dominant culture as a given for the study of Hollywood.

Wright's appropriation of Lévi-Strauss predicates everything on a series of seemingly unproblematic assumptions—that the Western films are the myth of contemporary American society; that their structures and values are the manifestations of a mass consciousness; and that myths are means by which the different economic phases of American capitalism "legitimize" their domination of society. The difficulties involved in positing a unitary mass consciousness and one genre to express it begin to emerge in Wright's chapter on the Western during the current "corporate" phase of American capitalism, where the individual hero has been replaced by the band of professionals who are representatives of the modern corporation, the "company" as an end in

itself. According to Wright, "For the professional hero, like the business executive, the only meaningful values are professional: his life is his work" (p. 180). The new ideology of the corporation is accepted by a "depoliticized population" because "the public becomes convinced that social values are coincident with technical needs of the economic system. They are therefore willing to surrender the discussion of social goals and rely on the technocrats who purport to understand the objective functioning of the system" (p. 177).

But is this "depoliticized population" really an accurate description of American society in the sixties? A certain percentage of Americans may have accepted the "your life is your work" adage; but it was anathema to another equally significant percentage of the American public who found the new technocracy abhorrent to the point that avoiding it helped shaped the counter-cultural movement generated during the same period. A film like Dennis Hopper's *Easy Rider* (1969) is a useful example, since it so self-consciously exploits its ties with the Western, and just a self-consciously opposes itself to any kind of corporate mentality in its endorsement of a new pastoralism (i.e. "getting back to the land"). More important, a host of popular Westerns—including Sam Peckinpah's *The Wild Bunch* (1969), Sergio Leone's *A Fistful of Dollars* (1964), Robert Altman's *McCabe and Mrs. Miller* (1971), and Sergio Leone's *Once Upon a Time in the West* (1969)—do indeed present a world in which monetary values are primary, but only as part of an extensive critique of those values, as part of a revisionist view of the American West overrun by robber barons and greedy colonialists. What Wright wants to see in these films as ringing endorsement of a new corporate ideology can also, just as easily, be considered a vehement denial of these "new" values by locating their source in the American West of the late 19th century-early 20th century.

That Wright does not acknowledge the simultaneity of conflicting "revisionist" perspectives on the West is directly attributable to his insistence that myth is a form of legitimation, itself directly attributable to the problems arising when he applies a conception of myth based on primitive societies to one far more sophisticated, without making the necessary modifications. Whether Westerns may be considered myths in the first place is not the primary problem; what is at stake is whether they embody a single unitary mass consciousness. In other words, Westerns may indeed have mythical status in contemporary American society, but only if we make one essential adjustment—that several different forms of myth represent the diverse consciousnesses of a heterogeneous culture. The assertions made by Lévi-Strauss about myth were generally restricted to primitive societies where a monolithic group consciousness can be expressed through one avenue, one form of discourse. But in complex, media-sophisticated societies characterized by the presence of multiple "shamans," with elaborate institutional frame-works to define and transmit their respective myths, simple connections between popular narrative and the supposedly dominant culture become impossible.

The competition between different forms of "myth" and the accompanying ideologies they supposedly vehiculate becomes apparent if we consider the state of other genres in the same period. Wright contends, for instance, that in the most recent phase of development of American capitalism the "key image is not the individual hero," but "the specialized man who works in an elite group"—since "membership in the techno-structure is the leading image of success in industrial society, having replaced the image of the independent entrepreneur." (p. 179) But what about Don Siegel's *Dirty Harry* (1971), Roman Polanski's *Chinatown* (1974), and other detective films during the same period? In each case, the lone hero's success and, most importantly, his integrity are the products of his refusal to play by the company's rules. Jake Gittes (Jack Nicholson) in *Chinatown* is a private detective who has quit the force, and Harry Callahan (Clint Eastwood) in *Dirty Harry* is the rogue cop constantly under the threat of dismissal due to his highly "individual" behavior. Wright's claims for the Western's status as the narrative form of mass consciousness become even more dubious if one examines his description of the group dynamics of the band of professionals that epitomize the "new" corporate mentality in the fifties and sixties.

> This sequence explains how the group develops from a collection of individuals with a specific purpose to an independent and restricted social group. The heroes are thrown together by circumstance, but because of their shared respect and ability, they develop affection, humor, and warmth so that the group provides an enjoyable and rewarding life. Close friendships arise; each member of the group trusts and depends on the others in a relaxed context of joking and trust. As a result the group becomes more and more self-contained, independent of the need for other social contracts; the professional heroes provide for themselves what the classical hero lacked and sought in society. Their group becomes an independent and elite society. (p. 171)

This descripotion may fit the post-World War II Western—but it also fits "backstage musicals" from the thirties as well as the forties and fifties. In films such as Lloyd Bacon/Busby Berkeley's *42nd Street* (1933), George Stevens's *Swing Time* (1936), Vincente Minelli's *The Band Wagon* (1953), etc., remarkably similar "groups" emerge that are equally self-contained and based on a kind of professionalism that results in the creation of an equally independent and elite society. As I have argued elsewhere,[8] the musical repeatedly sets in motion a value shift whereby economic success in society is replaced by a transcendent success in entertainment, the "show" bringing together couples and/or communities of professionals in a privileged world apart from everyday reality. As long as Wright's typology of Western

structures is linked to specific phases of American capitalism, the appearance of this structure in the musicals of the thirties cannot be satisfactorily accounted for—especially since these musicals were extremely popular in the thirties and the film-going audience then was, if anything, even more solidly a cross-section of the American public.

The argument that the Western expresses any kind of homogeneous mass consciousness, particularly in the post-war period, is seriously undermined by the existence of other genres (like the detective film) during the same period that represent social relations in a remarkably *different* manner, and by other genres (like the musical) from earlier "non-corporate" periods that represent social relations in a remarkably *similar* manner. Wright is correct in arguing that myth as popular narrative is a form of legitimation, but he does not appreciate the processes of *self*-legitmation that form an essential part of the mythology they produce in response to other competing modes of representation.

More recently Stephen Neale has argued for a less monolithic notion of genre as a way of coming to terms with the diversity of Hollywood film, but a master system that coordinates all apparent differences remains firmly in place. Neale argues convincingly that different genres structure desire in differing ways, appealing to divergent groups of spectators who wish to see their own desires resolved in particular ways. He resists lumping all genres together in one master Hollywood text, opting instead to demonstrate how fetishism and scopophilia are played out in fundamentally different ways in various genres. While he makes a case for differences, he neglects to examine the motivations for these differences in anything other than a repetition and difference paradigm. According to Neale,

> Repetition and difference have firstly to be understood in their relationship to desire, pleasure and jouissance. . . . Desire is always a function of both repetition and difference. . . . The mainstream narrative is nothing if not a "text of pleasure": a text that regulates the subject's desire for pleasure, that functions, therefore, according to a precise economy of difference . . . and of repetition. (pp. 48–49)

The use of the term "mainstream narrative" here represents that final collapse of any pertinent difference among genres since they all end up, in Neale's system, as mere formal variations on a master structure, an abstract play of structural categories dependent upon the pleasure of the Imagined Spectators as it is regulated by that "precise economy."

Neale's argument might explain why genres put a high premium on repetition, but it doesn't explain why so many genres existed in competition with one another long before Hollywood appeared. The end result is a notion of genre which appears to be a set of shifting psychic stylistic features which

metamorphose according to the dictates of nebulous pleasure monitors that coordinate repetiion and difference across popular culture. The implicit faith in an "unseen hand" that orchestrates variations within cultural production presupposes a total absence of tensions among various forms of popular film, and in the process constructs a culture so centralized and fundamentally homogeneous that ideological divisions among popular discourses appear mere surface variation.

Neale stresses the necessity of historical context in the consideration of any film, yet this notion of a master system comes close to being virtually ahistorical; this careful orchestration of genres in which texts take shape according to the play of repetition and difference could hardly be more "formalist" in orientation. A system that is devoid of tensions among genres may describe a culture such as that Jan Mukařovský envisions[9]—where hierarchies of classes match up with hierarchies of discourses in tandem relationships—but such cultures are difficult to locate today. This vision of a master system with "regularized variation" might be convincing if applied to Renaissance poetry or Neo-Classical drama, where differences at times seem a matter of pure formal play, but it fails to account for the competition among discourses that arises when the tandem hierarchies begin to disintegrate in the 19th century.

Once the popular becomes openly defiant of High Art (as discussed in Chapters Two and Three) and the proliferation and diversification of the popular becomes an ongoing process (nowhere more obvious than in Hollywood), the orchestration of all genres according to the needs of the master system can only be a structuralist fabrication that downplays fundamental differences in pursuit of universal laws or paradigms. The master system that coordinates surface variations is founded on a *langue-parole* relationship that appears to flow in only one direction; the *langue* determines the structure of various *paroles* but the specific forms and functions of these *paroles* seemingly have no effect on that *langue.*. Yet the development of value transformations, intertextual arenas, and semantic differentation, one which I have outlined in the previous chapters, suggests, if anything, a proliferation of *langues* defined and promoted by discursive ideologies that labor to legitimate themselves as privileged modes of representation.

Filmic Enunciation:
Two Types of Discursivity

The move away from the "dominant ideology" model to one which emphasizes a decentered power struggle among conflicting discourses and institutions has significant implications for theories of filmic enunciation and

spectator positioning, since the former model has served as a theoretical "given" for many of the subsequent assumptions that have developed over the past decade. If popular films are conceived not as one homogeneous master text, but as a field of competing discourses vying for decidedly heterogeneous audiences, then all films can hardly create or position spectators in the same way or use the same enunciative strategies in the process. A different series of presuppositions must be constructed to account for the effects of this discursive competition.

Any reconsideration of filmic enunciation and spectator positioning must begin with the work of Jean-Louis Baudry[10] and Christian Metz,[11] as their work has served as the theoretical foundation for most of the theorizing devoted to these issues. This is not to say that their work has not already come under closer critical scrutiny. David Bordwell,[12] for example, has questioned the use of "enunciation" itself in relation to film texts, and the recent work of Edward Branigan[13] and others suggests other critical paradigms for the analysis of narration in film. Nevertheless, "enunciation theory," as it was developed by Baudry and Metz, set the original terms for a comprehensive investigation of text-spectator relations and they continue to have the most profound impact on subsequent work in the field.

The chief limitation of Baudry's and Metz's theorizations of the enunciation-apparatus-spectator triad is that both are founded on a traditional Modernist vision of culture which they try to apply to Post-Modernist cultural production. They presuppose a uniform identical "mass culture" opposed by a radical alternative cinema that allegedly has yet to become institutionalized. The impact of the Adorno/Althusser line concerning the homogeneity of all mass art on spectator positioning is especially apparent in work on the filmic apparatus. Like his predecessors, Baudry posits the homogeneity of all texts and manifests the same paranoia concerning technological sophistication. As in Adorno, the technological developments of late capitalism have led only to the increasingly insidious subjugation of the individual. Baudry considers film perhaps the most insidious of all since its ultimate goal is the conflation of the eye of the camera with the eye of the spectator. Once this is accomplished the fantasmatic world of the film can be accepted as a duplicate of the real and a "false consciousness" is thoroughly instilled in the spectator.

Baudry invokes the analogy of Plato's cave to describe the manipulation of the spectator: "Projection and reflection take place in a closed space and those who remain there, whether they know it or not (but they do not), find themselves chained, captured, or captivated" (p. 44). The apparatus then is "destined to obtain a precise ideological effect, necessary to the dominant ideology." Like Adorno, for Baudry the only hope for an alternative to the domination of cultural production and enslavement of individuals lies in the radical avant-garde, specifically in those texts which foreground the apparatus, thereby precluding the conflation of the camera and spectator and the

successful fantasmatization of the real based on the invisibility of the apparatus.

This belief in the transparency of the apparatus also serves as the foundation of Metz's conception of text-spectator relations that has been so influential over the past decade. While Metz's chosen metaphor for the film-viewing situation is a voyeuristic dream state rather than Plato's prisoners in the cave, he too minimizes all signs that would serve as an acknowledgment of the relationship between text and spectator. By coupling Emile Benveniste's distinction between *histoire* (where the marks of a direct communication between sender-receiver are effaced) and *discours* (where the I-You relationship is visible in the open I-You address) with Freud's distinction between voyeurism and exhibitionism, he attempts to provide meta-psychological justification for the complete absence of enunciative marks in the film language.[14] The "defining quality" of the "traditional film" for Metz is "that it effaces all marks of enunciation and disguises itself as *histoire*." The lack of pronouns, verb tenses, or any other kind of shifters makes the film appear to come from out of nowhere, addressed to no one, which creates the possibility for voyeuristic pleasure. "The film is not exhibitionist. I look at, but it does not look at me looking at it. It knows what I am doing, but it does not want to know" (p. 228).

Neither Baudry nor Metz allows for other types of indicators of the sender-receiver relation, because the manipulation of the spectator is dependent upon their absence. Since the appearance of these seminal essays, a number of positions have been taken that have either tried to refine further the cave/dream state model (as in Raymond Bellour's work on hypnosis[15] or Laura Mulvey's writings on visual pleasure and sexual difference[16]); question its theoretical basis by rejecting the purely *historique* character of the film text; or question the monolithic nature of such a model by exploring the variable sources of pleasure spectators enjoy while watching a film, depending upon gender, class, etc. In his important analysis of Carl Dreyer's *Vampyr* (1932), Mark Nash attempts to construct an alternative notion of enunciation for film in which the pronoun as such is replaced by the "pronoun function."[17] He argues that "the system of linguistic signifiers has been replaced by a system of filmic signifiers spread over a number of cinematic codes. The pronouns of the literary systems are transposed into . . . filmic shifters, manifested in the punctuation and the angle of shots, that is, in the codes of multiplicity, motion and mechanical duplication" (p. 38). While his analysis of Dreyer's film is persuasive, it is concerned almost solely with the "point-of-view" structure. He makes a very strong case for the highly discursive quality of many features of the film language, yet that notion of discursivity depends entirely upon its manifestations in verbal language.

More recently, François Jost has argued for the existence of filmic marks of enunciation, but insists that at the level of the film language itself no specific features will be consistently marked or unmarked. Semiologically it is not

possible to define a priori marks of enunciation as linguistics does for *la langue.*[18] A semiotic mode of analysis is insufficient for Jost, since the discursive is always a matter of specific historical and textual contexts: "One can only define the enunciative usage of signs and not really the enunciative signs in themselves. . . . Everything depends on the contextual insertion" (p. 127). Jost maintains that the search for enunciative marks should be conducted at the level of narration within specific texts, and invokes concepts like "focalization" from Genette's *Figures III* as a way to proceed. Jost's arguments for a context-sensitive notion of enunciation are compelling, but he does not consider why, within those specific contexts, certain texts would want—let alone need—to foreground any indicators of the discursive relationship between the text and its spectators.

The various revisions of the Metz-Baudry approach have located distinctive indicators of discursivity at the level of filmic language or within the context of a specific narrational structure. But the range of indicators has remained quite limited, since the fundamental presuppositions concerning the cave/dream state models have remained for the most part unchallenged. Instances of a discursive relationship between text-spectator are still considered isolated moments, exceptions to the rule. The rather limited set of features used in demonstrating the possibilities of filmic discursivity is nowhere more obvious than in my own article on the Fred Astaire-Ginger Rogers films of the thirties.[19] There I argued for the musical's foregrounding of a discursive relationship with its spectators and contended that this was the basis of its generic difference, its distinctiveness from other Hollywood genres. I located this discursivity in a very conservative manner, using pronouns within the songs and direct *regard* to the camera as their visual equivalents. While I tried to show the complex variations of the I-You relation and examine their diverse functions, the indicators remained a limited set of variables thoroughly delimited by "person" and its visual analogues.

In doing similar analyses on hard-boiled novels that are often used as examples of *historique* narration in its purest form, I began to question the sufficiency of these categories. A line like "He stuck a pill in his kisser and lit it with a Ronson" is indeed perfectly *historique* since the third person and past tense are used, but does it really efface the signs of a sender and a receiver? Does it really appear to have come from nowhere addressed to no one in particular? The answer is yes and no: yes, insofar as it avoids explicit I-You pronouns, but no insofar as it represents a clear-cut attempt to foreground its difference from everyday speech. The use of "pill" instead of cigarette, and "kisser" instead of mouth indicates the semantic closure discussed in the previous chapter. The line contains definite indicators of a specific source for the image as well as a particular type of reader—specifically, one who understands the substitutions and the overall semantic field which produced them. The sentence indicates not only its allegiance to a very specific type of

discourse, but also presupposes the reader's familiarity with it. There are none of the "asides" to the reader that the narrator of a 19th-century novel like *Les Mystères de Paris* would provide, explaining to the uninitiated just what the novel's "exotic" slang terms mean. Instead, the sentence presupposes that the reader is part of the same language community or would like to be. It obviously could have been written straightforwardly, just as "loose that shootin' iron, greenhorn" could have been written "I say, drop that revolver, newcomer to the West." But both the "pill and kisser" and "shootin' iron" statements lose their force if they lose their semantic specificity. Both cases indicate a desire to foreground their differences as discourses and to mark their semantic closure in a self-conscious manner.

But are these semantic markers necessarily marks of enunciation or indicators of discursivity? The answer is negative only if we use the most narrow, fundamentally misleading definition. Gérard Genette, for instance, has insisted that "the slightest general observation, the slightest adjective that is a little more than descriptive, the most discrete comparison, the most modest perhaps the most inoffensive of logical articulations all indicate discursivity."[20] Using this notion of discursivity, the semantic markers discussed above are most definitely indicators of a highly discursive relationship between text and reader. Discursivity is not a matter of linguistic categories like pronouns, or other shifters, but of essentializing particular signifiers within otherwise "neutral" categories like nouns and adjectives, or verbs rather than merely certain tenses of verbs.

With the Astaire-Rogers films, then, the marks of enunciation are not limited to dance numbers and song lyrics. The opening shot of Mark Sandrich's *Top Hat* (1935) that inaugurates the credit sequence serves as a useful example in developing this "expanded" discursivity. The first shot is a medium long shot of a row of men's legs shown from the knees down, arranged from left to right across the back of the screen. They are clearly in formal wear, further accentuated by the sudden appearance of their canes falling symmetrically across the image left to right. From offscreen left, another pair of male legs enters in the foreground, does a few flashy steps, and is then joined by yet another pair of legs, this time female, dancing in from screen right. These legs link up, begin to spin, and, in the process of spinning, the woman's skirt dissolves into a giant top hat with the title superimposed.

This shot is a perfect example of the essentializing of the key signifiers that immediately marks the film's difference and simultaneous closure of its semantic field. The shot purposely eliminates everything but the feet, canes and dance floor. At this point, the credits have become redundant. We as spectators supposedly know just whose feet they are. Here the essentializing of distinctive signifiers is taken to such extremes that the image is virtually incomprehensible outside its own semantic field. Questions concerning why

feet as an introduction, why these feet, whose feet are they, etc., are considered already answered by the film, since it presupposes a thorough familiarity with previous Astaire-Rogers films. Like the "He stuck a pill in his kisser" example, the shot includes no signs of explicit discursivity in the strictest sense, yet it includes several indicators of a specific source for the image and for a very particular type of spectator. While the *discursif* effect may be minimal, the "discursiveness" (i.e. the effect of the sequence's belonging to a specific discourse) is maximal. These two related but distinct notions of discursivity are crucial to understanding how the text's spectators are shaped by the text-to-text relations, how the positioning of the spectator and the positioning of the text in relation to the field of competing discourses are simultaneous in interdependent processes.

In order to elucidate the differences between these two types of discursivity and at the same time demonstrate their interconnections I will compare the opening shots of two wartime films—*The Uninvited* (Lewis Allen, 1944) and *This Gun for Hire* (Frank Tuttle, 1942). I have once again limited my examples to Gothic and detective texts to demonstrate how similar types of "mystery" discourse establish their distinctive differences in divergent ways. To emphasize the concentration and complexity of their semantic closure, my analysis will focus on only the first three shots (after the credit sequence) of each film.

The opening shot of *The Uninvited* is a long, slow track across cliffs overlooking the roaring surf below. There are no characters present, but the voice of Ray Milland (who plays Rick in the film) begins a long description of these "haunted shores" and how they affect anyone who lives there long enough. This appears to be a point-of-view shot since the angle and pace of the track seem to simulate someone walking along the cliff as he speaks, looking down at the shores he is discussing in the voice-over. This opening track dissolves to another establishing, extreme long shot of a couple climbing up the side of the cliff in the distance in an effort to reach the house above them; we then dissolve to a somewhat closer shot (still long) that allows for more precise identification of the couple as they reach the crest of the hill. The voice-over continues throughout all three shots, as does the non-diegetic music of the "eerie" violins variety, and both end when the dialogue begins in the fourth shot.

This series of shots is "discursive" in two related, but fundamentally distinct ways. In the classical Benvenistean sense of the term, the voice-over could hardly be more discursive. The voice outside the fiction speaks directly to the audience in a manner not unlike the opening of Max Ophuls's *Le Plaisir* (1952). Not only is "I" repeated, but so are the "you's": "*You* see day and night," "If *you* listen . . . *your* senses are sharpened. *You* come by strange instincts. *You* get to recognize the peculiar cold." Additionally, several aspects of this series can be considered filmic equivalents of marks of enunciation, as

Nash and others have rightfully argued. The use of the voice-over itself, the non-diegetic music, the lap dissolves, and the point-of-view shot are rather clear-cut indicators of a definite source for the text, which thus does not come out of nowhere, directed toward no one. In each case the text opts for a discursive mode, the non-diegetic music replaces the natural sound of the surf, the voice narrates from without instead of talking from within. (This is made explicitly clear in the transition from the first shot to the succeeding ones, where the apparent point-of-view shot gives way to that same voice—Milland's—laid over images of Milland walking up the hill.)

But an analysis of these visual and verbal marks of enunciation only describes one level of discursivity at work in these shots, a level constituted by indicators or signifiers of an I-You relationship located at the "universal" level of the film and verbal language(s) themselves. Another level of signifiers exists which is just as important in shaping the text-spectator relations. From the start, a proliferation of signifiers emphasizes not just discursivity, but "discursiveness"; in other words, the text belongs to a very specific discourse whose distinctiveness and superiority will be consistently foregrounded. In these first three shots the text may open itself to the spectator, but at the same time closes itself off from competing discourses through a process of semantic closure. All the standard, accumulated features of Gothic discourse are essentialized in these shots—the opening first-person frame that explains how the outsider (diegetic representative of the spectator) has come to his mysterious world; the mysterious and threatening landscape; the isolated house on the hill; and the overall mood of imminent disaster. These features mark discursiveness; Milland's voice-over takes the process even further by arguing for the text's privileged status as a discourse. The "eerie stories" are considered natural manifestations of this particular spot, gathering as mists on the moor or fog on the sea. To be ignorant of "eerie stories" is to be somehow outside the realm of truth; to be unaware of them is to be woefully unprepared for understanding how the world works. According to Milland, to listen is the key to a higher form of consciousness: "There's life and death in that restless sound, and eternity too. If you listen to it long enough all your senses are sharpened." He insists that this place is not unique in having ghosts, but "it's just that people who live hereabouts are strangely aware of them," stressing the fact that they "had the disadvantage to be outsiders—my sister Pamela and I knew nothing about such matters—not then we didn't." Milland speaks from within the world of eerie stories at this point, after he has been properly initiated, and his understanding of them has given him the higher consciousness he initially lacked when he was skeptical about such stories. Now that he is inside the discourse of eerie stories he can tell all that he didn't know before when he was outside, like the spectator at the beginning of the film.

The first three shots of *This Gun for Hire* provide a more interesting case

for the discussion of discursivity, since they have none of the I-You direct address found in *The Uninvited*. If anything, the shots which open *This Gun for Hire* could be used as an example of film at its most *historique*. In the opening shot a figure (Alan Ladd) lies in bed in a dark room. (See Figure 1) He sits up and takes something out of his briefcase. The second shot is a point-of-view shot of what he is reading, and the third shot is a medium shot of Ladd again on the bed, looking down vacantly as he prepares to leave. There is no voice-over or any human voice involved whatsoever. The music is off, but diegetic (a jazz piano in an adjacent room), and straight cuts rather than lap dissolves serve as transitions. Following the Benvenistean criteria, only the brief point-of-view shot could be considered in someway discursive; everything else is perfectly historical.

But is it really? These shots try to hide or efface a source for their emission about as much as the "He stuck a pill in his kisser" example. Both are perfectly *historique*, but also perfectly "discursive"—since they foreground their allegiance to a very particular type of discourse. In the opening shot, the overwhelming shadows obscuring Ladd's face; the low angle; the use of only natural non-human sounds (alarm clock, piano); the rooming-house decor; all make this film's source, as far as its genre is concerned, unmistakable. In the third shot, this essentializing of distinctive signifiers is taken even further when Ladd picks up his automatic pistol and chambers the first round. At this point, the semantic field of the text (in reference to surrounding discourses like those of the Western and the Musical) could hardly be more closed. Like the close-ups of only the dancing feet in *Top Hat*, the images are completely comprehensible only within the closed context they invoke.

This "discursiveness," as opposed to "discursivity" in the traditional sense, creates a different kind of rapport between texts and spectators than to pronoun and verb tenses. The latter establishes the channels for the possibility of intimacy between text and spectator, but presupposes little about the receiver other than the fact he/she will answer to "you" in the present tense. The former presupposes its spectator's familiarity with its distinctive features and his or her ability not only to recognize them immediately, but also

to take the same sort of pleasure in that recognition. "Discursiveness" necessarily involves aspects of the filmic medium not normally considered in relation to enunciation, like iconography.

While countless genre studies have been obsessed with the formal permutations of a given genre's inconographic features, none has considered what motivates their foregrounding or has investigated their function in regard to semantic differentiation. The points of contact between inconography and enunciation need to be explored because the filmic image seldom contains either element in utter isolation. Metz and Eco both insist that iconic signs are not reducible to neutral, minimal units, that the film image is already a "text." The opening shots of *This Gun For Hire* exemplify this, since the image depends upon the interaction of specific cinematic codes (lighting, minimalist mise-en-scène, low angle), as well as a host of non-specific genre codes (connotations of jazz piano music) and overall social codes (dress, hair style, etc.). Because a given image is "always already" a text based on the interplay of multiple codes, isolating one element or category of elements as determinants of text-receiver relationships is bound to be a procrustean exercise, demonstrating only the inappropriateness of verbal categories for visual images. Just as the significance of an image is not reducible to neutral units, the discursivity of the image is not reducible to specific types of units, but rather is spread across the configuration of specific and non-specific codes that make up that image. Just as the entire utterance is shaped by a multiplicity of factors in the tension-filled environments that surround it, the entire stylistic profile of the image is shaped by that same environment where different modes of image-making collide.

In neither *The Uninvited* nor *This Gun For Hire*, then, is it a matter of marks of enunciation being effaced or any film "telling me this," but rather a specific type of film foregrounding its essential differences from other rival discourses. Consequently, the audience can hardly be seen as prisoners in a cave since they are well aware of fundamentally different objects being passed in front of the light. An "Aristotelian" dimension needs to be added to Baudry's purely Platonic scenario, one which is founded on perceptible differences among images that are not shadows of a hidden real, but signifiers of their own "reality" as forms of discourses, institutionalized power relations within specific cultural contexts. The semiotic glut discussed above makes the relevance of Plato's cave to contemporary contexts problematic—not because we as spectators suddenly have access to the "real" or that we now control the fire and what passes before it—but rather because we are witness to multiple projections on the wall simultaneously, which makes the total conflation of the eye of the camera and the eye of the spectator highly improbable. The lover of the hard-boiled tradition would hardly surrender his or her consciousness willingly and take "women's films" such as *Dark Victory* or Max Ophuls's *Letter from an Unknown Woman* (1948) to be a satisfying representation of life

as they would have it imaged for them. Only as long as all popular films are exactly the same in their style of visual representation and ideology can the uniform "enslavement" of spectators occur. Once conflicting modes of representation and divergent ideological positions exist across competing aesthetic discourses, the enslavement of spectators' consciousnesses becomes pure myth, an idea in the mind of an avant-garde god.

One could object that I have overstated the case, and claim in Baudry's defense that he was only trying to locate distinctions between reactionary classical films and more liberating avant-garde films and that, after all, the above-mentioned films are more similar to one another than they are to Straub's *History Lessons* (1972). Differences between say John Ford and Jean-Marie Straub are, of course, undeniable. But in regard to making images that may be easily differentiated as conflicting modes of envisioning social life, is there a greater difference between Straub and Godard or between Ford and Hitchcock? But whether a given text is more or less avant-garde is not really the issue in deciding if the eye of the camera/eye of the spectator conflation occurs in the film-viewing situation. The key issue should be whether the film signals where it is coming from, from a source clearly outside the mind of the spectator, and therefore recognizble as an *image of the real* rather than as *the real*. Foregrounding the differences between various types of popular film is not a mere quibble, but is of primary importance; it problematizes the eye/eye conflation that is the very foundation of Baudry's theory of the apparatus and its transmission of the dominant ideology.

The shift from *person* to *source* must be accompanied by a move away from the dream state model of spectator positioning in which the presence of overt indicators of a sender or author of the image must necessarily shatter the spectator's pleasure. The recognition of a source outside the self producing the image does not mean that the spectator must bolt from the theater screaming "lies, lies, it's all a lie," any more than a literary narrator's "dear reader" remarks shatter the reader's involvement with a novel. Ever since the proliferation of popular narrative discourses in the early 19th century, these remarks have, more often than not, foregrounded discursive (in both senses of the word) narration in various ways. Popular narrative since the 19th century has seldom been frightened to admit its status as a "tale," and has generally shown few signs that the recognition of the source might preclude spectator/reader involvement. If anything, it is the definite recognition of the source—whether it be a specific author, genre, or school, etc.,—that is in large part responsible for a given text's popularity.

The "pleasure of the text," then, is all too often at its most intense when certain passages or scenes stand out as "pure Hitchcock," or "pure Chandler," where the spectator/reader is most aware of a specific source for the text. The key point here is that such a recognition does not shatter the illusions of fictionality. The spectator is simultaneously "lost" in fiction, but

also keenly aware of whose fiction it is. Once the profusion of popular narrative presents diverse, and more important, contradictory positions for potential spectators, the foregrounding and recognition of the specific sources become of primary interest.

Octave Mannoni's famous phrase, "je sais bien, mais quand meme,"[21] is particularly relevant to this seemingly divided attitude the spectator has toward specific film genres. Mannoni's formulation has been invoked countless times in film study as the foundation of the audience's fetishistic pleasure in the act of film-viewing, of the willing suspension of disbelief that is the key to the intense involvement with the filmic apparatus. Unfortunately, many of those who have appropriated his formulation have failed to emphasize that the "quand meme" is entirely dependent upon a specific discursive situation. Mannoni himself sets up the notion of "je sais bien, mais quand meme" in an introductory chapter, and then spends the rest of the book detailing its permutations in relation to different literary and dramatic texts. In other words, fetishistic belief, like a transitive verb, always takes a very direct object or class of objects. It is decidely not a matter where just anything will do, where anything may serve as that which allows the individual to bracket his or her disbelief and say "quand meme." Suggest to a leather fetishist that a nice box of kleenex will do just as well as an object of desire and he or she will find the very idea utterly ludicrous. In very much the same manner, the devoted fan of the hard-boiled genre will seldom say "quand meme" to a "woman's picture" or vice versa. The "quand meme" is thoroughly contingent upon what follows it in the phraae—since not every type of narrative will bridge the gap between belief and disbelief for every spectator. A recognizable source for the image is therefore absolutely essential for spectator involvement since the "quand meme" will simply not be a possibility in the wrong discourse. Mannoni's phrase, then, must always be completed if we are to discuss its actual generation: "Je sais bien, mais quand meme . . . c'est un film noir . . . c'est un roman de Philip K. Dick . . . etc." Discursive ideologies are the means specific discourses use to provide ample justification for a spectator or reader to formulate a "quand meme" position regarding that discourse.

Once the competition of discourses begins, the ideology of the image or image-making process becomes a far more complicated matter. Within film study, the consideration of visual ideology has for the most part been limited to Hollywood's ongoing drive to create increasingly sophisticated duplicates of "the real." The distinctions that are made here are generally between those films or practices that are "illusionist," and those that are anti-illusionist. While a great deal of fascinating analysis has been done in the pursuit of such distinctions, they can hardly account for the differences between specific types of visual discourses (which consistently foreground uniqueness as a mode of imaging or visualization), since they presuppose a fundamental uniformity in the imaging process of all but the avant-garde text.

John Tagg's essay "The Currency of the Photograph"[22] is an excellent example of this propensity for locating one dominant mode of imaging throughout a given culture. He examines the work done by photographers who worked for the Historical Section of the Farm Security Administration, a government agency set up by the New Deal and concludes that these images are "ways of seeing" that are realized within the "dominant form" of "hegemonic institutions." Tagg is able to make a strong case for the photo being a function of the State, but after all, he is dealing with a government agency. What about all the other institutions which deal in images—film, television, magazines, art galleries, etc.? The distinctive feature of contemporary "ways of seeing," one that sets today's culture apart from the Quattrocento, for example, is the conflict between various forms of image-making, each asserting its own value as a privileged mode of representation. It we are going to talk about the "currency" of the image we must recognize one crucial point: within a given culture a variety of visual "currencies" are exchanged, and no single mode of image creation serves as the "official" standard. It is as if a given country has several different forms of currency, each insisting on its own legitimacy and superiority. If we take Hollywood film in the thirties as an example, one could hardly argue that Leo McCarey's *The Awful Truth* (1937), King Vidor's *Our Daily Bread* (1934), and Busby Berkeley's *Gold Diggers of 1935* are all examples of the same "way of seeing" any more than, in American television programming of the 1980s, *Three's Company*, *Hill Street Blues*, and *Max Headroom* are all indistinguishable manifestations of a dominant mode of image-making. The dramatic differences between the "ways of seeing" encouraged by texts within the same medium—let alone differences between media—make the construction of a single dominant mode problematic to say the least. The various "ways of seeing" are indeed institutionalized, and those institutions must . certainly delimit the parameters of image-making within them, but the multiplicity of such institutions existing outside of any orchestrated system or coordinated hierarchy results only in competing modes of image-making.

Popular films as modes of imaging are fundamentally ideological, but as such they do not operate according to coordinated wholes or orchestrated either/or (dominant/oppositional) divisions. Both formulations presuppose the uniformity of cultural production as though one mass consciousness existed and all discourses represented it in more or less the same manner. But once the homogeneity of such a "mass consciousness" or "common culture" has been exploded, differentiation and competition become the core of popular cultures. Popular films fail to demonstrate any uniform mode of imaging because the centralized culture they supposedly represent has become an absent center. The resulting tensions between various types of popular films are inevitable—since those tensions reflect not just differences in style, but fundamental differences in the cultures they construct in their individual processes of imaging.

Five

Post-Modernism as Culmination: The Aesthetic Politics of Decentered Cultures

The goal of this study has been to explore the nature of popular narratives and the ideologies they promote once an "official" or "common" culture begins to fragment and various discourses begin to compete for the same or overlapping functions within the same semiotic context. Much of what I have said about the tensions between narratives, the overall lack of "cultural orchestration," and the basic decentering of culture has been ascribed specifically to Post-Modernism both as a movement and as a "condition." While I have referred to Post-Modernist texts throughout this work, here a full-scale discussion of its most distinctive characteristics is essential as a way of understanding how those characteristics are not sudden developments, but the culmination of processes that were at work even in the pre-Modernist period. The debate over Post-Modernism has been highly politicized, and a thorough examination of the key points of conflict should clarify the politics of such decentering as a style, a cultural context, and a critical approach.

In true Post-Modernist fashion this chapter will juxtapose radically opposing positions concerning the nature of Post-Modernism coming from both critics and artists of various media—Jean Louis Baudrillard, Jean-Françoise Lyotard, Fredric Jameson, Charles Jencks, Charles Moore, Manuel Puig, Hans-Jürgen Syberberg. This multi-media, multi-discourse combination is necessary for a number of reasons. First, the vast majority of theorizing done on Post-Modernism has been extremely polemical and, unfortunately, extremely narrow in its scope, thereby producing only distorted notions about what it is as an artistic movement as well as a cultural milieu. Second, the comparative approach will establish the sites of conflict in the debate on Post-Modernism and evaluate many of the charges made against it: specifically that it annihilates artistic "difference," demolishes narrative, abolishes subjectivity, and just plain denies "history." Third, the multi-media approach has become necessary if for no other reason than that so many of

the artworks in question are explicitly or implicitly a reaction to the interpenetration of various modes of encoding and decoding used by and for different media. Fourth, the analysis of textual practices in tandem with critical theory is virtually unavoidable because the distinctions between primary and secondary texts have become increasingly difficult to make since the former has very often made the latter a constitutive element of the text itself. Lastly, any thorough discussion of Post-Modernism must examine the diversity of styles and positions taken by different discourses because one of its chief defining factors is that it is a context without a *Zeitgeist*, and therefore the conflicts and gaps between these discourses are a central part of that which differentiates that context from preceding ones.

While critical opinion on Post-Modernism may be sharply divided, the elaborate attacks and defenses have one common denominator—the establishment of a dialogic relationship between Modernism and Post-Modernism, in which one must be the clear force of artistic and cultural good, and the other must threaten the future of civilization. The resulting distinctions between the two movements/moments have tended toward the hyperbolic. Nevertheless, most of them remain valuable, since the only real "mistaken" opinion in this debate is one that fails to recognize that the substantial stylistic and ideological differences between the two reflect radical differences in the cultures they envision. As Andreas Huyssen has said, "Postmodernism at its deepest level represents not just another crisis within the perpetual cycle of boom and bust, exhaustion and renewal, which has characterized the trajectory of modernist culture. It rather represents a new type of crisis *of* that modernist culture itself."[1]

Dominant for Whom? The Last Train to *Zeitgeist*

Perhaps the best way to begin a discussion of Post-Modernism is to consider how it has already been "historicized," since the problems implicit in such attempts reveal the complexity of the contemporary situation and its resistance to traditional modes of historiography. The vast majority of histories of cultural production have concentrated on the evolution of "dominant" styles; Stefano Tani's study of the Post-Modernist detective novel is a perfect case in point.[2] Tani contends that the history of detective fiction is the shifting of "dominants" in dialectical fashion. The British (White Glove) detective novel was dominant until replaced by the American hard-boiled, which was dominant until replaced by the Post-Modernist detective novel. He invokes Yuri Tynjanov's stages of literary change as the theoretical foundation for this evolution—i.e. the "automatized constructive principle" is replaced by the

"opposite constructive principle," which then becomes "automatized" and so on. The emphasis on the changing "dominant" may well provide an explanation for the evolution of certain genres, but it does so only by minimizing their heterogeneity at any given point.

According to Tani, now that the Post-Modernist detective novels have become the new dominant, earlier forms such as the White Glove and hard-boiled have faded into oblivion. Quite the opposite is actually the case. How does this evolving dominant mode of literary history account for not only the very active continuation of both traditions by very popular contemporary authors (e.g. Martha Grimes, P. D. James, Robert Parker, Elmore Leonard), but also the continued popularity of Sayers, Hammett, and company through regular re-editions and new adaptations of these novels on radio, television, film, etc.? The persistence and continuation of earlier forms of detective fiction now supposedly non-dominant (and therefore dead or dying) can be seen in the popularity of their reactivations, e.g. Nicholas Meyer's *The Seven-Per-Cent-Solution* (1974), Julian Symons' *The Black Heath Poisonings* (1978) and *Three Pipe Problem* (1975). This last text in particular epitomizes the spirit of these reactivations. *Three Pipe Problem* focuses on an actor portraying Sherlock Holmes on a TV series who, because of his ability to bring Holmesian standards to the present, eventually solves an actual murder in modern London—"in character," as it were. His popularity, and the popularity of all such recreations of Holmes or Marlowe or Spade, suggests that these earlier supposedly non-dominant forms continue to fulfill a function for the modern reading publics.

That so many texts from so many different stages in the history of detective fiction continue to enjoy simultaneous popularity, especially over the last decade, suggests the insufficiency of the alternating dominant model to describe the Post-Modernist situation. The Tani/Tynjanov model is essentially evaluative; it may describe the radically new or avant-garde of a given period, but not indicate what is actually "dominant" either in regard to production or consumption. This is particularly obvious when Tani suggests that Post-Modernism is the new "dominant" in detective fiction. Dominant for whom?

What differentiates Post-Modernism from earlier periods is that while a specific style may be identifiable, its circulation and popularity do not define what is distinctive about the period. In other words, there is indeed a Post-Modernist textual *practice* in literature, film, architecture, etc., but what distinguishes the Post-Modernist *context* is the simultaneous presence of that style along with Modernist, pre-Modernist, and non-Modernist styles—all enjoying significant degrees of popularity with different audiences and institutions within a specific culture. While this co-presence of competing styles could be found in the Modernist period as well, Post-Modernism departs from its predecessors in that as a textual practice it actually

incorporates the heterogeneity of those conflicting styles, rather than simply asserting itself as the newest radical alternative seeking to render all conflicting modes of representation obsolete. As a style, then, Post-Modernism can become "dominant" only in localized situations; Post-Modernism's recognition that culture has become a multiplicity of competing signs necessarily prevents it from asserting total stylistic "dominance"—to do so would violate one of the constitutive principles of the movement. *Diva* may be a Post-Modernist text, but the truly Post-Modernist context is one in which Beineix's film plays on Cinemax, while *Murder, She Wrote* and *Mickey Spillane's Mike Hammer* runs on opposite network channels.

The presence of tensions between conflicting types of representations, a presence that one finds incorporated in Post-Modernist texts and thoroughly ingrained in the Post-Modernist context problematizes the Tani/Tynjanov approach—as well as all other histories that seek to minimize heterogeneity in pursuit of a dominant style, collective spirit, or any other such unitary conception. The common denominator of all such histories, from Oswald Spengler's *The Decline of the West* to Will Wright's *Six Guns in Society*, has been the privileging of homogeneous structures that allow historians to draw rather neat generalizations that support far more grandiose claims about a culture "as a whole." Emphasis has been placed repeatedly on the diachronic changes between periods, movements, moods, etc., instead of on synchronic tensions within those subdivisions—which would naturally undermine any unitary formulations concerning a particular period's representation of itself in a specific time.

Traditional histories of artistic production have failed to account for its heterogeneity in decentered cultures because time and culture have been treated as if they were uniform. Siegfried Kracauer describes this problem quite succinctly: "Under the spell of the homogeneity and irreversible direction of chronological time, conventional historiography tends to focus on what is believed to be more or less a continuous large scale sequence of events and to follow the course of these units through the centuries."[3] The chief way to break this spell is to begin with a different set of priorities—specifically that most periods (particularly since the 18th century) are a "mixture of inconsistent elements," and that different art forms, discourses, etc., all have their own history as well as a societal history. Fundamental changes in the Western may run parallel to changes in American capitalism, but the musical and the crime film either run counter to such changes or demonstrate no awareness of them whatsoever. To account for these differences, histories (not only of Post-Modernism, but of any cultural production since the end of the 18th century) that have been predicated on theories of evolution, mass consciousness, or *Zeitgeist*, must be replaced by histories that emphasize synchronic tensions, the fragmentation of mass consciousness, and the possibility of more than one *Zeitgeist* per culture.

Kracauer describes the ongoing process that culminates in Post-Modernism quite effectively when he claims that "the upshot is that the period, so to speak, disintegrates before our eyes. From a meaningful spatiotemporal unit it turns into a kind of meeting place for chance encounters—something like the waiting room of a railway station" (p. 150). The waiting-room analogy can be fruitful only if further elaborated. In decentered cultures, various narrative discourses may originate within the same space, but they depart on different trains for different destinations. To make one discourse or traveler the representative of all travelers and assume they are all headed in the same direction on the same train, based on an individual itinerary, can only lead to a basic misrepresentation of that situation. At different times during the day, of course, such assumptions may be relatively safe (e.g. at five o'clock, commuters in large numbers will all be headed towards the suburbs). One can also formulate assumptions based on representative texts more safely in certain cultural circumstances than in others (e.g. during world War II, virtually every genre in Hollywood incorporated the "War Effort" in one way or another). In other words, homogeneity of artistic production is not an impossibility; in a specific situation it may be inevitable. But to presuppose homogeneity in every situation leads to fundamentally reductive and, in the long run, thoroughly misleading characterizations of that culture; this is clearly the case regarding Post-Modernism.

Difference and Belief: But Oh!
the Difference to *Them*

The notion of culture as a semiotic train station without a *Zeitgeist* has been judged unacceptable by many cultural theorists and has been cause for many vehement attacks on the "chaotic" nature of Post-Modernist cultures. Much has been made of the technological revolution's impact on production and consumption of film and television, but the changes wrought by this revolution have had little impact on the presuppositions of most cultural studies. The force of these changes has all too often been measured by models of society and cultural production developed in the 19th century. Jean Baudrillard's belief in a basic implosion of meaning in a technological age exemplifies the use of 19th-century models to account for cultural production in post-industrial, post-technological-revolution societies.[4] He insists that the constant bombardment of the individual by so many different sources of information has led to "the relentless destructuring of the *social*." Baudrillard seeks the lack of coordination of these sources as pure entropy, yet they appear so only if one's model for the State is one in which some agency somehow coordinates all cultural activity into a cohesive, centralized whole.

He contends that "information, in all its forms, instead of intensifying or even creating the 'social relationship' is, on the contrary, an entropic process, a modality of the extinction of the social" (p. 140). He confuses decentralized activity with pure entropy, as if once coordination and centralization have faded "the social" no longer exists.

But as Kenneth Roberts[5] and others have argued, the fragmentation of traditional categories of class solidarity results not in entropy, but in realignment along different, specifically 20th-century lines. Underlying all of Baudrillard's claims is a basically Adorno-like combination of nostalgia and paranoia: "Whatever its content . . . the objective of information is always to circulate meaning, to *subjugate the masses to meaning*. . . . There is a kind of reverse shamming among the masses, and in each of us, at the individual level, which corresponds to that travesty of meaning and communication in which we are *imprisoned by the system*" (p. 142). As in Adorno, one finds in Baudrillard this basic distrust of the mass media culture created by technological change, with authentic "social relationships" existing only in the Paradise Lost of the pre-technological age.

The inability of this fundamentally nostalgic position to account for a decentered, but not entropic techno-culture becomes clear in Baudrillard's belief that "the masses . . . do not choose, do not produce differences, but indifference. . . . Yet is is not meaning or the increase of meaning that produces intense pleasure. It is rather its neutralization that fascinates us" (p. 146). The masses respond to the bombardment of signs "by reducing all articulate discourse to a single irrational groundless dimension in which signs lose their meaning and subside into exhausted fascination." Yet Baudrillard offers a poor case for this indifference in the masses and their refusal to differentiate or make choices. Where is this mass indifference, this mass recognition that somehow it's all just the same difference. Does it really make no difference to a housewife whether she reads Rosemary Rodgers or Thomas Pynchon, or to a teenager whether he or she watches MTV or Mutual of Omaha's *Wild Kingdom*? Signs may be exhausted for Baudrillard, but are they for everyone?

The problem is that "the masses" for Baudrillard are always a unitary quantity—*they* think this, or *they* believe that as *one* undifferentiated body. The failure to recognize the persistence of belief in differences within the masses is most obvious in Baudrillard's misappropriation of Mannoni's "je sais bien, mais quand meme." He asserts, "One both believes it and doesn't believe it at the same time, without questioning it seriously, an attitude that may be summed up in the phrase: 'Yes, I know, but all the same'" (p. 139). For Baudrillard the phrase signifies an intellectual shrug of the shoulders, yet for Mannoni the phrase describes the basis of fetishistic belief which, if anything, means the insistence on differentiation, the denial of neutrality.[6] The basis for fetishistic pleasure is always a specific object, and, as such, totally contradicts

Baudrillard's belief that differences are no longer important. The suspension of disbelief or the leap of belief that makes the "quand meme" possible in a given individual depends upon a specific object or text of desire. Without differentiation there can be no desire.

The intensification rather than disappearance of this desire to believe in significant differences within an ever-expanding range of competing alternatives is perhaps best illustrated by recent children's films where the will to believe in "x" and not "y" is fetishized to an extreme degree. I choose children's films as an example since they appeal to what are, more than anyone else, the truest subjects of the Post-Modern culture, the most unadulterated constructs of the post-industrial, technologized society. Joe Dante's *Explorers* (1985) provides a useful example since it acknowledges the glut of cultural production Baudrillard describes, yet thoroughly refutes his notion that all meaning has imploded and all difference has faded away. The film concerns the adventures of three early adolescent boys who, after receiving instructions through dreams planted in their psyches by aliens, decide to build a spacecraft and fly into space to meet them. The aliens they meet are the perfect Post-Modernist subjects à la Baudrillard—pure "viewing screens," mere intersections of radio and television waves that are incapable of recognizing any difference whatsoever. The main room of the aliens' spacecraft consists of a series of mammoth screens all receiving transmissions of programs throughout television history—rather like a thirty-six channel cable-television box spread out on the wall simultaneously. The aliens' speech is entirely "mediated," in that the majority of their utterances are simply lines drawn directly from game shows, cartoons, rock songs, and old Hollywood films. Yet the visitors from earth insist that the aliens have misinterpreted American culture, since they have merely reproduced the glut of information without understanding the codes which differentiate them as obviously separate discourses. The aliens' speech is hysterically funny, but the humor comes from their obvious failure to understand the messages they are receiving (as the "male" alien admits himself—"I watched four episodes of *Lassie* before I figured out why the little hairy kid never spoke. He rolled over, I mean sure, he did that fine, but I didn't think he deserved a series for that").

When the explorers from earth meet the aliens, their confrontation is ludicrous—in large part because they are such thoroughly different types of subjects. The three explorers from earth represent a very different kind of Post-Modernist subject, one who has been bombarded by these same signals, but due to that very bombardment, has seized on one particular discourse and believes it to be the privileged mode of representing experience—either as it is, or as it should be. The central figure, Ben, is obsessed with Science Fiction and believes that it is the only discourse that can explain his world for him. He keeps a secret library of Science Fiction novels (despite parental objections), watches videotapes of Science Fiction classics, quotes from *Star*

Trek, etc. The privileged discourse becomes a kind of *bricolage* of his own devising, especially when the boys build and name their spaceship. The ship is constructed out of the refuse of the modern technologized world—doors from washing machines, a shell from a carnival ride, a worn-out television set, a stolen computer, etc.

The naming of the ship reflects the combination of different sources that defines *Explorers* itself as a discourse. The boy scientist, Wolfgang, suggests "The Einstein"; the intellectual-dreamer, Ben, wants "The Jules Verne"; and Darren, the thug, opts for "The Thunder Road," since he loves Bruce Springsteen. As a representative of the New Science Fiction film, *Explorers* may best be described exactly in this way—a careful combination of semi-hard science, late 19th-century fantastic adventure, and contemporary rock culture. The key point here is that the *bricolage* may be made up of disparate components, but they form a recognizably differentiated discourse that has a certain power for the explorers as well as the spectators who view the film—one which still interpellates specific subjects for specific ends. As Ben himself says, "Somebody's been calling us since the beginning. It's like we're supposed to go." They are indeed being called, and just as the aliens implant dream images within their minds, the film implants the same dream images within the minds of its spectators (a link repeatedly emphasized by the use of point-of-view shots throughout the dream sequences).

This fetishizing of belief is directly responsible for the persistence of narrative in the eighties. One of the more problematic issues in the theorizing devoted to Post-Modernism has been the alleged disappearance of narrative. In his introduction to Lyotard's book on Post-Modernism, Fredric Jameson asserts that the great "master-narratives" that societies have used to organize their collective experiences, dreams, etc., have either vanished or "gone underground," and remain as part of our "political unconscious."[7] Narrative, as a form of discourse, has become increasingly unfashionable in .Post-Structuralist thought, its explanatory power being considered artificial for history-writing, psychoanalysis, and literature. But the question that must be asked once again is for whom, other than Post-Structuralists, has narrative disappeared or lost its force?

The increased emphasis on belief and differentiation is a product of the proliferation of narrative, both in the further diversification of traditional packages and in the emergence of new narrative modes for areas that were previously "non-narrative," or only weakly narrativized. As for the former, the standard half-hour and hour formats for television narrative have been augmented by the multi-night mini-series (as well as an increasing serialization in dramatic programs), as well as the twelve to fourteen hour mega-narrative, divisible into various formats, such as Rainer Werner Fassbinder's *Berlin Alexanderplatz* (1983). In book publishing, one finds the same sort of move toward increasingly longer and more ambitious

formats—the "monster"-sized paperback novel, the multi-volume family saga series, etc. Obviously, the multi-volume, continuing saga was an established tradition by the 19th century, so this, in and of itself, is hardly a new phenomenon; but its re-emergence and ubiquity next to cash registers in supermarkets throughout the nation can hardly be seen as a sign that narrative is somehow dying or losing its force in contemporary culture.

That the opposite is indeed in effect, that the power of narrative not only has persisted, but intensified, can be seen in the narrativization of non-narrative discourses. The most striking example is, of course, rock music, especially in video form. Rock lyrics since their inception have tended to tell stories, but the ballad form (in its strictest definition) was always far more common in folk, country, and blues music. The most significant change has not been in the lyrics as such, but rather in the actual presentation of rock music; here, the performance mode of the sixties has been completely transformed into a narrative mode of the eighties. A significant percentage of rock videos have either done away with outright performance, or placed it entirely within a narrative context, so that very few videos maintain anything like a "concert" aesthetic. (There are, of course, significant exceptions— Bruce Springsteen's *Dancing in the Dark* (1985), Robert Palmer's *Addicted to Love* (1986).) Most surprising about this transition is that very often, even though narrativization appears entirely unjustified by the song lyrics, the band members "act out" those lyrics (often in period costumes and settings); videos such as these are attempting to narrativize, spatially and temporally, songs about atemporal "states of consciousness." It is difficult to imagine a quintessentially sixties band like Crosby, Stills, Nash, and Young acting out *Ohio* (1971) (even though the lyrics appear ripe for narrativizing), because the dominant mode of presentation remained the rock concert/festival, and the dominant modes of dissemination remained largely non-narrative media— radio, record album, television variety shows, etc. Now that one of the major modes of dissemination has become television, it has developed its own narrative format (the four to five minute mini-narrative) to compete with the narrative on the channels that surround it. It comes as no surprise that a recent Neil Young video *Touch the Night* (1987) is completely narrativized, with Young acting the role of a local newscaster in full make-up and costume that completely disguise his recognizable stage image.

Lyotard's notion of "micro-narratives" used as the basis of legitimation of various forms of discourse, scientific as well as non-scientific, would be especially useful were his notion of narrative legitimation not oversimplified and ahistorical.[8] In his discussion of scientific and narrative "knowledge," he claims that "narrative knowledge does not give priority to the question of its own legitimation and that it certifies itself in the pragmatics of its own transmission without having recourse to argument or proof" (p. 27). While narrative may not utilize the same type of proof as scientific discourse, the

history of narrative since the 18th century has been one in which strategies of legitimation have become increasingly sophisticated as narrative has continued to differentiate itself into multiple, often conflicting discourses. Lyotard's conception of narrative here would appear to be based on a primitive storytelling situation around the proverbial camp-fire where one storyteller told one body of tales to an exremely homogeneous audience. The ramifications of this conception of narrative (and its transmission) are especially serious, since it presupposes not only a grand uniformity to narrative, but to cultural production as a whole, excluding the *philosophe* tradition and the radical avant-garde.

The Post-Modernist condition posited by Lyotard, with its fragmentation and decentering, can only appear to be a radically new *episteme* rather than the culmination of processes at work within popular culture for the past two centuries. Lyotard asserts, like Jameson, that "grand narratives" have disappeared, but the two questions that need to be asked at this point are whether such "grand" or "master" narratives actually did exist for entire cultures once narrative and audience begin to fragment (i.e. since the disintegration of the public sphere in the 18th century), and whether the absence of the alleged "master narratives" has produced only a greater reliance on narratives insisting on their ability to explain fragmentary existence to fragmentary audiences. For Lyotard, the only hope for this "chaotic" culture is that which resists commodification—the avant-garde of the high Modernist period. Belief, differentiation, and narrative have not only survived, but intensified in contemporary cultures; but since they are supposedly commodified, they are, for Lyotard, therefore invalid.

And the Radical Avant-Garde Shall Make You Free, or "Cigarettes and Whiskey and Commodification"

One of the most frequent attacks on the chaotic nature of Post-Modernist culture has taken the form of an elaborate apology for Modernism, where an "authentic" avant-garde still existed. In the appendix to *The Post-Modern Condition*, Lyotard dismisses the eclecticism of this movement as "the degree zero of contemporary general culture," as "kitsch" that "panders" in the "absence of aesthetic criteria" (p. 76). Likewise, Jameson rejects Post-Modernism because it is "sheer heterogeneity, random difference, a co-existence of a host of distinct forces whose effectivity is undecidable."[9] This shared paranoia concerning heterogeneity and the lack of absolute aesthetic criteria reveals several of the basic limitations of both of these essays, especially their nostalgia for the Paradise Lost of the homogeneous culture,

and the Marxists'/avant/gardists' ability to stand in opposition to it, making easy, yet absolute value judgments—rather like a counter-cultural Salvation Army beating its moralistic drum about the wickedness of the dominant culture.

The cornerstone of this elaborate defense of what Jameson calls the "High Modernists" is a fascination with the then still operative category of "personal expression," which is now seemingly lost for ever. The Post-Modern world, Jameson insists, means the end of "style, in the sense of the unique and the personal, the end of the distinctive individual brushstroke which results in the collapse of the high modernist ideology of style—what is as unique and unmistakeable as your own fingerprints, as incomparable as your own body" ("Postmodernism," 1984, p. 65). The choice of terms used here to characterize this cultural crisis suggests that what Jameson considers High Modernism bears a striking resemblance to High Romanticism as it has been transformed and carried into the 20th century. The obsession with the absolute uniqueness of self and style, carried to the point where a quasi-private language (as individual as a fingerprint) becomes the ideal mode of expression, is a common thread that ties Chateaubriand's *René* (1802) to Barthes's *Fragments d'un discours amoureux* (1977). The 20th century artist must occupy the position of perpetual, enlightened outsider. Popular culture in such a scenario serves only as a vapid background against which the personal expression of the artist stands out in bold relief.

The chief crime of Post-Modernism, then, would appear to be its robbing the Modernist/Romantic of the neat binary oppositions which made their status so easily definable. Jameson claims that our contemporary society "reflects not only the absence of any great collective project, but also the unavailability of the older national language itself" ("Postmodernism," 1984, p. 65). There are two enormous problems with this assertion. First, is Jameson really bemoaning the loss of a common national language for its own sake, or rather as a monolith which allows individual oppositional values to stand out clearly against it? When Jameson moves his argument into the realm of contemporary architecture, his preference for Modernists such as Mies van der Rohe becomes explicit, but Mies's architecture (which will be discussed in greater detail below) and that of the International Style as a whole was conceived as a radical break with the impoverished "national" architecture that served as the status quo. The International Style office building was never intended to blend into the "vernacular" architecture, but rather to serve as an affront to it, a disjunctive break with its surroundings.

The second, and more fundamental problem here concerning the mythic "national language" is that it was never (as Bakhtin has argued so convincingly) the univocal, homogeneous entity that linguists and theoreticians have assumed it to be.[10] If anything, the centripetal and centrifugal forces Bakhtin describes, the intersection of various specialized discourses

and dialects could be described as a kind of radical eclecticism, the "sheer heterogeneity" that so repulses Jameson. No simple binary oppositions can exist within the "heteroglot" nature of culture, nor can any one agency decide on the "effectivity" of all cultural production in a once and for all manner for entire publics.

The attacks leveled against Post-Modernism by Jameson, Terry Eagleton[11] and their disciples call out for the same kind of symptomatic reading that Eagleton does of the Scrutiny group or the New Critics.[12] Eagleton's rejection of Post-Modernism is total, with nary a specific textual example to mar the effect. This wholesale rejection reveals the latent Romanticism not only of the High Modernists they praise, but of Marxist critics as well. This becomes most obvious in the fetishizing of alienation as a positive value in and of itself, as if somehow, Post-Modernism as a movement has ruined all the fun of being alienated. Eagleton asserts that the "depthless, styleless, dehistoricized, decathected surfaces of postmodernist culture are not meant to signify alienation, for the very concept of alienation must necessarily posit a dream of authenticity which postmodernism finds unintelligible" (1986, p. 132).

But what is really dehistoricized here? Is it Post-Modernism, or this vision of "authenticity" which floats above various cultures like some sort of representational El Dorado transcending all signification? This "authenticity" is remarkably similar to the Romantics' notion of "individual genius," in that both exist as asemiotic, sanctified categories predicated on alienation. This merging of Romanticism and Marxism becomes apparent in Eagleton's only specific example of the dreaded Post-Modernism—"Mayakovksy's poetry readings in the factory yard become Warhol's shoes and soup cans" (p. 132). The Mayakovksy image epitomizes the conflation of Romanticism and Marxism—Chateaubriand Meets the Noble Savages of the Working Jungle.

For Neo-Romantic Marxists, perhaps, the most significant and unacceptable ramification of this decentered and heteroglot culture is that within such a context any number of different aspects of popular culture must cease to operate as mere backdrops for theory and must actually assume a critical function that is normally reserved for avant-garde or radical cultural analysis. Jameson's rejection of popular culture as a vehicle for such a function is most obvious in "Reification and Utopia in Mass Culture" where he comes very close to the Frankfurt School in his characterization of these twin functions.[13] On one level, the essay might appear a rather lukewarm apology for popular culture, since he acknowledges that "even the most degraded type of mass culture remains implicitly negative and critical of the social order from which, as a product and a commodity, it springs" (p. 144). But the utopian value is there only because "they cannot manipulate unless they offer some genuine shred of content as a fantasy bribe to the public about to be so manipulated." He summarizes his position in the following manner:

> We will now suggest that anxiety and hope are two faces of the same *collective consciousness* so that the works of mass culture, even if their function lies in the legitimation of the existing order—or some worse one—cannot do their job without deflecting *in the latter's service* the deepest and most fundamental hopes and fantasies of the collectivity to which they can therefore, no matter in how distorted a fashion, be found to have given voice (p. 144, emphasis mine).

Popular movies and films, then, may have a utopian/critical dimension, but it is entirely produced and managed by the existing order. The presuppositions here reflect a rigidly monolithic society—*the* collective consciousness, *the* collectivity, which orchestrates all cultural production quite effectively—all, of course, except for the avant-garde and radical social theorists who somehow stand above this manipulation. The notion that popular culture may be heterogeneous and therefore take a critical position regarding the society which produces it simply cannot be allowed within the Culture as Grand Hotel scenario outlined in Chapter One.

Underlying this rejection of a "mass culture" is the belief that the commodification of cultural phenomena has meant their subjugation to the dominant order, and therefore their invalidation as "genuine" expressions of anything other than that of the multi-national corporations which produce them. The commodity status of both popular and Post-Modernist texts appears to be their "original sin" according to Jameson and Eagleton, that which makes them inferior works of art, somehow tainted by the filthy lucre one must pay in order to appreciate them. The foundation for this, of course, is a nostalgia for a Golden Age of "folk" culture (discussed in the first chapter). Jameson states in unequivocal terms, "The commodity production of contemporary or industrial mass culture has nothing whatsoever to do, and nothing in common, with older forms of popular or folk art" (1979, p. 134).

Only the Modernist text remains somehow admirable in this, since it utilizes various strategies to resist commodification, usually by resisting the use of codes comprehensible to its audience (which ironically suggests an extremely "privatized" rather than "folk" aesthetic—the "fingerprint" instead of the "carnival"). But the contention that commodification suddenly tainted all cultural production starting somewhere in the 19th century, and then just plain ruined it in the 20th century is fraught with a number of historical problems. The argument that art has become commodified, and therefore less aesthetically and politically pleasing than it had been before, has been made by innumerable critics from a wide variety of critical perspectives and has been located, interestingly enough, at different time periods. One could argue quite convincingly, as John Berger and others have done, that the key transition phase was the replacement of the fresco by easel-painting as the dominant mode of European painting.[14] The industrial revolution is another commonly chosen phase, as is the arrival of supposedly "late" capitalism

somewhere after World War II. The variation in the dates chosen for the Age of Commodification does not suggest that such transitions have not occurred, but instead problematizes the alleged impact—since so much of the cultural production that has been valorized by one theorist as pre-commodified has been vilified as post-commodified by another. Such discrepancies suggest that the impact of commodification is hardly as far-reaching or one-dimensional as many would have it, since its impact and temporal dimensions appear to depend more on the scenario of the historian than any kind of *episteme*-shattering moment in the evolution of material production.

One of the more perplexing developments that has occurred in theorizing the "history" of commodification has been the admiration for pre-capitalist modes of financing artistic activities, resulting in rather odd apologies for patronage rather than public support. Jameson's work once again summarizes this position quite effectively. In the pre-capitalist period

> the relationship between artist and public was still in one way or another a social institution and a concrete social and interpersonal relationship with its own validation and specificity. With the coming of the market, this institutional status of artistic consumpiton and production vanishes: art becomes one more branch of commodity production, the artist loses all social status and faces the options of becoming a *poète maudit* or a journalist. The relationship to the public is problematized and the latter becomes a virtual 'public introuvable'" (1979, pp. 136–37).

The "social status" is truly problematic here, since that status, when not dependent upon a paying public, depended entirely upon a patronage system in which the artist's status was carefully proscribed (as countless forewords in 16th- and 17th-century volumes of literature will attest), thoroughly "institutionalized" within a carefully orchestrated system. With the shift from patron to public support did indeed come a fundamental change in the relationship between artist and public—but rather than de-institutionalization, it must be understood as a de-stabilization of the entire exchange, one which changed the pre-established relationships (both in the constitution of the audience and the hierarchy of discourses [à la Mukařovský]) that had institutionalized *what* was read *by whom* for *what* reason. The public does not become *introuvable*, nor *invisible*, but *infixible* in its fragmentation into shifting reading publics consuming competing modes of narrative discourse.

Eagleton virtually makes commodification and Post-Modernism co-terminous, since the latter to his mind is merely the end result of processes begun in the former. Although critical of Modernism as a movement for a number of reasons, Eagleton praises it for at least resisting commodification, whereas Post-Modernism simply embraces it whole-heartedly—"Post-Modernist culture will dissolve its own boundaries and become co-extensive with ordinary commodified life itself" (1986, p. 141). For Eagleton, commodification has replaced the "public sphere" of the 18th century in a

bastardized form, making the product rather than the opinions of the learned community the basis for a sense of common culture.

Yet this shift from public sphere to commodified sphere is challenged by works which thematize commodification in the former period. Perhaps the best example of this is William Hogarth's "The Battle of the Pictures" (1744, see figure 2). While this print was no doubt inspired by Jonathan Swift's "The Battle of the Books" (1704), the conflict is situated in a different terrain here. Swift's battle was located entirely "within the library," as it were, and combat between the ancients and the moderns remains an idealist struggle. Hogarth's engraving also includes such conflicts, but places them within a materialist context that acknowledges in explicit detail that his own works are products as well as artistic creations. Designed as a bidder's ticket for an auction of his own paintings, the engraving represents the struggle between his own work and the invading foreign paintings, the former depicting scenes of British life, the latter all of a religious-mythological nature. The foreign paintings are assembly-line products, emphasized not only by their stockpile arrangement, but by the "Dto" (for "ditto") designation in the upper right-hand corner of each, and the auctioneer's gavel as their battle-flag. Behind them sits a building (the auction house or the House of Commerce), as poorly designed as these paintings, with "PUFS" (as in "pufted up") on its weathervane, and a

ludicrously over-framed portrait by the door. At the far right, British paintings emanate from Hogarth's own studio, and the weathervane is balanced at the opposite corner by the palette and brushes of the artist. The opposition could hardly be more clear-cut, and one could quite easily construct a reading in pure Frankfurt School fashion that would see "Commodity attacking Pure Art," or "Creativity Defeated by Mass Production."

Yet the choice of images within the engraving stresses the naivete of such a reading. The Hogarth works which are clearly identifiable within his studio all come from *The Harlot's Progress*, *The Rake's Progress*, and *Marriage à la Mode*, three series which focus explicitly on characters completely consumed and defined by their material circumstances. The painting on the easel, for example, is the second picture from *Marriage à la Mode*, in which the commodified nature of contemporary British society is emphasized by a loveless marriage of financial convenience, and the actual representation of bank notes and bills in the hand of a valet (obscured, not coincidentally, by an "attacking" European painting of Van Eyck's *The Aldobrandini Marriage*).

The conflict between the two representations of marriages—one mythological, one realist—is central because it depicts the struggle between two different styles (in perhaps the most explicit kind of intertextuality imaginable), but also the differences in the societies there depicted. Rather than set up an idealistic landscape that transcends the vulgarity of commodified art, and by extension commodified existence, Hogarth's engraving acknowledges that the commodification of art is simply part of a commodified society and that within such a context conflict becomes a fact of existence. To extrapolate Hogarth's message for today's artworld, the appropriate gesture on the part of the artist is to engage actively in such representational battles rather than attempt a utopian transcendence through mythology or Modernism.

In addition to the historical limitations of the Age of Commodification argument, a serious theoretical problem undermines the obsession with commodification as the underlying evil of all cultural production beginning sometime after the sack of Rome. The emphasis placed on commodification presupposes the uniformity of intentions and functions, as well as its subservience to one set of interests, specifically those of the ruling class. But as Paul Hirst has so persuasively argued, the interests of that class are hardly as unified as they might appear, and even more importantly, there is no necessary link between those interests and cultural production as a whole—"There is no necessary relation between the conditions of existence of the means of representation and what is produced by the action of those means, no necessity that they 'represent those conditions.' "[15] Althusser's dictum that the role of ideology is to reproduce the means of production is accurate, but only if applied at the level of the individual commodity—i.e. the goal of the detective novel is to construct specific detective subjects, thereby reproducing the demand for the production of detective fiction as a privileged

mode of organizing experience. That individual commodities altruistically work in harmony for the greater good of the system as a whole would necessitate an enormous degree of orchestration of those commodites and a strict uniformity of purpose. As commodities, they may indeed have one common goal—to be consumed—but in the attainment of that goal they may take different forms that problematize the construction of a uniform subjectivity and fail to exhibit any kind of integration or coordination of design.

In other words, commodification may not only be a fact of life as well as a fact of art in the 20th century, but its lack of orchestration, specifically within a Post-Modernist context, has so thoroughly negated its homogenizing force that it can produce only decentered subjects. We may indeed be constantly encouraged to define ourselves through commodities, but the absence of coordination in such a process results in our being asked to define ourselves in quite different ways, thereby producing anything but a uniform subjectivity.

Post-Modernism as Popular Semiotic, or "We Built This City on Rock and Roll"

What, then, is Post-Modernism's alternative to the High Romantic/High Modernist dismissal of all commodified art (especially popular culture) and to the insistence that a decentered culture can only be sheer heterogeneity without purpose? According to many of its critics, it could not possibly have an alternative because it is so thoroughly without politics, or any kind of coherent critical theory. The following passage from Jameson's attack on the movement expresses this attitude: [the] "complacent eclecticism of Post-Modern architecture which randomly and *without principle* but with gusto cannibalizes all the architectural styles of the past and combines them in over-stimulating ensembles" ("Postmodernism," 1984, p. 65, emphasis mine).

That the movement's juxtapositions are without principle will come as somewhat of a surprise to anyone familiar with the various manifestos written by Post-Modernist architects over the past two decades. Their detractors would have us believe that Post-Modern artists are glitz-loving barbarians, utterly devoid of theoretical foundation or without any grasp of what made High Modernism so "special." Yet nothing could be less accurate. Since the early sixties countless articles, conferences, and book-length treatises have appeared which have tried to establish not only a theoretical common ground among Post-Modernists, but a pragmatic agenda concerning its place within the larger context of urban planning—an issue which seldom seems to have troubled the High Modernists. Perhaps most telling, three of the most important book-length studies—Peter Blake's *Form Follows Fiasco: Why*

Modern Architecture Hasn't Worked (1974), Paolo Portoghesi's *After Modern Architecture* (1982), and Charles Jencks's *The Language of Post-Modern Architecture* (1977)—were written by figures who were formerly confirmed Modernist architects and critics. In each case, one finds the move to Post-Modernism motivated by a thoroughgoing rejection of Modernism as an aesthetic and political dead end—hardly a fad pursued by irresponsible philistines!

A brief discussion of Jencks's work becomes essential here because his position concerning the shift from Modernism to Post-Modernism represents a significant alternative to the Baudrillard-Lyotard-Jameson perspective. His analysis of this shift and his attempts to define the differences between the two movements semiotically are also extremely relevant to our understanding of film and literary texts; Jencks describes not just architectural stylistics, but larger issues concerning the context that produced that shift. Lyotard and Jameson both making passing reference to Jencks, yet both significantly omit discussion of his most devastating attacks on Modernism and the avant-garde.

Jencks makes the crucial point that while Modernism depended on the elite coding of professional architecture, Post-Modernism's primary distinguishing characteristic is that it is "double-coded";[16] it respects both the professional and popular codes simultaneously, thereby speaking a "language" that can be understood by two quite different groups through its uses of signifiers accessible to both professional and layman. Architecture is not a quasi-private artistic language, but an avowedly "public language," in which the architect is not a "savior/doctor," but a "representative and activist" (pp. 104–8). According to Jencks, the collapse of Modernist architecture as a whole was inevitable because from its inception it was a movement that demonstrated indifference—if not outright contempt—for the context and eventual inhabitants of its designs. Its emphasis on purely formal concerns led to a fetishizing of the means of production, and, as a result, to the development—under Mies van der Rohe—of a "universal grammar of steel I-beams" that was seemingly appropriate for any function (whether office building, housing complex, schools, churches, etc.) and any culture (war-ravaged Europe, thriving business centers in the United States, etc.).

The relevance of these statements to narrative and ideological theory since the late sixties is nothing short of uncanny, since "radical signifying practice" has served in many significant ways as the literary and filmic equivalent of an "International Style" in architecture, with all the accompanying limitations. In both, one finds the valorization of the means of production as an end in itself, as well as an apparent disregard for their function within a special cultural context. This led to the creation of a pseudo-pantheon, however unintentional, by the *Tel Quel/Screen/Cinéthique/Cahiers due cinéma* combines, of those writers and filmmakers whose work epitomizes "radical signifying practice" down through the ages—thereby producing a culturally transcendent radical

avant-garde that somehow manages to link Rabelais, the Marquis de Sade, Lautrémont, Godard, and Straub as proponents of the same "International Style," linked by the same "grammar" (i.e. the endless "play" of signifiers). In both its architectural and literary/filmic versions, the International Style was utopian and acontextual, a kind of second-order Esperanto that would signify "radical other" or "oppositional voice" regardless of situation. Jencks sums up the problem quite succinctly by insisting that Modernists had a rigorous theorized *univalent* style, but no theory at all of city planning (1984, p. 15). In much the same way, "Tel Quelisme" advocated, quite brilliantly, a radical mode of signification, but had only the most utopian, ill-defined notions of how this would have any far-reaching impact on the cultures which surrounded it.

The alternative to the "universal grammar" of the International Style has been the determination on the part of Post-Modernists to develop a "neo-vernacular." The use of the term "vernacular" is especially interesting here, since it clearly states a different program from that of the International Style. The latter is the "classical" language of the 20th century, the "universal" language of an intellectual elite; it is self-consciously demarcated as a special means of communication transcending the common "babble" of local ethnic cultures.

A renewed interest in the vernacular and the recognition of its political effectivity are made explicit in Fernando Solanas's Post-Modernist film *Tangos, the Exile of Gardel* (1985). The film follows the lives of several Argentinian exiles living in Paris (before the fall of the Argentinian military dictatorship) as they try to produce a "Tangody"—part comedy, part tragedy, part tango. The tango serves as the basis for their collective creation because it is that form which allows them to preserve their national identity in regard to their exiled existence within France, as well as their refusal to acknowledge the legitimacy of the sitting government in Argentina.

Solanas's emphasis on a vernacular art form like the tango marks a significant departure from his earlier documentary *The Hour of the Furnaces* (1967), which insisted that a materialist film-making style based on radical signifying practice—the filmic equivalent of the International Style—was the only way to combat colonization by North American media. By adopting the tango as a new, preferred weapon in the war for national identity, Solanas bases his film on the same kind of "double-coding" that Jencks ascribes to Post-Modern architecture. *Tango* addresses an elite audience in its use of specific codes associated with art cinema—direct address to the camera, non-linear narrative, a very fluid relationship between diegesis and actual performance, homages to other films, etc. But he also addresses a broader, more general, but specifically Argentinian audience through the use of the tango and the domestic/familial problems of his principal actors. The point here is that the vernacular form itself must be seen as political. Near the end

of the film Gerardo, the professor, is visited in his sick-bed by two figures—San Martin, the general who liberated Argentina from Spain, and Gardel, the most famous of all tango singers—both of whom died in exile in France. Within the space of Gerardo's room, the three men converse in a triangle with the professor placed directly between the two visitors. This scene functions as a synthesis of Solanas's "tangody": to be Argentinian is to become engaged with both political history and popular culture, each serving as a source of instruction for the professor in his desire to maintain his Argentinian identity. Most importantly, Solanas's use of the tango is not mere nostalgia for a lost "folk" culture; Gardel's status as a *recording* star is repeatedly foregrounded in the film. His records, like Solanas's film, represent the possibility of the vernacular within mass media, a vernacular that maintains its force and authenticity despite its commodity status.

The development of a neo-vernacular has been accompanied by increased emphasis on contextualism and participatory design. Architects like Ralph Erskine, Lucien Kroll, and Charles Moore have completely reversed the Modernist aesthetic of simply inserting the genius-architects' plans into cities without undue concern about their reception or appropriateness. When Erskine was commissioned to design the Byher housing community outside of Newcastle, he actively solicited the participation of the inhabitants in the planning of the project; he set up an office in a flower shop and made that space the local "lost and found" as a way of understanding the non-architectural codes at work within a very specific community. In much the same way, Kroll, while designing buildings at Louvain University, directly involved students by breaking them into teams responsible for developing their own design concerns as well as arriving at a group consensus.

Where the International Style building was architecture "from above," and obedient to the pre-existent principles of the universal grammar, these Post-Modernist projects were developed from within, in a purposefully ad hoc fashion calculated to meet the desires of a specific spatial and temporal context. The dynamics of such an exchange between Post-Modernist architects and the communities they design for is perfectly illustrated by the working methods of Charles Moore and the Centerbrook group. One of their most recent projects, the Cedar Rapids Art Museum, is a case in point. This project involved the development of a hybrid structure—converting an older Carnegie Library into an art museum and building an extensive addition onto that building that would coordinate stylistically with that library and the surrounding downtown area.

The design of the museum was from the earliest stages an interactive process based on the solicitation and incorporation of community opinion. A series of five workshops were conducted over the course of a week, making it not only an interactive, but additive process in which the exchange of ideas continued from one step to the next. Participants in these sessions were issued

"Workshop Books" designed to elicit as much oral and written commentary as possible. For the first sitewalk, for example, participants were to respond to specific questions about the site location, its eventual users, its relationship to the surrounding area, etc. The "Beauty Contest" conducted at the second workshop consisted of an eighty-image slide show in which the participants indicated in their workshop books first whether they liked the image, and then whether they felt it appropriate as a model for their museum. After initial designs were executed based on these responses, participants were asked to suggest further alterations so that the process continued to be interactive.

The accusation that Post-Modernist style has no social responsibility appears rather ludicrous coming from Modernists or their admirers, since this kind of social intervention by architects—this self-conscious attempt to integrate themselves into the micro-cultures they design for—was impossible within the International Style, with its semiotically impossible "universal grammar." Modernists have rejected participatory architectural design as mere gimmickry or have dismissed its premise as counter-productive to artistic excellence. While the "genuineness" of this activity can of course be questioned by its critics, the fact remains that Modernist architects disdained any such activity, preferring to maintain the purity of single-coded architectural language for a coterie of architects and critics. Participatory architecture may indeed be accused of false populism, but no one could ever accuse the International Style of false elitism. Not all Post-Modernist buildings will be founded on such participatory and integrationist principles, but the community activity Moore and his associates encourage clearly indicates a radically different orientation—beginning not from a pre-existent grammar (no matter how avant-garde), but from specific spatial and cultural contexts.

The move toward recontextualization in Post-Modernist art has necessarily been accompanied by a renewed interest in the historical traditions that preceded it. Jameson attacks this tendency rather vociferously, dismissing it as mere "cannibalization," or rejecting it entirely as a reactionary "nostalgia mode" ("Postmodernism," 1984, p. 66). His attack on Post-Modernism's use or abuse of history is especially puzzling, since, in the first place, Post-Modernism's use of past styles is not haphazard activity, but carefully executed juxtaposition for specific effect; and, in the second place, historical consciousness was hardly a defining feature of the Modernists. Paolo Portoghesi has compared the outright rejection of historical tradition (especially indigenous ones) by the Modernist movement to the myth of Lot's wife—that by turning around to see from whence they came they could only turn into a pillar of salt (as opposed to a pillar of I-beams).[17] The universal grammar of the International Style (in architecture as well as in film and literature) was founded on a temporality that denied the past and sealed off any further development in the future (a closure that its admirers have tried to insure), resulting in a perpetually transcendent "modern" nether-world.

Portoghesi summarizes this situation most effectively when he discusses the obsession with "purity" that led the Modernists to opt for a pure Euclidean geometry as the basis for their designs:

> This radical choice interrupted a continuous process based on the recycling and creative transformation of any number of prototypes which had survived in the Western world for centuries. . . . In reality the destruction of morphological continuity was a revolution of methods and ideas. The result, as we shall see, was the creation of a culture incapable of evolution and renewal . . . an iron cage, a labyrinth without exit, in which a search for the new, for the different has produced a tragic uniformity, a trail of ashes. (p. 5)

Rather than a mere expression of nostalgia, Post-Modernism may be seen as an attempt to recover the morphological continuity of specific cultures. In his film criticism, Jameson quite brilliantly exposes the counter-productive dimensions of a "retro" culture that simply resurrects past styles in films like Lawrence Kasdan's *Body Heat* (1981) or Steven Spielberg's *Raiders of the Lost Ark* (1981). The revivalism at work in these texts has indeed become a kind of industry unto itself which cross-cuts a variety of media—nowhere more obviously than in the fashion and interior design collections of Ralph Lauren that allow individuals to become metteurs-en-scène of their own existence, turning their households into movie sets, complete with the appropriate clothing and furniture to recreate the Wild West or Edwardian England. But this simple revivalism does not describe the complex "layering" of past styles found in a film like Ridley Scott's *Blade Runner* (1982).

Where the Ralph Lauren interior has one goal—to create a hermetically sealed time-capsule devoid of anachronism that might come from the present—Scott's film is founded on the simultaneous presence of multiple time frames and modes of image-making antithetical to such revivalism. Throughout *Blade Runner*, director Ridley Scott and production designers Lawrence Paull and Syd Mead explicitly visualize the successive layers of urban history by juxtaposing images drawn from William Hogarth, Edward Hopper, Frank Lloyd Wright, Moebius, and Michael Graves. The distinctiveness of *Blade Runner*'s vision of the future is this "archaeological" attitude toward the past, which exposes the layers of sedimented representations—the cityscape is simultaneously archaic, early Modern, and futuristic. In much the same way the androids become invested with the accumulated functions that the "other" has served for those cultures, appearing to be simultaneously the Fallen Angel, Wagnerian superman, exploited minority, and technology gone berserk.

The use of past styles in this case is motivated not by a simple escapism, but by a desire to understand our culture and ourselves as products of

previous codings. In her article on the semiotics of fashion, Kaja Silverman defends "retro" dressing (the wearing of vintage clothing) because

> it inserts its wearer into a complex network of cultural and historical references ... by putting quotation marks around the garments it revitalizes, it makes clear that the past is available to us only in a textual form, and through the mediation of the present. ... It is thus a highly visible way of acknowledging that its wearer's identity has been shaped by decades of representational activity, and that no cultural project can ever "start from zero."[18]

Modernist and Post-Modernist texts differ fundamentally, then, in their respective attitudes toward the "already said." The former constructs a dialogic relationship with previous representations only to reject them as outmoded, resulting in an asemiotic zero-sum game. The latter constructs an entirely different relationship with the accumulated representational activity, recognizing that this activity cannot be conjured away by a sudden rupture because it forms the very fabric of our "structures of feeling." Post-Modernist texts acknowledge that "meaning," "identity," etc., are complicated not only by the decentered nature of current political production, but also by the co-presence of previous representations persisting through mass media—specifically television, which presents it own morphological continuity on a daily basis. In concentrating on synchronic tensions rather than diachronic breaks, the Post-Modernist text constructs *polylogic* rather than dialogic relationships with multiple "already saids," where the relationship between past and present coding is based on interaction and transformation instead of simple rejection.

The temporality that the Modernists labored to create was a quasi-perpetual present, hermetically sealed against historical antecedent or eventual change. This attempt to establish thoroughly ahistorical time frames is especially obvious in the way time has been handled in Modernist fiction. Jameson sees a concern with "time and temporality" as one of the distinguishing features of the High Modernists, a feature that has supposedly been replaced by an aesthetic of "space" in Post-Modernism. Yet this emphasis on temporality is a direct manifestation of the desire to construct a hermetically sealed private world. High Modernists, from Marcel Proust to Jean-Paul Sartre to Michel Butor, made temporality a thoroughly subjectivized order, consistently opposed to the public notion of time that was exposed as empty, bogus, or superficial. Butor's *L'Emploi du temps* (1956) serves as a particularly relevant example, since the narrator's obsession with his intensely personal ordering of time is what defines him as a character, what he used to keep himself separate from the city around him. This tendency is taken to its inevitable conclusion in Roger Laporte's *Fugue* (1970), in which subjective time is no longer set in opposition to public time, but rather replaces it

altogether, the only temporality being the time of the writing of the book itself. The High Modernist notion of time and history, then (in literature, film, and architecture), was subsumed entirely to "personal expression." Not coincidentally, the chief narrative mode of both the Romantics and the Modernists was the first-person confession; in both cases personal expression creates a private temporality that, in effect, kills history by making the main character step out of it into the time frame of his or her own creation.

The problem of temporality vs. historical consciousness leads to a large prroblem with Modernism itself, or more specifically, in the criticism devoted to it. The central contradiction within the International Style in its various media was a simultaneous fascination with the personal expression of a few Modernist/Romantics and the "universal grammar" that supposedly unified the movement. But the tension between the individual style (as unique as a set of fingerprints) and the universal aesthetic remains unresolvable semiotically. The former presupposes a virtually private language and the latter presupposes a "natural" one, having the same meanings and resonances regardless of cultural context. Either assertion by itself is based on rather questionable, decidedly non-semiotic foundations; but the successful combination of the two is simply an impossibility, since the presence of an intensely "personal" style becomes possible only at the expense of the universal. What occurred instead of the harmonious merger of the two was the promotion *as* universal of an elitism masquerading as a utopian signifying practice, regardless of context or reception.

The emphasis placed on cultural context by so many Post-Modernist artists is due, according to Jencks, to the fact that Post-Modernism, which has "developed from semiotic research, looks at the abstract notion of taste and its coding and then takes up a situational position, i.e. no code is inherently better than any other, and therefore the subculture being designed for must be identified before one code can be chosen rather than another" (1984, pp. 87—88). Coding as a concept has traditionally either been ignored in relation to High Modernists (the notion that "personal genius" transcends commonplace communication), or defined negatively (codes exist only to be broken by "personal genius"). The semiotic basis of Post-Modernism (no matter how consciously or unconsciously theorized), with its emphasis on the vernacular, the ad hoc, and the conventional, rejects any mode of communication predicated on the "personal" or the "universal," since neither can exist within a semiotic framework.

That the work of Post-Modernist architects (especially Jencks, Moore, Robert Venturi, etc.) has been labeled "neo-conservative" by Modernist partisans like Hal Foster is especially interesting, given the former group's insistence on making architecture an explicitly "public" language based on semiotics rather than Romantic conceptions. Foster, in particular, sees the Post-Modernist attempt to connect up with the cultural heritage and

traditions of a particular society as necessarily reactionary, since it is a "program that seeks to recoup the ruptures of modernism and restore the continuity with historical forms."[19] The choice of words here is telling: "rupturing" is the valorized activity, while historical/cultural "continuity" functions only as an uninteresting background for that activity. The cult of the individual genius, whether called Romanticism or Modernism, for Modernist apologists, remains firmly in place.

But which is the "neo-conservative" stance, the fascination with the "ruptures" produced by enlightened artists, or the attempt to produce an architectural language understandable to its inhabitants? Huyssen makes the essential point that "contemporary postmodernism ... operates in a field of tension between tradition and innovation, conservation and renewal, mass culture and high art, in which the second terms are no longer automatically privileged over the first: a field of tension which can no longer be grasped in categories such as progress vs. reaction, left vs. right, present vs. past, modernism vs. realism, abstraction vs. representation, avant-garde vs. kitsch."[20] For the avant-garde to be meaningful it must remain a relative term, yet those so desperate to label Post-Modernism as "neo-conservative" would de-relativize it by insisting that Modernism is the perpetual avant-garde, outside that field of tension, resulting in a frozen set of stylistic features that are supposedly able to provide the "shock of the new" throughout infinity, when they actually remain as fresh as Miss Havisham and her wedding cake, attempting to step outside of time as the only alternative to having been rejected.

Eclecticism as Interrogation: Text as Site

The high priority placed on eclecticism by Post-Modernists is a direct rejection of the purity of the International Style in its various incarnations in different media—a purity which, by its very nature would deny the existence of a semiotic context, both in its rigorous dismissal of all other styles and its indifference to the eventual users. The issue of eclecticism becomes perhaps the central issue in the debate over Post-Modernism, since it is not only a matter of stylistics, but politics, in regard to both textual practice and the critical approaches that have been brought to bear. Its detractors have considered this eclecticism "casual" or "schizophrenic," a veritable "non-style" devoid of personal artistry or authentic judgment. Its defenders, on the other hand, have argued that it is a style and an ideology which "builds in" the fragmentation and conflicted nature of contemporary culture—just as the perfect symmetry of Georgian architecture represented 18th-century culture's perception of itself.

In his discussion of the Stuttgart Museum designed by James Stirling,

Jencks stresses the confrontation within the architecture of classical motifs, German Romanesque, and ultra-modern, resulting in a thoroughly Post-Modern design that "confronts tradition and modern technology giving neither a supreme role. . . . They both feel the present condition of culture—and the Stuttgart buildings are cultural institutions—demands a juxtaposition of conflicting ideologies, not a resolution" (1984, p. 163). The lack of resolution becomes not a "non-style," but the only accurate way to reflect the cultural conflicts which have produced these texts. Eclecticism, then, must be seen as a decidedly "radical" feature of Post-Modernism, as these sorts of juxtapositions establish not only a design, but a specific view of the subject, society, and the functions that cultural production has in constructing the relationship between the two.

The emphasis placed on juxtapositions of conflicting discourses has become a distinguishing feature of Post-Modernist architecture, but similar types of juxtapositions are central to literary and film texts as well. Manuel Puig's *Kiss of the Spiderwoman* is a prime literary example of making conflicting styles and ideologies the basic structuring principle of the text as a whole.[21] Throughout the novel the dialogue between the cell mates (Molina, the homosexual, and Valentin, the political activist) is redoubled on the format of the pages themselves, the top section devoted to Molina's narratives, the bottom section containing an ongoing essay for each chapter. Throughout these double-tracked pages, the pulp romances and films of Molina appear to operate in perfect counterpoint to the erudite essays below: each functioning according to the modalities and prohibitions (in the Foucauldian sense) of its own discourse, each taking apparently very different views of desire—one romanticized in the extreme, the other clinical in the extreme. The prisoners, in their conversations, only stress these disjunctions. Valentin orders Molina not to tell the stories during the day since "it's better at night, during the day I don't want to be thinking about such trivia. I've got more important things to think about."[22] Specifically, Valentin means reading the sort of essays one finds at the bottom of each page. The tensions between the two discourses must be confronted by the reader quite actively due to the difficulty in the actual reading of the text. Should we read the narrative and the essays simultaneously, or read each to its conclusion, and then go back to the other track and read it as a whole? Either way, the reader must confront the conflicting discourses in a more direct way than in, say, Julio Cortázar's *Hopscotch* (1963; trans. 1966), where the hopscotching activity becomes a matter of temporal rather than discursive juxtaposition.

The most significant feature of the discursive juxtapositionings of *Kiss of the Spiderwoman*, however, is that their points of contact, as well as their points of departure are consistently foregrounded by the dialogic structure. These juxtaposition are discursive in a three-fold manner: first in the Foucauldian sense, but also in a doubly Benvenistean sense, in that a "discursive"

exchange occurs between those modes of representation as well as between the text and the reader/viewer. As the novel progresses it becomes increasingly clear that both men are victims of repression by the same totalitarian regime, and that both the narratives and the essays stress the primacy of desire. The confluence of the two tracks is most explicit when late in the novel the men come together, emotionally as well as physically. At that point, the essay track draws the explicit parallel, "Marcuse points out that the social function of the homosexual is analogous to that of a critical philosopher since his very presence is a constant reminder of the repressed elements of society." The power that Molina's stories and songs have to represent "real life" situations also becomes increasingly evident as the novel progresses. Valentin remains derisive about Molina's material, but then admits, "Know something? There I was laughing at your bolero, but the letter I got today says just what the bolero says." Molina insists, "Listen, big man, don't you know by now boleros contain tremendous truths, which is why I like them" (p. 139). The novel as a whole proves Molina correct in a rather bitterly ironic way. In one of Molina's later stories he has character sing, "Even though you're . . . a prisoner . . . in your solitude . . . your heart whispers still . . . I love you" (p. 227), foreshadowing quite perfectly the end of the novel when Valentin whispers exactly that before (after?) he dies from his torture.

Puig's use of discursive juxtaposition in *Kiss of the Spiderwoman* epitomizes one of the fundamental tenets of Post-Modernism—that only by confronting the conflicting discourses we use to structure experience can we begin to understand what is actually at stake in the structuring process. Only then may we begin to see that no hierarchy of discourses or "cultural orchestration" makes that process automatic in contemporary cultures. The Post-Modernist aim, then, is not haphazard "pastiche," motivated only by perversity, but specific juxtapositions for particular purposes. Charles Moore's Piazza d'Italia in New Orleans is a perfect architectural example of this (see figure 3). His design for an Italian cultural center incorporates Roman arches, neon bars, and skyscrapers, utilizing stone as well as highly polished aluminum in its various columns. But the juxtapositions here are not without a precise guiding principle. Moore has included most of the important styles that have been used within the Italian city-space since ancient Rome. This combination of seemingly contradictory styles makes perfect sense, given the Piazza d'Italia's function as a center intended to celebrate cultural traditions in the 1980s. It is an avowedly contemporary work "built" on past styles. Like *Kiss of the Spiderwoman*, the work juxtaposes disparate styles and foregrounds the unresolvable tensions between them, but also unifies these juxtapositions around a well-defined theme (repressed desire in *Spiderwoman* and Italian culture in the Piazza d'Italia). Where Modernism sought to replace outmoded styles entirely with another "radical" one, Post-Modern texts, like these by Puig and Moore, emphasize the question of style itself as a way of coming to

terms with the traditions of the past as well as the discursive and ideological conflicts in the present.

This gesture has been developed most elaborately in Hans-Jürgen Syberberg's *Parsifal* (1984), also structured around a series of discursive juxtapositions. While his project may be similar to Moore's, it takes a more overtly critical view of the particular cultural heritage which unifies the work's juxtapositions. While the film ostensibly presents a performance of the Wagner opera, Syberberg turns his production into a kind of filmic "Piazza Germania," in which the opera's visualization becomes a "site" where a range of German cultural traditions (political, sexual, artistic, etc.) interconnect simultaneously. Syberberg makes Wagner's *Parsifal* the lynchpin of a cultural continuum by emphasizing, at one and the same time, traditions which lead back to medieval times as well as traditions which lead forward into the 1980s. To make the opera into this kind of "site," Syberberg emphasizes conflicts between various of its stagings. Using back-projection, inserted photographs, and drawings, he repeatedly, within the space of the image, contrasts his own filmic production with the famous Bayreuth productions of 1882 and 1951, as well as with Fritz Lang's *Siegfried* (1922–24), and a puppet show modeled on the original singers who created the featured roles. In so doing, Syberberg is not only juxtaposing multiple productions, but multiple modes of represent-

ation—photos, puppet shows, highly stylized sets, minimalist sets, symbolic considerations, illuminated manuscripts, the score itself, etc. Likewise, Syberberg's treatment of the figure of Wagner takes on different forms, reflecting various popular conceptions of this composer: crucified artist, Romantic poseur, radical theoretician, a decapitated head, a death mask, etc.

There is one shot in *Parsifal* which encapsulates the whole of the activity of the film: the long tracking shot that leads into the Grail Hall. The camera moves past a seemingly endless series of flags and banners from German history, from the medieval to the 19th century up to the swastika. The historical/cultural continuum is clearly drawn here: *Parsifal* the opera is a product of the 19th century and it recreates a medieval myth which itself is appropriated as a myth for fascism in the 20th century. Throughout the film, the discursive juxtapositions lead us to a major conclusion about the opera; for us today, *Parsifal* cannot be looked at merely as a classic, or even as a radical new production of a classic, but rather it must be seen as the assemblage of all its past and present incarnations and appropriations. *Parsifal* is both the fulfillment of the Grail brotherhood and the foreshadowing of the Nazi brotherhood. What Thomas Elsaesser says of *Ludwig* (1972) in his compelling essay on Syberberg applies perfectly to this later film:

> Syberberg's film is not a mimesis or representation as much as an interpretation in the biblical sense of exegesis, it is a "reading" of German history which might with such justification, be called a hermeneutics of the texts that make up history, before it is narrativized, unified, and pressed into the unilinear flow of realist narrative. It is in the very nature of this kind of interrogation and interpretation that it not only "deconstructs" our view of history but also the cinematic space of representation.[23]

Juxtaposition as interrogation is characterized in Moore, Puig, and Syberberg by a careful, purposeful consideration of representational alternatives—rather than by simple pastiche or the "plundering" of history of art as though it were an attic filled with the artifacts of one's ancestors. The key point here is that the discursive juxtapositions do not result in an "emptying out" of all styles (where hyper-awareness of the multiple possibilities would somehow make any one style an impoverished dead end or their combination mere pastiche). Exactly the opposite is the case in a texts such as *The Kiss of the Spiderwoman*, *Parsifal*, *The White Hotel*, *Tangos, the Exile of Gardel*, *The Name of the Rose*, *Diva*, Moore's Piazza or Stirling's Stuttgart gallery; in each of these cases, a precise combination of styles forms the basis of a productive engagement with antecedent and contemporary modes of organizing experience as a way of making sense of life in decentered cultures.

Linda Hutcheon makes the crucial point that the parody that supposedly

defines Post-Modern textuality is not a uniform perspective, since "parody, paradoxically, exacts both change and cultural continuity; the Greek prefix *paras* can mean both 'counter' and 'against' *and* 'near' or 'beside.' "[24] That Post-Modernist texts employ eclectic combinations in order to produce meaning (as opposed to frustrating it), is perhaps best illustrated by the Kokuku sequence in Laurie Anderson's *Home of the Brave*. Two musicians sit before their guitars, playing them with forks, screwdrivers, etc., while directly above them on the rear screen, a series of simple drawings of objects are intercut with a series of Chinese characters—*conjis*, considered to be some of the earliest examples of symbolic signs (in the Peircean sense). In the foreground, an Oriental musician sits before an ancient form of the guitar; he is telling a story. The song's title, "Kokuku" signifies place of origin, and the composite space emphasizes the creation of meaning, in which sounds become meaningful as symbols. Throughout *Home of the Brave* and other Post-Modernist texts, the production of meaning depends upon a direct engagement with the "already said," which is neither a nihilistic "emptying out" nor a revivalist resuscitation of that already said.

The Functions of Criticism: The Semiotic Glut and the *Musée Imaginaire*

Within decentered cultures, no *Zeitgeist* can emerge as a dominant; nor can any one institution—whether the university of prime-time television—be considered the sole "official" culture responsible for establishing aesthetic ideological standards for entire societies. Throughout this study, I have discussed the shortcomings of the "Grand Hotel" conception of culture. I have argued that just as the organized cabal of mass culture czars seems quaintly out of date in contemporary culture, so too does the notion that any one group of scholars or critics could serve as its inverted, negating image—i.e. a master control room where Adorno-ites would establish official standards for what constitutes "culture" for entire societies and somehow enforce them in an all-pervasive manner. Just as the advent of Post-Modernist culture has not meant the end of "oppositional" art, it also does not mean the end of aesthetic judgment. The Post-Modernisms represented by Moore, Puig, and Syberberg, for instance, are vehiculations of very precise aesthetic judgments, judgments in which critical dialogue about conflicting styles becomes a structuring principle of the text. Aesthetic judgment is not, therefore, ignored, but redefined and relocated at the junctures between opposing discourses, where critical, ethical, and ideological decisions are made. Post-Modernist judgment is not formulated from out of an acontextual, a-vernacular set of transcendent principles that might constitute a "universal

grammar" of genius. Consequently, it does mean the end of any uniform conception of "the best that has been thought and said," or of any easy binary relations between two opposing sets (each equally uniform). Most critiques of Post-Modernism—similar to Adorno's attack on the "culture industry," an attack that so clearly informs these later critiques—are themselves written in a "nostalgia mode," essentially a nostalgia for a culture where the oppositional version of the "best that has been thought and said" was easily determinable and easily championed. Ironically, the anti-Post-Modernist nostalgia appears to be for a Panopticon Lost, where societies were supposedly centralized and homogeneous, but oppositional voices knew their own and endlessly plotted utopian prison breaks from out of officially Oppositional Cells.

The advent of Post-Modernist textual practice, and, more importantly, the Post-Modernist cultural context, makes ideological analysis more essential than it has ever been before in the decoding and evaluating of those diverse messages. In his eloquent conclusion to *The Function of Criticism*, Terry Eagleton insists that the role of the contemporary critic should be a traditional one—to be concerned with the interrelationships between symbolic processes and the social production of subjectivity.

> For it is surely becoming apparent that without a more profound understanding of such symbolic processes, through which political power is deployed, reinforced, resisted, at times subverted, we shall be incapable of unlocking the most lethal power-struggle now confronting us. Modern criticism was born of a struggle against the absolutist state; unless its future is now defined as a struggle against the bourgeois it might have no future at all. (p. 124)

While Eagleton is quite correct in outlining the project and recognizing the stakes involved, the question that arises is whether this can be done effectively if it is based on problematic preconceptions about how cultural production creates our perception of that bourgeois state. The project would appear, if anything, doomed to failure if its attitude toward so much of that cultural production is outright rejection. Criticism must be evaluative in this context, but it becomes ineffectual when it degenerates into a "nostalgia mode" for cultures lost. The survival of Marxist cultural analysis is truly in jeopardy if its treatment of contemporary culture (specifically in regard to popular culture and Post-Modernism) amounts to self-righteous dismissal. The inevitable and ironic result of such a stance is a bizarre temporality that inverts the temporality of the Modernism it admires; in its nostalgia for the past and its utopian visions of the future, it constructs not a perpetual present, but an "absent present."

The denial of Post-Modernism is symptomatic of a much broader problem concerning the relevance and the efficacy of Marxist analysis in the present

conjuncture. Eagleton points to Raymond Williams as a kind of model of what the contemporary critic should be, and in doing so compares him to Wordsworth, leading to an explicit comparison of the Socialist Critic and the Romantic Poet:

> Socialist criticism cannot conjure a counterpublic sphere into existence; on the contrary, that criticism cannot itself fully exist until such a sphere has been fashioned. Until that time the socialist critic will remain stranded between sage and man of letters, combining the critical dissociation of the former with the practical, engaged, wide-ranging activity of the latter. (p. 114)

Williams indeed managed to maintain a balance between the two roles. But in their self-consciously dissociated stances, Jameson, Eagleton, and Foster appear to be adopting the role of the romantic "sage" far too wholeheartedly. Eagleton's own epitaph for the Romantic sage describes, ironically, his own position vis-à-vis Post-Modernist cultures:

> No critique which does not establish such an implacable distance between itself and the social order, which does not launch its utterances from some other different place, is likely to escape incorporation; but that powerfully enabling distance is also Romanticism's tragedy, as the imagination joyfully transcends the actual only to consume itself and the world in its own guilt-stricken self-isolation. (p. 41)

Eagleton here performs (unwittingly) a brilliant self-diagnosis. The search for one great counter-public sphere is doomed to be fruitless, due to the cultural fragmentation produced by the heterogeneity of encoding and decoding strategies at work within a given society. But even if the creation of such a sphere were a possibility, would the outright dismissal of all that is tainted by commodification—especially popular and Post-Modernist texts—be an appropriate way to begin constructing it (considering the determination of these texts to use the most accessible codes for non-elite audiences)? Could such a sphere ever exist between anything but latter-day dissociated sages?

The issue of subject construction should indeed remain the central problematic in ideological analysis, but, here again, we can hope to understand the complexity of the processes involved in current context only if we go beyond simple denunciation. It is frequently argued that the individual self has been annihilated by Post-Modernism since it is no longer a centered subject; yet this presupposes that subjectivity is impossible without a rigorous homogeneity of all ideological messages within a given context. In fact, in a world defined by competitive interpellation (as outlined in the previous chapters), the subject is seldom answering one uniform "call," but, rather, being hailed by multiple, competing messages all issued simultaneously. The

"disappearing self" criticism is common, but it fails to take into account the centering power of individual discourses, or the power of individuals to make choices regarding those discourses.

Eagleton acknowledges that the centered subject has become in some ways inappropriate, but argues that this has not led to its complete disappearance— "The subject of late capitalism ... is neither simply the self-regulating synthetic agent posited by classical humanist ideology, nor merely a decentered network of desire, but a contradictory amalgam of the two" (1986, p. 145). Eagleton does not fully pursue the causes of this "contradictory amalgam," yet the existence of such a contradictory situation is itself a product of the conflicting ideological messages being processed by those subjects on a daily basis. While a unitary culture may have disappeared, unitary discourses constructing very specific subjects have only intensified. The category of the subject remains highly viable in large part because it has never been so hotly contested.

The function of criticism vis-à-vis subject construction must be thoroughly reconceived if it is to have any significant impact in contemporary society. In discussing the influence of new technologies on Post-Modernist practice, Jencks states,

> We can reproduce fragmented experiences of different cultures and, since all the media have been doing this for fifteen years our sensibility has been modified. Thanks to color magazines, travel, and Kodak, Everyman has a well-stocked *musée imaginaire* and is a potential eclectic. At least he is exposed to a plurality of other cultures and he can make choices and discriminations from this wide corpus, whereas previous cultures have stuck with what they'd inherited. (1984, p. 95)

This point contains several ramifications for subject construction. The image of the *musée imaginaire* is especially useful since it suggests not only the stock-piling, but purposeful arrangement of the signs which bombard us constantly (even if Jencks's list seems paltry at best and emphasizes only the international nature of such a *musée* without acknowledging the diversified nature of the "national" collection). Here the activity *of* the subject is as important as activity *on* the subject, whereas previous conceptions of the subject have emphasized only the latter. Due to the bombardment of conflicting messages the individual subject *must* be engaged in processes of selection and arrangement. Not that subjects are completely "free to choose" as an independent agent, unconstructed by the very messages they come into contact with, or that a range of choices doesn't change drastically from society to society. Nevertheless, to deny that a selection process hasn't been made mandatory by that bombardment is to posit an absurdly simplified subject, strapped down with eyes pryed open like Alex in Anthony Burgess's *A*

Clockwork Orange (1963), force-fed a carefully orchestrated series of images. But the lack of orchestration of cultural production is precisely what makes such an imagined spectator ludicrously outmoded.

The situation, then, is not a "democratic" plurality, where aesthetic and ideological alternatives are carefully arranged in a kind of laissez-faire smorgasbord. Instead, a semiotic glut necessitates the arrangement, even hierarchizing of conflicting discourses by individual subjects at a localized level. The bombardment of signs has produced, by no preconceived design whatsoever, a subject who is engaged in the process of being interpellated while simultaneously arranging those messages—as if the lack of cultural orchestration has produced a subject who must act as curator of his or her *musée imaginaire*.

This lack of uniformity in *interpellation* necessitates a new conception of the subject, defined by activity rather than passivity, by selection rather than simple reception. Jencks's image of the *musée imaginaire* suggests that *bricolage* is one of the distinguishing characteristics of life in Post-Modern cultures. In *Subculture*, Dick Hebdige utilizes the term *bricolage* to describe how individuals manipulate disparate cultural phenomena in order to explain their world to themselves in satisfactory ways (restricting it to explicitly subcultural groups).[25] Hebdige's use of this term in relation to technologically sophisticated cultures is a significant move, since he demonstrates effectively that *bricolage* as an activity cannot be limited to primitive, pre-literate societies. If anything, its appearance within subcultural groups reflects an extremely refined understanding of complicated semiotic environments. I believe this notion of *bricolage* may be pursued even further; characters in Joe Dante's *Explorers* or Puig's *Kiss of the Spiderwoman* can hardly be considered subcultural in the same way as punks or Rastafarians, yet their manipulation of signs (in locally meaningful structures) involves the same kind of ad hoc arrangements.

Within media-saturated cultures where no overarching, pan-cultural distinctions between official and unofficial, mainstream and avant-garde are in effect, *bricolage* becomes the inevitable response to semiotic overload. It should not, therefore, be reserved for *sub*-cultural activity, but should be applied to all kinds of *micro*-cultural activity. This is not to suggest that individual discourses and institutions within our cultures do not attempt to provide totalizing modes of organizing experience; the decentering of the subject that typifies Post-Modernism is the direct result of the simultaneous appearance of multiple centers, multiple unified subject positions that are often fundamentally incompatible with one another. The situation is not unlike that conceived by Thomas Pynchon in *The Crying of Lot 49* (1966), where Oedipa Maas searches for the signs of an underground communication system only to uncover an endless proliferation of subcultural languages—at which point she realizes that what she thought was marginal is instead endemic; that to be

alienated from some imaginary central language has itself become central; that everyone has become a potential *bricoleur* in a sense, because everyone is caught in that endless "roar of relays."

The project of contemporary criticism as outlined by Eagleton is then imperative, but it lacks a third component. In addition to an understanding of symbolic processes and subject construction, we need a theory of the subject that emphasizes the activities undertaken by that subject when faced with conflicting cultural messages. The function of the critic cannot be limited merely to showing his or her readers the error of their culture's ways; it must instead sensitize readers and students to the processes involved in the production of subjectivity. Unless we emphasize the active role all people may play in that production, criticism remains a "spectator sport" for an increasingly smaller audience. The activity of the critic, then, must be directly linked to the activity of subject production; the critic's activity, undertaken in a specific cultural context, should serve as a model for the latter. In *The Cheese and the Worms*, Carlo Ginzburg elucidates in thorough detail how, in the 16th century, Menocchio constructed what amounted to a *cosmogonie imaginaire* through his distinctive decodings of the texts he had read. In our technologically sophisticated age, where the bombardment of diverse sign systems will only continue to intensify (as will the individual's ability to manipulate them with VCRs and remote-control devices), the proliferation of techno-Menocchios becomes inevitable. Umberto Eco summarizes the situation in the following manner:

> What radio and television are today, we know—incontrollable plurality of messages that each individual uses to make up his own composition with the remote control switch. The consumer's freedom may not have increased, but surely the way to teach him to be free and controlled has changed.[26]

The opponents of Post-Modernism have been especially critical of the notion that individual subjects are capable of making selective decisions in the face of this semiotic glut, preferring to dispense with the issue by insisting that this "free to choose" mentality plays directly into the "free market" ideology. But such a move, in addition to being sadly reductive, only brackets the central issue—what *is* the individual subject to *do* in such a context? Of course, it is quite possible to link the making of choices to capitalist ideology as a whole. But one can just as easily conceive of the ability to choose in quite another way, as *heretical* action (since the Greek root for heretic means "able to choose"). For Post-Modernism as a cultural program to succeed critically, and have the kind of widespread impact that the private languages of High Modernism never did, heretical activity must be conducted on three interrelated fronts. As a particular type of textual practice or "style," Post-

Modernist artists must continue to violate the precepts of Modernism as a way of demonstrating the possibility that "multiple aesthetics" are appropriate for different publics within a given culture at the same time. Critical practice must likewise be heretical, by conducting a complete re-examination of all the "givens" of cultural analysis—especially those that depend on outmoded categories and scenarios that are more appropriate to pre-industrial societies. But the most important of these fronts is the heretical activity of individual subjects who can strike a balance between involvement and critical distance so long as they recognize that they are not only able to choose, but *impelled* to choose if they hope to gain any control of their cultures.

Notes

1. Cultural Fragmentation and the Rise of Discursive Ideologies

1. Peter Sellars, quoted in *The New York Times* (Sunday, Dec. 16, 1984).

2. Bruce Springsteen, "No Retreat, No Surrender," *Born to Run*, 1984.

3. Tomas Borge Martinez, Interview, *Playboy* (Sept., 1983).

4. John Cage, quoted in *The New York Times* (Sunday, Dec. 16, 1984).

5. William Bennett, "To Reclaim a Legacy," rep. in *Chronicle of Higher Education* (Nov. 28, 1984).

6. Robert Darnton, *The Great Cat Massacre and Other Episodes in French Cultural History* (New York: Basic Books, Inc., 1984).

7. Carlo Ginzburg, *The Cheese and the Worms: The Cosmos of a Sixteenth-Century Miller* (New York: Penguin, 1982).

8. Terry Eagleton, *The Function of Criticism* (London: Verso/New Left Books, 1984).

9. Tony Davies, "Transports of Pleasure," *Formations of Pleasure* (Boston: Routledge & Kegan Paul, 1983), pp. 46–58.

10. Kenneth Roberts, The Fragmentary Class Structure (London: Heineman 1977).

11. Edward Said, "The Text, The World, The Critic," in *Textual Strategies* (Cambridge: Harvard University Press, 1979), pp. 161–88.

12. Jan Mukařovský, *Aesthetic Function, Norm and Value as Social Facts* (Ann Arbor: University of Michigan Press, 1973).

13. Patrick Brantlinger, *Bread and Circuses: Theories of Mass Culture as Social Decay* (Ithaca: Cornell University Press, 1983).

14. Alan Swingewood, *The Myth of Mass Culture* (Atlantic Highlands, New Jersey: Humanities Press, 1977).

15. Martha Woodmansee, "Toward a Geneology of the Aesthetic: The German Reading Debates of the 1790's," *Cultural Critique*, No. 10 (Fall 1988).

16. Theodor Adorno and Max Horkheimer, "The Culture Industry: Enlightenment as Mass Deception," in *Dialectic of Enlightenment* (New York: Seabury Press, 1972).

17. Theodor Adorno, "Transparencies on Film," *New German Critique*, No. 24–25 (Fall/Winter 1981–82), pp. 199–205. See also Miriam B. Hansen, "Introduction to Adorno's 'Transparencies on Film'," *New German Critique*, No. 24–25 (Fall/Winter 1981–82), pp. 186–198.

18. Michel Foucault, *The Archaeology of Knowledge and The Discourse on Language* (New York: Harper Colophon Books, 1972).

19. Thomas Kuhn, *The Structure of Scientific Revolutions* (Chicago: University of Chicago Press, 1970).

20. Colin MacCabe, ed., *High Theory/Low Culture* (New York: St. Martin's Press, 1986).

21. Tania Modleski, ed., *Studies in Entertainment: Critical Approaches to Mass Culture* (Bloomington: Indiana University Press, 1986).

22. Tony Bennett, Colin Mercer, and Janet Woollacott, *Popular Culture and Social Relations* (Philadelphia: Open University Press, 1986).

23. Umberto Eco, *Travels in Hyperreality* (New York: Harcourt, Brace, Jovanovich, 1986).

24. Ien Ang, *Watching Dallas* (New York: Methuen, 1986).

25. Dana Polan, *Power and Paranoia: History, Narrative, and the American Cinema, 1940–1950* (New York: Columbia University Press, 1986).

26. For an extended discussion and bibliography concerning Liberal Pluralist approaches, see Tony Bennett, "Theories of the Media, Theories of Society," in *Culture, Society and the Media*, ed. Michael Gurevitch, Tony Bennett, James Curran, Janet Wollacott, et al. (New York: Methuen, 1982), pp. 30–55.

27. Bernard Gendron, "Theodor Adorno Meets the Cadillacs," in *Studies in Entertainment*, pp. 18–36.

28. Tony Bennett, "The Politics of 'the Popular' and Popular Culture," in *Popular Culture and Social Relations*, pp. 6–21.

29. Patrice Petro, "Mass Culture and the Feminine: The Place of Television in Film Studies," *Cinema Journal* 25, No. 3 (Spring 1986), pp. 5–21.

30. Andreas Huyssen, "Mass Culture as Woman: Modernism's Other," in *Studies in Entertainment*, pp. 188–207.

31. Tania Modleski, "The Terror of Pleasure: The Contemporary Horror Film and Postmodern Theory," *Studies in Entertainment*, pp. 155–66.

32. Linda Williams, "Something Else Besides a Mother: *Stella Dallas* and the Maternal Melodrama," *Cinema Journal*, 24, No. 1 (Fall 1984), pp. 2–27.

33. Robin Wood, "An Introduction to the American Horror Film," *Movies and Methods*, Vol. II, ed. Bill Nichols (Berkeley: University of California Press, 1985), pp. 195–220.

34. Raymond Williams, "Base and Superstructure," *Problems in Materialism and Culture* (London: Verso, 1980).

35. John Fiske, "British Cultural Studies and Television" in *Channels of Discourse* ed. Robert Allen (Chapel Hill: University of North Carolina Press, 1987), p. 286.

36. Mikhail Bakhtin, "Discourse in the Novel," *The Dialogic Imagination*, ed. Michael Holquist (Austin: University of Texas Press, 1981), pp. 259–422.

37. Mary Louise Pratt, "Interpretive Strategies/Strategic Interpretations: On Anglo-American Reader-Response Criticism," *Postmodernism and Politics*, ed. Jonathan Arac (Minneapolis: University of Minnesota Press, 1986), pp. 26–54.

38. Richard Terdiman, *Discourse/Counter Discourse: The Theory and Practice of Symbolic Resistance in 19th Century France* (Ithaca: Cornell University Press, 1985).

39. See especially Charles Jencks, *What is Post-Modernism* (London: Academy/New York: St. Martin's Press, 1986); Linda Hutcheon, "The Politics of Postmodernism: Parody and History," *Cultural Critique*, No. 5 (Winter, 1986–87), pp. 179–207; Andreas Huyssen, *After the Great Divide; Modernism, Mass Culture, Postmodernism* (Bloomington: Indiana University Press, 1986); Umberto Eco, "Postmodernism, Irony and the Enjoyable," *Postscript to The Name of the Rose* (New York: Harcourt, Brace, Jovanovich, 1984), pp. 65–72; Paolo

Portoghesi, *After Modern Architecture* (New York: Rizzoli, 1982); and John Barth, "The Literature of Replenishment, Postmodernist Fiction," *The Atlantic* (January 1980), pp. 65–71.

40. Dennis Porter, *The Pursuit of Crime: Art and Ideology in Detective Fiction* (New Haven: Yale University Press, 1981).

41. Louis Althusser, "Ideology and Ideological State Apparatuses" in *Lenin and Philosophy and Other Essays* (New York: Monthly Review Press, 1971).

42. Michel Foucault, *Discipline and Punish: The Birth of the Prison* (New York: Vintage, 1979).

43. Mark Poster, *Foucault, Marxism and History* (Cambridge: Polity Press, 1984).

44. Michel de Certeau, "On the Oppositional Practices of Everyday Life," *Social Text*, 3 (Fall 1980), pp. 23 ff.

45. William McIlvanney, *The Papers of Tony Veitch* (New York: Pantheon, 1983), p. 59.

46. Ernest Mandel, *Delightful Murder: A Social History of the Crime Story* (Minneapolis: University of Minnesota Press, 1984).

47. Michael Denning, *Mechanic Accents: Dime Novels and Working Class Culture in America* (New York: Verso, 1987).

48. Stephen Knight, *Form and Ideology in Crime Fiction* (Bloomington: Indiana University Press, 1980).

49. John Cawelti, "*Chinatown* and Generic Transformation in Recent Genre Films," *Film Theory and Criticism*, ed. Gerald Mast and Marshall Cohen, 2nd ed. (New York: Oxford University Press, 1980), pp. 559–79.

50. Paul Hirst, *On Law and Ideology* (New York: MacMillan Press, 1977).

51. Chantal Mouffe, "Hegemony and Ideology in Gramsci," in *Culture, Ideology, and Social Practice*, ed. Quintin Hoare and Geoffrey Nowell-Smith (London: Open University Press, 1981), pp. 219–34.

52. Louis Althusser, "Ideology and Ideological State Apparatuses," p. 171.

2. Life in the Arena: Intertextuality in Decentered Cultures

1. Jonathan Culler, "Presupposition and Intertextuality" in *The Pursuit of Signs* (Ithaca: Cornell University Press, 1981), p. 101.

2. Roland Barthes, *S/Z* (Paris: Editions de Seuil, 1970), p. 16.

3. Julia Kristeva, *Semiotike* (Paris: Editions du Seuil, 1969), p. 146.

4. Pierre Macherey, *A Theory of Literary Production* (London: Routledge & Kegan Paul, 1978), pp. 79–80.

5. Harold Bloom, *The Anxiety of Influence* (New York: Oxford University Press, 1973).

6. Tzvetan Todorov, "The Typology of Detective Fiction," in *The Poetics of Prose* (Ithaca: Cornell University Press, 1977).

7. P.D. James, *The Skull Beneath the Skin* (New York: Scribner's, 1982), p. 21.

8. Umberto Eco, "Introduction," *The Role of the Reader* (Bloomington: Indiana University Press, 1979).

9. Edmund Crispin, *The Moving Toyshop* (London: Penguin Books, 1958), p. 87.

10. Raymond Chandler, "The Simple Art of Murder," in *The Simple Art of Murder* (New York: 1950, reprinted Ballantine, 1972).

11. Raymond Chandler, *The Big Sleep* (New York: Vintage Books, 1976), p. 17.

12. For a more extended discussion of this problem see Ava Collins, "Uses of Popular Forms in Modern Fiction," dissertation in manuscript (University of Iowa, forthcoming).

3. Speaking in Tongues: The Languges of Popular Narrative

1. Mikhail Bakhtin, "Discourse in the Novel," in *The Dialogic Imagination*, ed. Michael Holquist (Austin: University of Texas Press, 1981).

2. Dennis Porter, *The Pursuit of Crime: Art and Ideology in Detective Fiction* (New Haven: Yale University Press, 1981).

3. Dashiell Hammett, *Red Harvest* (New York: Vintage Books, 1972), p. 39.

4. Vera Caspary, *Laura* (Boston: Houghton Mifflin, 1942), p. 18.

5. Clement Greenberg, "The Modernist Painting," in *The New Art*, ed. Gregory Battock (New York: E. P. Dutton, 1973), pp. 66–77. Rpt. from *Art and Literature*, no. 4 (Spring 1965).

6. Ernest Hemingway, "Big Two-Hearted River," *The Nick Adams Stories* (New York: Charles Scribner's Sons, 1925), p. 177.

7. Edward Keenan, "Two Types of Presupposition in Natural Language," in *Studies in Linguistic Semantics*, ed. Charles Filmore and D. Terence Langendeon (New York: Holt, Rinehart and Winston, 1971).

8. Eco discusses infinite semantic recursivity in relation to semantic trees. He contends that each sememe generates "a sort of embedded sememe generating its own tree and so on ad infinitum, each of their semantic markers in turn generating another tree." *Theory of Semiotics* (Bloomington: Indiana University Press, 1976), p. 121.

9. Umberto Eco, *Semiotics and the Philosophy of Language* (Bloomington: Indiana University Press, 1984), p. 71.

10. Umberto Eco, *The Role of the Reader* (Bloomington: Indiana University Press, 1979).

11. Stanley Fish, "What Is Stylistics And Why Are They Saying Such Terrible Things About It?," in *Questions of Textuality* (Baltimore: The Johns Hopkins University Press, 1981).

12. Raymond Chandler, *The Big Sleep* (New York, Vintage Books, 1976), p. 1.

13. Robert Scholes, *Textual Power* (New Haven: Yale University Press, 1985), p. 61.

14. Tony Bennett, "Texts, Readers, Reading Formations," *PMLA*, 16 (1983).

15. For a more thorough discussion of this issue see Mary Louise Pratt's "Interpretive Strategies/Strategic Interpretations: On Anglo-American Reader-Response Criticism," in *Postmodernism and Politics*, ed. Jonathan Arac (Minneapolis: University of Minnesota Press, 1986), pp. 26–54.

16. Norman Holland and Leona Sherman, "Gothic Possibilities," *New Literary History*, no. 2 (1977), pp. 279–94.

17. Tzvetan Todorov, *Introduction à la littérature fantastique* (Paris: Editions du Seuil, 1970), p. 38.

18. Bram Stoker, *Dracula* (New York: Signet, 1965), p. 45.

4. Discursive Ideologies and Popular Film

1. Jean-Luc Comolli and Jean Narboni, "Cinema, Ideology, Criticism," *Movies and Methods*, Vol. I, ed. Bill Nichols (Berkeley: University of California Press, 1976).

2. Linda Williams, "Something Else Besides a Mother: *Stella Dallas* and the Maternal Melodrama," *Cinema Journal*, 24, No. 1 (Fall 1984), pp. 2–27.

3. Robin Wood, "An Introduction to the American Horror Film," *Movies and Methods*, Vol. II, ed. Bill Nichols (Berkeley: University of California Press, 1985), pp. 195–219.

4. Horace Newcomb, "On the Dialogic Aspects of Mass Communication," *Critical Studies in Mass Communication*, no. 1 (March 1984), pp. 34–50.

5. Raymond Williams, "Base and Superstructure," in *Problems in Materialism and Culture* (London: Verso, 1980), pp. 31–49.

6. Will Wright, *Six Guns and Society* (Berkeley: University of California Press, 1977).

7. Stephen Neale, *Genre* (London: BFI, 1980).

8. Jim Collins, "Toward Defining a Matrix of the Musical Comedy: The Place of the Spectator Within the Textual Mechanisms," in *Genre: The Musical*, ed. Rick Altman (Boston: Routledge & Kegan Paul, 1981), pp. 161–73.

9. Jan Mukařovský, *Aesthetic Function, Norm and Value as Social Facts* (Ann Arbor: University of Michigan Press, 1973).

10. Jean-Louis Baudry, "Ideological Effects of the Basic Cinematographic Apparatus," *Film Quarterly*, 28, no. 2 (1974–75), pp. 39–47.

11. Christian Metz, *The Imaginary Signifier: Psychoanalysis and the Cinema* (Bloomington, Indiana University Press, 1982).

12. David Bordwell, *Narration in the Fiction Film* (Madison: University of Wisconsin Press, 1985).

13. Edward Branigan, *Point of View in the Cinema: A Theory of Narration and Subjectivity in Classical Film* (New York: Mouton, 1984).

14. Christian Metz, "History/Discourse: A Note on Two Voyeurisms," in *Theories of Authorship*, ed. John Caughie (Boston: Routledge & Kegan Paul, 1981), pp. 225–31.

15. Raymond Bellour, "Alternation, Segmentation, Hypnosis," *Camera Obscura*, No. 3–4 (1979), pp. 71–103.

16. Laura Mulvey, "Visual Pleasure and Narrative Cinema," *Screen*, 16, No. 3 (1975), pp. 6–18.

17. Mark Nash, "*Vampyr* and the Fantastic," *Screen*, 17, No. 3 (1976), pp. 29–67.

18. Françoise Jost, "Discours Cinématographique, Narration: Deux façons d'envisager le problème de l'enonciation," in *Théorie du film* (Paris: Albatros, 1980).

19. See note 8 above.

20. Gérard Genette, "Frontières du recit," *Communications*, No. 8 (1966), pp. 152–63.

21. Octave Mannoni, *Clefs pour l'Imaginaire ou L'Autre Scène* (Paris: Editions du Seuil, 1969).

22. John Tagg, "The Currency of the Photograph," *Screen Education* (Autumn 1978), pp. 45–67.

5. Post-Modernism as Culmination: The Aesthetic Politics of Decentered Cultures

1. Andreas Huyssen, *After the Great Divide: Modernism, Mass Culture, Postmodernism* (Bloomington: Indiana University Press, 1986), p. 217.

2. Stefano Tani, *The Doomed Detective: The Contribution of the Detective Novel to Postmodern American and Italian Fiction* (Carbondale: Southern Illinois University Press, 1984).

3. Siegfried Kracauer, *History: The Last Things Before the Last* (New York: Oxford University Press, 1969).

4. Jean Baudrillard, "The Implosion of Meaning in the Media and the Information of the Social in the Masses," in *Myths of Information: Technology and Post-Industrial Culture*, ed. Kathleen Woodward (Madison: Coda Press, 1980), pp. 137–48.

5. Kenneth Roberts et al., *The Fragmentary Class Structure* (London: Heinemann, 1977).

6. Octave Mannoni, *Clefs pour l'Imaginaire ou L'Autre Scene* (Paris: Editions due Seuil, 1969).

7. Frederic Jameson, "Introduction," *The Postmodern Condition: A Report on Knowledge*, by Jean-François Lyotard (Minneapolis: University of Minnesota Press, 1984).

8. Jean-François Lyotard, *The Postmodern Condition: A Report on Knowledge* (Minneapolis: University of Minnesota Press, 1984).

9. Frederic Jameson, "Postmodernism, or The Cultural Logic of Late Capitalism," *New Left Review*, 146, (July-August 1984), p. 57.

10. Mikhail Bakhtin, "Discourse in the Novel," *The Dialogic Imagination*, ed. Michael Holquist (Austin: University of Texas Press, 1981), pp. 259–422.

11. Terry Eagleton, "Capitalism, Modernism, Post Modernism," in his *Against the Grain* (London: Verso, 1986), pp. 131–48.

12. Terry Eagleton, *The Function of Criticism* (London: Verso/New Left Books, 1984).

13. Frederic Jameson, "Reification and Utopia in Mass Culture," *Social Text* (Winter 1979).

14. John Berger, *Ways of Seeing* (London: Penguin, 1972).

15. Paul Hirst, *On Law and Ideology* (New York: MacMillan Press, 1981).

16. Charles Jencks, *The Language of Post-Modern Architecture* (New York: Rizzoli, 1984). See also Charles Jencks, *What is Post-Modernism?* (London: Academy/New York: St. Martin's Press, 1986); and *Charles Jencks, Architecture and Urbanism*, extra edition, A&U Publishing Company, Tokyo, Japan, January, 1986.

17. Paolo Portoghesi, *After Modern Architecture* (New York: Rizzoli, 1982).

18. Kaja Silverman, "Fragments of a Fashionable Discourse" in *Studies in Entertainment: Critical Approaches to Mass Culture*, ed. Tania Modleski (Bloomington: Indiana University Press, 1986), p. 150–51.

19. Hal Foster, "Post Modern Polemics," in his *Recodings: Art, Spectacle, Cultural Politics* (Port Townsend: Bay Press, 1985), p. 125.

20. Huyssen, *After the Great Divide*, p. 216.

21. For another discussion of this novel in relation to theories of popular culture see Tania Modleski, "Feminity as Mas(s)querade: A Feminist Approach to Mass Culture," in *High Theory/Low Culture*, ed. Colin MacCabe (New York: St. Martin's Press, 1987), pp. 37–52.

22. Manuel Puig, *Kiss of the Spiderwoman* (New York: Vintage Books, 1980), p. 9.

23. Thomas Elsaesser, "Myth as Phantasmagoria of History: H. J. Syberberg, Cinema and Representation," *New German Critique*, no. 24–25 (Fall/Winter, 1981–82).

24. Linda Hutcheon, "The Politics of Post Modernism: Parody and History," *Cultural Critique* (Winter, 1986–87), pp. 179–208.

25. Dick Hebdige, *Subculture: The Meaning of Style* (New York: Methuen, 1979).

26. Umberto Eco, *Travels in Hyperreality* (New York: Harcourt, Brace, Jovanovich, 1986), p. 148.

Index